THE ARTIST—
AN ILLUMINATING SELF-PORTRAIT

This remarkable and inspired selection from Leonardo da Vinci's *Notebooks* was begun as a joint project by Francis Henry Taylor, retired Director of the Metropolitan Museum of Art in New York, and his wife, Pamela. When Mr. Taylor died suddenly, Pamela Taylor carried on the work, completing the book as she and her husband had originally planned it.

THE NOTEBOOKS OF

Leonardo da Vinci

A NEW SELECTION BY PAMELA TAYLOR

A PLUME BOOK from
NEW AMERICAN LIBRARY
TIMES MIRROR
New York, Toronto and London

 PLUME TRADEMARK REG. U.S. PAT. OFF. AND FOREIGN COUNTRIES
REGISTERED TRADEMARK—MARCA REGISTRADA
HECHO EN CLINTON, MASS., U.S.A.

SIGNET, SIGNET CLASSICS, SIGNETTE, MENTOR, AND PLUME BOOKS
are published *in the United States* by
The New American Library, Inc.,
1301 Avenue of the Americas, New York, New York 10019,
in Canada by The New American Library of Canada Limited,
295 King Street East, Toronto 2, Ontario,
in the United Kingdom by The New English Library Limited,
Barnard's Inn, Holborn, London, E.C. 1, England.

First Printing, April, 1971

PRINTED IN THE UNITED STATES OF AMERICA

PREFACE

Shortly before he retired as Director of the Metropolitan
Museum of Art in New York, my husband, Francis Henry
Taylor, was involved in various ways in the celebration of
the five hundredth anniversary of the birth of Leonardo da
Vinci. A medievalist himself originally, he was fascinated
by the man Leonardo, who emerged from the Middle Ages
to dazzle the Renaissance. A selection from Leonardo's
Notebooks was one of the projects on which my husband
and I were engaged together at the time of his sudden death
in 1957.

Leonardo's notes, which he was always promising him-
self to organize, were the haphazard accumulation of years,
an enormous mass which was scattered after his death.
Vast scholarship has gone into the reconstruction of order
and subject, the dating of each page as far as has been pos-
sible. The translation used here is that of the 1883 edition,
by Jean Paul Richter, of *The Literary Works of Leonardo
da Vinci* (Sampson Low, Marston, Searle & Rivington, 188
Fleet Street, London). In the main this book follows the
order of Richter's great edition. In some instances, how-
ever, his subject arrangement has been departed from, and
in various places alterations in the translation have been
made in the interest of clarity, using the latest Italian edi-
tions of the manuscripts as a basis of comparison.

It was our intention to make a selection that would
illustrate as fully as possible the many interests, powers,
and preoccupations of this genius. Some sections are of
necessity larger than others; each was chosen in relation to
the other portions of what we hoped might be a self-
portrait.

Florence, 1960 —PAMELA TAYLOR

CONTENTS

PLATES

INTRODUCTION

"He has been called 'the universal man,' and has so been considered as the greatest genius of the Renaissance, that period of man's awakening from the long slumber of the Middle Ages, in which the modern world, and the spirit of inquiry which it provoked, came into being, and thus determined the character of the society in which we live today." The dimensions that bind most human beings never limited Leonardo, and every facet of this unique man presents some paradoxically contrasting counterpart.

Thus, while his thinking was indeed colored by the superstitions and credulities of the Middle Ages, yet he was the most brilliant ornament of Renaissance culture, and in the multitude of his scientific interests the most modern of men as well. If "universal" is to be used, it must be said of his intellect only. Eschewing action as he did, he does not epitomize the Renaissance. Since he, of all men, combined the passionate dual love of science and art, we may not claim him as modern, having so firmly in our own minds divorced the two. Rachel Annand Taylor is probably right in saying that first and last he was, as he always signed himself, "Leonardo the Florentine," for in that identification is implicit all the most lavish flowering of the most typical city of the age. When most men's minds were only beginning to stir from the medieval darkness, Leonardo's insatiable curiosity drove him into the light; he "created once and for all that ruthless and sometimes dangerous dominion of the intellect which is the proudest possession of free peoples."

Loneliness must always have been his companion. A gentle man who bought in the bird markets in order to set his purchases free and became a vegetarian because he disliked the taking of animal life, he was the willing familiar of one ruthless

despot after another; dispassionate, he moved through violent times without concern.

The endless notebooks have only recently been made available to fascinated readers; he had no contemporary biographer, yet his reputation has remained undimmed since his lifetime. No matter what the fashion of the period, each has found something to admire in this extraordinary figure. Never before or since perhaps has so much potential been enclosed in one human personality, one mind, sweeping like a lighthouse beacon, probed in so many directions. Towering genius that he was, he scorned the businesslike bustle of his contemporaries, worked at his own pace, left unfinished what had ceased to interest him—human foibles which, like his tendency to be self-conscious about his lack of education, only endear him to us, though they irked his contemporaries.

If the biographical material is slight, the da Vinci notebooks provide as fascinating a complex of his mind at work as could be asked. They are extremely difficult to read, as they move from right to left, their author having been left-handed and a "mirror writer" as well. In addition he used a number of abbreviations and signs of his own and a variety of odd spellings. He mentions more than once that he intends putting his notes in order for publication, but seems never to have done so.

The fortunes of the notebooks over the years are typical of the vicissitudes of material treasures in the hands of men. Leonardo, dying in France, willed to his young friend and companion Francesco Melzi "each and all of the books of which the said Testator is at present possessed together with the instruments and portraits which belong to his art and calling as a painter." Melzi returned to Milan, where he apparently remained until his death in 1570, conserving his precious inheritance with reverence. But already letters were being exchanged among the acquisitive concerning this treasure trove of important objects. After Melzi's death his family allowed them to be scattered, a tutor taking some volumes to Florence for possible sale to the Grand Duke, other irreplaceable items from da Vinci's studio being given away with incredible insouciance. A large collection was acquired by one Pompeo Leoni, a sculptor employed in the Escorial by the Spanish king. He proceeded to cut up and have bound in one volume four hundred and two sheets of notes and over seventeen hundred drawings. This priceless scrapbook, now known as the Codex Atlantico, having with twelve other

manuscripts been given to the Ambrosian Library in Milan, was swept off to France in the great looting by Napoleon after his first Italian campaign, and was deposited in the Bibliothèque Nationale in Paris, the other twelve items going to the Institut de France. When, in 1815, the Duke of Wellington appeared at the diplomatic conferences with a memorandum requiring all plundered works of art to be returned to their owners, the Codex was restored to Milan, but the other twelve manuscripts remained, overlooked, in the Institut de France, where they still remain.

Thomas Howard, Earl of Arundel and one of the great collectors of all time, also coveted the Leonardo relics and constantly urged his agents to purchase some. Apparently a sale was made in 1640 by Juan de Espina. Subsequently the drawings disappeared for many years, but in 1760 they were discovered by Dalton, George III's librarian, in the bottom of a chest, and now form the magnificent collection of Leonardo drawings at Windsor Castle. Other portions of the notebooks have found their way into private and public collections in England, the Continent and the United States, and some seem to have been destroyed in the siege of Milan and in subsequent library fires.

Leonardo is mentioned in contemporary poems, Paolo Giovio wrote a short biography of him in 1530, Vasari one in 1568, and there were early printings of the *Treatise on Painting*. The twelve manuscripts in the Institut de France and two from the Bibliothèque Nationale were published in French translation in the years 1880 to 1891. Publication of the other known manuscripts in French, German, and Italian followed in the years 1882 to 1926. The first great compilation and selection from the manuscripts in English, by the distinguished scholar Jean Paul Richter, appeared in London in 1883. In 1906 Edward MacCurdy published in London his own arrangement and translation of the notebooks. Both these selections have been brought up to date in later editions.

On April 24, 1452, in the little village of Anchiano near Vinci in Tuscany, a peasant girl named Caterina gave birth to the bastard son of Ser Piero, a notary of Vinci. Piero's father noted down that his little grandson was christened Leonardo by the local priest, in the presence of a suitable gathering of family friends. Of Caterina we know only that she subsequently married a man of her own station. Probably the little Leonardo was allowed to stay with his mother for his first

years, and then was evidently taken into his father's household to be brought up by his father's young first and childless wife, an arrangement which had plenty of precedent in the proudest houses of Europe at the time.

Although Ser Piero came in direct descent from four notaries and was himself to prosper in his profession, it was evidently not considered necessary to give this first son the formal education which would have been useful for the family station. Instead he was left free to roam the beautiful countryside around Vinci, observing minutely and noting with his extraordinary eye and glittering curiosity the flight of birds, the growth of plants, the individuality of trees and all the natural delights at once commonplace and wonderful to a boy of his imaginative vitality.

Ser Piero's father and first wife died, he remarried, and sometime after 1465 moved his family to Florence. According to Vasari the boy was already busying himself with arithmetical studies, attempts at sculpture, displaying as well great talent in music and drawing. His father may have known Verrocchio and asked his advice; at all events around 1468 Leonardo entered his *bottega* on the via del Agnolo. Here, in the shoptalk of the brilliant visitors, Michelozzo, Paolo Uccello, Benozzo Gozzoli, Antonio Rossellino, Mino da Fiesole, Antonio Pollaiuolo, and Signorelli, as well as the much younger Botticelli, Ghirlandaio, and Perugino, his real education began. Here was born his interest in the "science of painting" and in mechanics, especially the linear perspective which was then exciting Brunelleschi, Leon Battista Alberti, and Piero della Francesca. Verrocchio himself, an extraordinarily skilled craftsman whose ability to turn his hand to almost any form of art made him an ideal master for the versatile Leonardo, was particularly fascinated by aerial perspective. Simultaneously, as was usual in Florentine studios, exquisite goldsmith's work, grandiose equestrian monuments, elaborate altarpieces, meticulously carved gems, the intricate working of wood, drafting of plans for a proud palace, the creation of fantastic pennons, costumes, and floats for some magnificent fete of marriage or welcome, might all be going on in Verrocchio's *bottega*. The painter laid down his brushes to amuse himself with geometrical problems or to pick up his favorite musical instrument. Although Leonardo remained touchy throughout his life as to his lack of "book-learning," it is hard to imagine where the many-sided genius could have better passed the crucial years of early manhood.

It was in Verrocchio's studio too that he painted the head of the angel in his teacher's *Baptism of Christ*, painted it so movingly, so expertly, that legend has claimed Verrocchio straightway laid down his own brush and thereafter devoted himself to other forms of art in which he did not yet feel himself surpassed. Facts and documents do not, unfortunately, bear out this pleasant fiction, but the delicious head remains, an earnest of things to come.

Ser Piero, having buried two childless wives, married a third time and in 1476 sired the first of an impressive list of legitimate children (when he died in 1504 he was survived by ten sons and two daughters). This may have been the reason why Leonardo, no longer an apprentice but, in 1472, enrolled as a master painter in the Guild of St. Luke, was nevertheless living in Verrocchio's house, not in his father's household, when legal charges were made against him and other young painters as homosexuals. The process was dropped for lack of proof, later reopened and again abandoned, but Leonardo's anguished appeals to various prominent Florentines who he thought might help him indicate, it is not too farfetched to say, an apparent terrible feeling of helplessness and being without support in the community.

From these years in Verrocchio's studio have come the two *Annunciations*, one in the Louvre, the other in the Uffizi; the portrait of Ginevra de' Benci, in the Liechtenstein Gallery in Vienna; the first drawing, of a landscape in the Val d'Arno, dated 1473 by his own hand. For the period between 1477 and 1483, however, the record is obscure; to it undoubtedly belong the Benois *Madonna* and *Madonna Litta* (if it is his), both in the Hermitage. Studies for these madonnas are in the Louvre. In 1481 the Monastery of San Donato at Scopeto ordered from him an Adoration of the Magi for the high altar. After making innumerable studies and the magnificently planned cartoon in the Uffizi, he abandoned the project, and in the end it was Filippino Lippi who delivered an altarpiece to the monks. Thus early was the pattern set for the passionately absorbing study which did not lead to completion.

Did Leonardo visit Egypt, Armenia, and the Taurus mountains during this time? Notes on them seem to be based on first-hand information. His patron during the period we know to have been Lorenzo de' Medici, and Leonardo was, among other projects, employed on the gardens of the Piazzo San Marco, where Lorenzo was establishing an academy. In 1479 Leonardo stood under a window of the Bargello and sketched

the dangling body of Bernardo Bandini, third and last of the Pazzi conspirators to be hanged for the murder of Giuliano de' Medici in the previous year. Dispassionately he added a careful inventory of the dead man's costume.

In 1481 some of the leading painters in Florence were invited by Pope Sixtus IV to come to Rome and work in the Sistine Chapel. Botticelli, Perugino, Ghirlandaio, and Cosimo Rosselli accordingly journeyed southward, and Leonardo, insecure as ever in the Florentine community, may have felt the slight of not being included in the group. When, ten years before, Galeazzo Maria Sforza visited Florence, the elaborate festivities had been planned and executed, on commission by the Signoria, in Verrocchio's studio, and, as the young Leonardo had unquestionably worked on them, it was not surprising that he might consider this first Sforza connection a source of valuable patronage. Accordingly he addressed a long letter to Lodovico il Moro, Duke of Bari, who, as regent for his timid nephew, thirteen-year-old Giangaleazzo Sforza, Duke of Milan, was not only the "colorful and complex" ruler of the great Milanese dukedom but "one of the most civilized men in history" as well. Leonardo proposed himself largely in his capacity as engineer, mentioning battle machines, fortifications, and warships, and also architecture, sculpture, and painting. He made for himself an inventory of the drawings which he was taking with him, and, probably in October, 1481, arrived in Milan.

Even to the brilliant and ambitious Milanese court Leonardo must have been a striking addition. His was no great mind meanly housed. He was, on the contrary, exceedingly handsome, with noteworthy eyebrows and a long, beautifully cared for beard, a sumptuous taste, and an original flair in dress, fastidious, a beguiling conversationalist, and, surprisingly, hands so strong that they could perform feats which were to become part of his legend. He took with him to Milan a silver lyre, made by him in the shape of a horse's head, on which to accompany his very beautiful singing voice. If, as has been hazarded, Lorenzo de' Medici himself dispatched da Vinci to il Moro as a diplomatic gesture, he could hardly have found an emissary more certain to please.

In the year of his arrival, the beautiful Cecilia Gallerani had become Lodovico's mistress, so it was natural that the commission to paint her should have been one of the earliest given to Leonardo by the Duke. Now known as the *Lady with the Ermine,* it hangs in the Czartoryski Gallery in Cracow, and

though the lady herself, years later, was to write to Isabella d'Este that it did not do her justice as she was then so young that her beauty had not developed, it was, she hastened to add, through no fault of the painter, whose ability was incomparable. In 1483 the Confraternity of the Immaculate Conception in Milan gave to Leonardo, Ambrogio da Predis, and his half-brother, Evangelisto, a commission to create for their chapel at San Francesco an ornate gold frame (for which payment was to be 700 lire), a central painting to be done for 100 lire by Leonardo, and the side panels by Ambrogio. There was litigation over the price and not until 1508 was final payment made. Meantime Leonardo evidently made two versions of his panel; the first, the exquisite *Virgin of the Rocks* in the Louvre, was finally retained by him; that in the National Gallery in London was probably the one which the Confraternity received. This was the period of the strong, unfinished *St. Jerome with a Lion*, now in the Vatican, and the unfinished portrait of a musician in the Ambrosiana in Milan.

It was chiefly and increasingly his engineering inventions and observations, however, which were absorbing Leonardo's attention, sketches for flying machines and for underwater navigation, for war paraphernalia particularly. On March 26, 1485, he observed a total eclipse of the sun, noting a method of watching it without pain to the eye; details of excursions to Lake Como and the surrounding country were recorded in his notebooks.

In 1488 and 1489 the preliminary sketches for the long-planned equestrian monument to Lodovico's father were definitely in work (they are now in Windsor Castle) but there were innumerable other projects afoot as well: possible solutions for the problem of domes rising from square and octagonal bases, in connection with Milan's cathedral; replanning of the city; the beginning of his intensive anatomical studies and dissection of cadavers. For contrast he collaborated on the Festa del Paradiso which celebrated the marriage of young Isabel of Aragon with Giangaleazzo Sforza, creating an intriguing mechanism of an enormous gilded hemisphere within which men dressed as planets revolved as the verses of Bernardo Bellincioni were declaimed. Soon after, he was constructing a marble pavilion with hot and cold baths for the Duchess's pleasure in the garden labyrinth of her husband the Duke, and decorating stable walls for the Duke. Called to Pavia to advise, in 1490, on the completion of the cathedral there, he lingered for six months of study, grateful no doubt

to escape from the incessant demands of the elaborate Sforza court. Pavia was at its intellectual apogee, and her libraries contained many books which he longed to consult.

Milan in 1491 was preparing to celebrate the double wedding of Lodovico with Beatrice d'Este and Anna Sforza with Alfonso d'Este, and Leonardo designed the costumes for the great tournament. His chief commitment, however, was the equestrian statue; he observed the antique, collected beautiful horses to use as models, made notes on casting. Two years before, Lodovico, who was "devoured by an almost desperate dynamism," sent word through the Florentine ambassador to Lorenzo de' Medici that he feared Leonardo might not complete the commission. The great plaster model was, nevertheless, displayed, in 1493, under a triumphal arch and before the Castello Sforzesco, as part of the celebrations for the approaching marriage in Innsbruck of Bianca Maria Sforza, Lodovico's niece, and Maximilian I. But the towering monument, which would have required hundreds of thousands of pounds of bronze, was never cast. Lodovico, who became Duke of Milan in 1494 on the somewhat suspicious death of his nephew, shipped the metal downstream on the Po to Ferrara to be made into cannon. It appeared that they might shortly be of more avail than monuments. The Gascon archers, during the French occupation, used the great model as a target and ultimately it was completely destroyed.

Early in 1494 Leonardo was at Vigevano, on the Ticino, with the great architect Bramante. Alterations were being made in the summer castle of the Sforzas, and the notebooks contain estimates for decorating a great hall with scenes from Roman history, sketches for a pavilion in the gardens, new waterways, the laying out of vineyards. Lodovico maintained a vast dairy farm around his "cottage," experimenting in the breeding of horses and cattle as well as the cultivation of rice, vineyards, and mulberries. Again the return to Milan must have been hard.

Work on *The Last Supper*, which was to cover one wall of the refectory of S. Maria delle Grazie, began the following year. Leonardo searched tirelessly for models, along the streets of Milan and in Lodovico's crowded court, for the apostles, and, most difficult of all, for the head of Christ, pondering and theorizing meantime on the gestures, which must all express the same emotion in terms of eleven widely differing personalities. One of the greatest paintings of all time, *The Last Supper* projects its supreme spiritual significance because

an unparalleled mind informed an unrivaled hand. The consummate artistry of the brush conceals the science which planned every line and plane, conveying only the drama of the moment following Jesus' statement: "But, behold, the hand of him that betrayeth me is with me on the table." We have contemporary accounts of Leonardo at work on this fresco, how he sometimes worked for hours on end without stopping, at others, being occupied in some other section of the city, would suddenly go to the monastery, mount the scaffold, and, after making one or two carefully calculated brush strokes, take himself off again as suddenly as he had come.

The painting is in far from perfect condition, but that it has been preserved to us at all is miraculous. Louis XII, after his triumphal occupation of Milan in 1499, tried vainly to have it removed from the wall and shipped to France. In 1796 the French used the room to stable their horses. Repainters and restorers have left their mark, and in the last war bombing reduced the entire wall to a seemingly hopeless pile of rubble, considered by the Italian government too far gone to restore. Only the vision and indomitable courage of Dr. Fernanda Wittgens, the Director of the Brera, made possible the magnificent restoration which has preserved it once more—for who knows how long?

They were busy years, the last few in Milan. At the Metropolitan Museum in New York is a sheet of his sketches for scenery, and a list of the characters in a play concerning the legend of Danaë, given at the house of Count di Cajazzo for the entertainment of the Duke and his court. Leonardo was contriving hydraulic systems for the castle, painting the portait of Lucrezia Crivelli (*La Belle Ferronnière* at the Louvre), who had succeeded Cecilia Gallerani in il Moro's favor, making journeys in the train of Lodovico, and working on the first cartoon, now in Burlington House, London, for the St. Anne, Virgin, and Child. But constantly and most frequently he pored over the mathematical studies which so fired his imagination. By 1498 he had completed the decoration of the Salle delle Asse, a striking pattern of interlaced trees and cords with white and gold medallions, and of the Saletta Negra. Nothing worth mentioning of the latter remains, but a much restored fragment of the former gives some idea of the fascinating original. In this same year Fra Luca Pacioli, the mathematician with whom he was in daily consultation, commended Leonardo to il Moro in the dedication of his

treatise *De Divina Proportione*. For this work, which was not actually printed until 1509 by Paganinus, Leonardo had prepared sixty drawings.

Time was running out, not only for the fortunes of the Duke but for the hitherto warm relationship of patron and artist. Leonardo was forced to remind Lodovico that his salary was in arrears, drafting letters which would tactfully remind without giving offense. Presently the Duke made over to him a vineyard outside Milan which would yield an annual income.

In October, 1499, the former Duke of Orleans, having become Louis XII of France in 1498, marched upon Milan to avenge his rout in 1495, when he had first put forward his claim to Milan through his descent from the Visconti. Lodovico escaped, to make his hazardous way to Innsbruck where he hoped to get aid from Maximilian; the Castello was surrendered for a huge bribe. Although il Moro made a brief recapture of Milan, he was finally, in 1500, betrayed by his Swiss mercenaries to the French, taken prisoner, and died in the dungeons of Loches in 1508.

Leonardo sent his savings of 600 florins to Florence for safekeeping, disposed of much of his property, and set out for Venice with Fra Luca Pacioli. Isabella d'Este was delighted to have them stop over in Mantua, where Leonardo drew her profile in red chalk. Early in 1500 he was in Venice, advising the Senate in his capacity of military engineer, and in April, following a brief trip to Rome, he returned to Florence.

Some nineteen years had passed while Leonardo worked in Milan, and the city to which he had returned was no longer under the patronage of the banished Medici, but an ambitious Republic. His father had prospered, holding among other offices that of procurator of the Servite Friars. Probably it was this circumstance which led to the courteous withdrawal of Filippino Lippi, in favor of Leonardo, from the commissioned altarpiece for the Annunziata. The Servites lodged Leonardo and his household at their expense, and after months of waiting were rewarded by the exhibition of the cartoon for the projected painting of the Virgin and Child with St. Anne and John the Baptist. The reverent admiration of the crowds who flocked to see it may have brought temporary satisfaction to the patient friars, but once again Leonardo failed to follow the sketch with the finished work. Ultimately not Filippino, who was a second time commissioned, but Perugino completed the altarpiece.

There were always bystanders who were ready to complain
of the smallness of Leonardo's painted output and now the
Vicar General of the Carmelites, Fra Pietro di Novellara,
wrote to Isabella d'Este, who had set her acquisitive heart on
adding something by the great man to her treasures, that
Leonardo had done only the sketch for the St. Anne and the
Virgin and seemed to be living in a feckless manner from day
to day. Shortly thereafter, however, he was able to report an
interview with Leonardo and the promise of a painting, and
in 1502 Leonardo, at Isabella's request, gave his opinion on a
pair of handsome vases, once the property of Lorenzo il Mag-
nifico and then on sale in Florence.

That summer of 1502 Cesare Borgia, with the connivance
of the French king and the Pope, was campaigning in the
Romagna, and Leonardo appears to have entered his service,
visiting Siena, Urbino, and Cesena in his capacity of military
engineer, drawing many maps and unfailingly noting the
natural details which caught his eye. He met and became
friends with Machiavelli, also in the Borgia employ. By
March, 1503, with Cesare Borgia's campaign at an end,
Leonardo had returned to Florence, and by October he was
again enrolled as a member of the painters' guild, possibly to
enable him to take up the commission of the Signoria to paint
a huge battlepiece on the wall of the newly built Sala del Gran
Consiglio in the Palazzo Vecchio. It was planned that Michel-
angelo should also execute a battle scene on the opposite wall.
Subjects were chosen, for Leonardo the Battle of Anghiari,
a Florentine victory over the Milanese in 1440, for Michel-
angelo the Battle of Cascina, which followed a surprise of
the Florentine soldiers by the Pisans while bathing. The
great Sala del Papa at Sta. Maria Novella was turned over
to Leonardo for preparation of the cartoon, while Michel-
angelo was at work in the hospital at Sant' Onofrio. The
progress of the cartoons awakened passionate interest in the
Florentines and was followed with partisanship and endless
argument. The records of payment indicate that Leonardo was
working with extraordinary (for him) application; a detailed
description of the battle was prepared for him (possibly by
Machiavelli), he himself made innumerable sketches and
notations. In May of 1504 the legal contract for the com-
mission was drawn up, setting the monthly salary at fifteen
florins (niggardly enough after the munificent patronage of il
Moro), and, no doubt with past performance in mind, definite

specifications of completion of the cartoon and ownership of it should the painting not be completed.

In February, 1505, an ingenious scaffolding, especially designed by Leonardo, was erected so that the painting might be begun. Using a recipe taken from Pliny for the plaster on which he was to paint, a recipe he tried out with success in the smaller Sala del Papa, Leonardo evidently worked for at least six months; but the great height of the hall prevented the braziers from drying out the upper reaches of the wall, and the colors ran disastrously. Possibly the damage could have been repaired with an alteration in the composition of the plaster, but undoubtedly Leonardo's attention had been diverted elsewhere. Michelangelo, meanwhile, had finished his cartoon but without even beginning to paint had departed for Rome.

Not all of Leonardo's time, during the years from 1503 to 1506, had been absorbed in this one undertaking. He had been working fitfully on another project, the portrait of Elisabetta Gherardini, third wife of Francesco Giocondo, diverting her during the endless sittings he required with music and songs which he caused to have performed for her delight. Like *The Last Supper* one of the masterpieces of Western painting, it partakes of the legend of its creator. Mona Lisa was in her late twenties when it was painted, which for an Italian woman of that time was not young; nor is she by conventional standards a uniquely beautiful woman. Evidently the portrait did not please her husband, for Leonardo retained it, taking it with him to France a few years later. Hundreds of copies have been made of it; endless prose shading from deep purple to the scholar's crisp black and white written about it, but none have explained its enigmatic, haunting quality.

Leonardo was also apparently at work on the early sketches for *Leda and the Swan,* three versions of which he designed and at least one of which he executed, for it existed in Fontainebleau until the end of the seventeenth century. Sir Kenneth Clark remarks the curious anomaly that it should have been Leonardo, of all painters, who was the first "Renaissance artist to represent a naked woman as a symbol of creative and generative life." On a page of anatomical drawings from the year 1504, when the process of human reproduction first began to monopolize his scientific attention, appears, beside some noted questions, the first sketch of Leda. "Since women did not arouse in him any feelings of desire, he was all the more curious about the mysterious character of generation.

He could consider the sexual act as part of the endless flux of growth, decay and rebirth which formed for him the most fascinating and fundamental of all intellectual problems."

Isabella d'Este, the indefatigable collector, was still persistent in her demands for attention. She wrote suggesting that when tired of painting the history of Florence he refresh himself by painting for her the young Christ disputing with the elders. He acquiesced pleasantly enough but apparently never undertook the painting.

In 1504 his father died, a fact which he noted without comment among other memoranda. Apparently, from the tone of fragments of letters to his father sketched not long before the latter's death, Leonardo was on good terms with him, but Ser Piero's legitimate issue fought Leonardo's claims to any of his father's property, and contested for months in the courts his inheritance from an uncle.

The spring of 1506 found Leonardo on his way to Milan again. Charles d'Amboise, Lord of Chaumont and French governor in Milan, had persuaded the Signoria to allow him to come for a short period, but it is evident from the time limit set for his return that it was expected that the *Battle of Anghiari* would eventually be finished. There followed repeated requests for extension of leave for the man whom the French king already considered his chief painter and engineer in ordinary. Although obliged to return briefly to Florence by the lawsuits over his patrimony, Leonardo lingered on in Milan, no doubt enjoying an open-handed patronage not forthcoming in Florence. He was at work as usual on waterways, pursuing his studies, particularly of embryology, planning still another equestrian monument to Marshal Trivulzio, painting the *St. John* now in the Louvre, occupied with the *St. Anne and the Virgin* as well. At this time too he probably first became friends with young Francesco Melzi of Vaprio, a Milanese noble who was to remain his companion for the rest of his life.

In 1513, the French having been driven from Milan and a bloodless revolution having established the Medici in power in Florence once more, Leonardo set out, with Melzi and some others, for Rome. He went at the invitation of Giuliano de' Medici, whose brother Giovanni was now Pope Leo X, was lodged by him in the Belvedere Palace of the Vatican, and set to work by him on the Pope's great project of draining the Pontine marshes. It was a moment of incredible brilliance in the city. At the Vatican the thirty-one-year-old Raphael

was at work on the *Disputa* and the *School of Athens,* and Michelangelo, only eight years older, was spending his days on the scaffold in the Sistine Chapel. But Leonardo had never been on good terms with the much younger Michelangelo, there were others who intrigued against him, his anatomical dissections were suspect, and the Pope seems not to have been impressed by him. At all events, his patron Giuliano died in 1516, and Leonardo noted: "The Medici made me and ruined me."

In 1515 Leo X and the French king Francis I met secretly in Bologna, and it is possible that Leonardo may have been in the Pope's entourage. Whether or not this was a first meeting with Francis, he accepted the King's invitation in late 1516 and journeyed to Amboise, where, in the charming little manor house of Cloux, Francis established him. Here visited in 1517 by Cardinal Luigi of Aragon he displayed three paintings, probably the *Mona Lisa,* the *St. Anne,* and the *John the Baptist,* and the Cardinal's secretary also noted with admiration his many other accomplishments. His presence was a constant pleasure to the King, who enjoyed his conversation no less than he admired his virtuosity and genius.

The French court celebrated at Amboise in May, 1518, with great pomp, the baptism of the Dauphin and the marriage of Lorenzo de' Medici with the King's niece, Madeleine de la Tour d'Auvergne. One of the innumerable festivities arranged was a ball in the courtyard at Cloux, with decorations which recalled Leonardo's planets at the Masque in Milan years before. It is agreeable to think of the aging painter, who had always loved beautiful faces, the utmost luxury of dress, and the panoply of moneyed power, playing host to the brilliant court. On St. John's Day, June 24, 1518, he made the last notation in his own hand and on May 2, 1519, he died at Cloux. "For so long as my limbs endure I shall possess a perpetual sorrow," wrote Francesco Melzi to Leonardo's brothers, acquainting them with his death and the legacy of a property at Fiesole and 400 scudi which he, magnanimously enough considering their past performance, had left them. "It is a hurt to anyone to lose such a man, for nature cannot again produce his like." Nor indeed has she.

Under August 12, 1519, the register of the church of St. Florentin at Amboise records the burial in the cloister of "Leonard de Vincy, once Milanese, first painter, engineer and architect of the King."

Not the least fascinating aspect of the Leonardo legend is the extraordinary diversity of opinion about him. No one disagrees about the supreme quality of his paintings and drawings, but while one writer extols his scientific accomplishment another, like the distinguished historian of science and longtime Leonardo scholar George Sarton, points out more soberly that while he can certainly be called the father of aviation he cannot, as he has been, be described as the precursor of Harvey in all fairness, since his anatomical researches and drawings remained hidden for centuries. Moreover, there is some reason to believe that where technology seemed to encroach on art, as in the case of printing, for example, Leonardo was rather hostile to it. To some enthusiasts he is enormously learned, yet Sarton remarks again that in comparison to his contemporaries he quoted very little from the great minds of his day, and indeed seems for all his natural brilliance to have been comparatively unlettered. Nor is there any proof that all the machines he sketched were of his own inventing. Even the illustrations which he did for Pacioli's book on geometry are inaccurate, having been prepared without instruments. To some commentators his Madonnas are the most moving spiritual expression of the Renaissance, yet there is little to indicate that, until his last years, he was religiously inclined. To Sigmund Freud, who in 1910 published about him a work he described as "the only pretty thing" he had ever written (it proved violently shocking to most of its readers at the time), he was a fascinating case in point of many of his favorite theories.

The game of trying to claim as works by him variously attributed canvases and sculptures, or of identifying his hand in innumerable other surviving masterpieces, has occupied art historians endlessly and seems likely to go on doing so without end, no final solution to the fascinating parlor game being likely. Leonardo is the perpetual intriguing kaleidoscope of our civilization, varied for each who holds it to the light. "Surely," Bernard Berenson has written, "such a man brings us the gladdest of all tidings—the wonderful possibilities of the human family, of whose chances we all partake."

Chapter 1

THE PAINTER

Unlike most of Leonardo's writing, the Treatise on Painting has been well known practically since it was first inherited by the devoted Melzi. It is important because it sums up Leonardo's convictions on the painter's art, demonstrates his beliefs as to the scientific aspects of the art, includes many practical suggestions for the painter, and throws as much light as we find anywhere on Leonardo's personal preferences and opinions. Although it was not printed until 132 years after his death, borrowed excerpts appear in books by others, and it is evident that copies of the original manuscript were circulated among painters and scientists alike.

The earliest compilation of the notes which make up the Treatise is now known as the Codex Urbinas Latinus; it belonged in the collection of the dukes of Urbino, was willed by the last duke to the Roman Curia in 1626, disappeared in the Vatican Library and was not brought to light again until 1817.

There existed many other copies apparently, one of which Benvenuto Cellini owned; still another, in the collection of Cardinal Francesco Barberini in Rome, was edited by his secretary Cassiano dal Pozzo, illustrated by Nicolas Poussin, and published by Raphael du Fresne in 1651. It appeared in Italian and in French in this same year.

The eighteenth century saw twelve editions of the Treatise in five languages, the nineteenth century produced twenty-one editions, and in the first half of the present century twenty-five editions have appeared in six languages. The Belt Library in Los Angeles possesses the most complete collection of the sixty-two known editions of the Treatise.

INTRODUCTION

Begun at Florence, in the house of Piero di Braccio Martelli, on the 22nd day of March, 1508. And this is to be a collection without order, taken from many papers which I have copied here, hoping to arrange them later each in its place, according to the subjects of which they may treat. But I believe that before I am at the end of this task I shall have to repeat the same things several times; for which, O reader! do not blame me, for the subjects are many and memory cannot retain them all and say: "I will not write this because I wrote it before." And if I wished to avoid falling into this fault, it would be necessary in every case when I wanted to copy a passage that, not to repeat myself, I should read over all that had gone before; and all the more since the intervals are long between one time of writing and the next.

Seeing that I can find no subject specially useful or pleasing—since the men who have come before me have taken for their own every useful or necessary theme—I must do like one who, being poor, comes last to the fair, and can find no other way of providing himself than by taking all the things already seen by other buyers and not taken but refused by reason of their lesser value. I, then, will load my humble pack with this despised and rejected merchandise, the refuse of so many buyers, and will go about to distribute it, not indeed in great cities, but in the poorer towns, taking such a price as the wares I offer may be worth.

I know that many will call this useless work, and they will be those of whom Demetrius declared that he took no more account of the wind that came out their mouth in words than of that they expelled from their lower parts: men who desire nothing but material riches and are absolutely devoid of that wisdom which is the food and the only true riches of the mind. For so much more worthy as the soul is than the body, so much more noble are the possessions of the soul than those of the body. And often, when I see one of these men take this work in his hand, I wonder that he does not put it to his nose like a monkey, or ask me if it is something good to eat.

I am fully conscious that, not being a literary man, certain presumptuous persons will think that they may reasonably blame me, alleging that I am not a man of letters. Foolish folks! do they not know that I might retort as Marius did to the Roman Patricians by saying that they who deck themselves out in the labors of others will not allow me my own. They will say that I, having no literary skill, cannot properly express that which I desire to treat of; but they do not know that my subjects are to be dealt with by experience rather than by words, and experience has been the mistress of those who wrote well. And so, as mistress, I will cite her in all cases.

Though I may not, like them, be able to quote other authors, I shall rely on that which is much greater and more worthy—on experience, the mistress of their Masters. They go about puffed up and pompous, dressed and decorated with the fruits, not of their own labors, but of those of others. And they will not allow me my own. They will scorn me as an inventor, but how much more might they—who are not inventors but vaunters and declaimers of the works of others—be blamed.

And those men who are inventors and interpreters between Nature and Man, as compared with boasters and declaimers of the works of others, must be regarded and not otherwise esteemed than as the object in front of a mirror when compared with its image seen in the mirror. For the first is something in itself and the other nothingness.—Folks little indebted to Nature, since it is only by chance that they wear the human form and without it I might class them with the herds of beasts.

Many will think they may reasonably blame me by alleging that my proofs are opposed to the authority of certain men held in the highest reverence by their inexperienced judgments; not considering that my works are the issue of pure and simple experience, who is the one true mistress. These rules are sufficient to enable you to know the true from the false— and this aids men to look only for things that are possible and with due moderation—and not to wrap yourself in ignorance, a thing which can have no good result, so that in despair you would give yourself up to melancholy.

Among all the studies of natural causes and reasons Light chiefly delights the beholder; and among the great features of Mathematics the certainty of its demonstrations is what preeminently (tends to) elevate the mind of the investigator. Per-

spective, therefore, must be preferred to all the discourses and systems of human learning. In this branch of science the beam of light is explained on those methods of demonstration which form the glory not so much of Mathematics as of Physics and are graced with the flowers of both. But its axioms being laid down at great length, I shall abridge them to a conclusive brevity, arranging them on the method both of their natural order and of mathematical demonstration; sometimes by deduction of the effects from the causes, and sometimes arguing the causes from the effects; adding also to my own conclusions some of which, though not included in them, may nevertheless be inferred from them. Thus, if the Lord—who is the light of all things—vouchsafe to enlighten me, I will treat of Light; wherefore I will divide the present work into 3 Parts.

On the three branches of perspective. There are three branches of perspective; the first deals with the reasons of the (apparent) diminution of objects as they recede from the eye, and is known as Diminishing Perspective. The second contains the way in which colors vary as they recede from the eye. The third and last is concerned with the explanation of how the objects in a picture ought to be less finished in proportion as they are remote and the names are as follows:

Linear Perspective
The Perspective of Color
The Perspective of Disappearance

Of the mistakes made by those who practice without knowledge. Those who are in love with practice without knowledge are like the sailor who gets into a ship without rudder or compass and who never can be certain whither he is going. Practice must always be founded on sound theory, and to this Perspective is the guide and the gateway; and without this nothing can be done well in the matter of drawing.

The painter who draws merely by practice and by eye, without any reason, is like a mirror which copies all the things placed in front of it without being conscious of their existence.

Here, in the eye, forms, here colors, here the character of every part of the universe, are concentrated to a point; and that point is so marvelous a thing . . . Oh! marvelous, O

stupendous Necessity—by thy laws thou dost compel every
effect to be the direct result of its cause, by the direct result
of its cause, by the shortest path. These indeed are mir-
acles. . . .

In so small a space it can be reproduced and rearranged
in its whole expanse. Describe in your anatomy what propor-
tion there is between the diameters of all the images in the eye
and the distance from them of the crystalline lens.

Of the 10 attributes of the eye, all concerned in painting.
Painting is concerned with all the 10 attributes of sight, which
are: Darkness, Light, Solidity and Color, Form and Position,
Distance and Propinquity, Motion and Rest. This little work
of mine will be a tissue of the studies of these attributes, re-
minding the painter of the rules and methods by which he
should use his art to imitate all the works of Nature which
adorn the world.

On painting. 1st. The pupil of the eye contracts, in pro-
portion to the increase of light which is reflected in it. 2nd.
The pupil of the eye expands in proportion to the diminution
in the daylight, or any other light, that is reflected in it. 3rd.
The eye perceives and recognizes the objects of its vision with
greater intensity in proportion as the pupil is more widely
dilated; and this can be proved by the case of nocturnal ani-
mals, such as cats, and certain birds—as the owl and others—
in which the pupil varies in a high degree from large to small,
etc., when in the dark or in the light. 4th. The eye out of
doors in an illuminated atmosphere sees darkness behind the
windows of houses which nevertheless are light. 5th. All
colors when placed in the shade appear of an equal degree
of darkness, among themselves. 6th. But all colors when
placed in a full light never vary from their true and essential
hue.

Of the eye. If the eye is required to look at an object placed
too near to it, it cannot judge of it well—as happens to a
man who tries to see the tip of his nose. Hence, as a general
rule, Nature teaches us that an object can never be seen per-
fectly unless the space between it and the eye is equal, at
least, to the length of the face.

The eye—which sees all objects reversed—retains the
images for some time. This conclusion is proved by the re-
sults; because the eye, having gazed at light, retains some im-
pression of it. After looking at it there remain in the eye

images of intense brightness, that make any less brilliant spot seem dark until the eye has lost the last trace of the impression of the stronger light.

LINEAR PERSPECTIVE

Perspective is a rational demonstration by which experience confirms that every object sends its image to the eye by a pyramid of lines; and bodies of equal size will result in a pyramid of larger or smaller size, according to the difference in their distance, one from the other. By a pyramid of lines I mean those which start from the surface and edges of bodies, and, converging from a distance, meet in a single point. A point is said to be that which, having no dimensions, cannot be divided, and this point placed in the eye receives all the points of the cone.

To prove how objects reach the eye. If you look at the sun or some other luminous body and then shut your eyes you will see it again inside your eye for a long time. This is evidence that images enter into the eye.

Perspective. The air is filled with endless images of the objects distributed in it; and all are represented in all, and all in one, and all in each, whence it happens that, if two mirrors are placed in such a manner as to face each other exactly, the first will be reflected in the second and the second in the first. The first being reflected in the second takes to it the image of itself with all the images represented in it, among which is the image of the second mirror, and so, image within image, they go on to infinity in such a manner as that each mirror has within it a mirror, each smaller than the last and one inside the other. Thus, by this example, it is clearly proved that every object sends its image to every spot whence the object itself can be seen; and the converse: that the same object may receive in itself all the images of the objects that are in front of it. Hence the eye transmits through the atmosphere its own image to all the objects that are in front of it and receives them into itself, that is to say on its surface, whence they are taken in by the common sense, which considers them and if they are pleasing commits them to the memory. Whence I am of opinion that the invisible images in the eyes are produced towards the object, as the image of the object to the eye. That the images of the objects must be disseminated through the air. An instance may be seen

in several mirrors placed in a circle, which will reflect one another endlessly. When one has reached the other it is returned to the object that produced it, and thence—being diminished—it is returned again to the object and then comes back once more, and this happens endlessly. If you put a light between two flat mirrors with a distance of 1 braccio between them you will see in each of them an infinite number of lights, one smaller than another, to the last. If at night you put a light between the walls of a room, all the parts of that wall will be tinted with the image of that light. And they will receive the light and the light will fall on them, mutually, that is to say, when there is no obstacle to interrupt the transmission of the images. This same example is seen in a greater degree in the distribution of the solar rays which all together, and each by itself, convey to the object the image of the body which causes it. That each body by itself alone fills with its images the atmosphere around it, and that the same air is able, at the same time, to receive the images of the endless other objects which are in it, this is clearly proved by these examples. And every object is everywhere visible in the whole of the atmosphere, and the whole in every smallest part of it; and all the objects in the whole, and all in each smallest part; each in all and all in every part.

If the object in front of the eye sends its image to the eye, the eye, on the other hand, sends its image to the object, and no portion whatever of the object is lost in the images it throws off, for any reason either in the eye or the object. Therefore we may rather believe it to be the nature and potency of our luminous atmosphere which absorbs the images of the objects existing in it, than the nature of the objects to send their images through the air. If the object opposite to the eye were to send its image to the eye, the eye would have to do the same to the object, whence it might seem that these images were an emanation. But, if so, it would be necessary to admit that every object became rapidly smaller, because each object appears by its images in the surrounding atmosphere. That is: the whole object in the whole atmosphere, and in each part; and all the objects in the whole atmosphere and all of them in each part; speaking of that atmosphere which is able to contain in itself the straight and radiating lines of the images projected by the objects. From this it seems necessary to admit that it is in the nature of the atmosphere, which subsists between the objects,

and which attracts the images of things to itself like a load-stone, being placed between them.

Prove how all objects, placed in one position, are all everywhere and all in each part. I say that if the front of a building —or any open piazza or field—which is illuminated by the sun has a dwelling opposite to it, and if, in the front which does not face the sun, you make a small round hole, all the illuminated objects will project their images through that hole and be visible inside the dwelling on the opposite wall, which should be made white; and there, in fact, they will be upside down, and if you make similar openings in several places in the same wall you will have the same result from each. Hence the images of the illuminated objects are all everywhere on this wall and all in each minutest part of it. The reason, as we clearly know, is that this hole must admit some light to the said dwelling, and the light admitted by it is derived from one or many luminous bodies. If these bodies are of various colors and shapes the rays forming the images are of various colors and shapes, and so will the representations be on the wall.

Perspective. Perspective, in dealing with distances, makes use of two opposite pyramids, one of which has its apex in the eye and the base as distant as the horizon. The other has the base towards the eye and the apex on the horizon. Now, the first includes the visible universe, embracing all the mass of the objects that lie in front of the eye; as it might be a vast landscape through a very small opening; for the more remote the objects are from the eye, the greater number can be seen through the opening, and thus the pyramid is constructed with the base on the horizon and the apex in the eye, as has been said. The second pyramid is extended to a spot which is smaller in proportion as it is farther from the eye, and this second perspective, = pyramid, results from the first.

Simple perspective. Simple perspective is that which is constructed by art on a vertical plane which is equally distant from the eye in every part. Complex perspective is that which is constructed on a ground plan in which none of the parts are equally distant from the eye.

No surface can be seen exactly as it is, if the eye that sees it is not equally remote from all its edges.

There is no object so large but that at a great distance from the eye it does not appear smaller than a smaller object near.

Among objects of equal size, that which is most remote from the eye will look the smallest.

The differences in the diminution of objects of equal size in consequence of their various remoteness from the eye will bear among themselves the same proportions as those of the spaces between the eye and the different objects.

Find out how much a man diminishes at a certain distance and what its length is; and then at twice that distance and at 3 times, and so make your general rule.

The eye cannot judge where an object high up ought to descend.

ON LIGHT AND SHADE

Having already treated of the nature of shadows and the way in which they are cast, I will now consider the places on which they fall, and their curvature, obliquity, flatness, or, in short, any character I may be able to detect in them.

Shadow is the obstruction of light. Shadows appear to me to be of supreme importance in perspective, because without them opaque and solid bodies will be ill defined; that which is contained within their outlines and their boundaries themselves will be ill understood unless they are shown against a background of a different tone from themselves. And therefore in my first proposition concerning shadow I state that every opaque body is surrounded and its whole surface enveloped in shadow and light. And on this proposition I build up the first Book. Besides this, shadows have in themselves various degrees of darkness, because they are caused by the absence of a variable amount of the luminous rays; and these I call Primary shadows because they are the first, and inseparable from the object to which they belong. And on this I will found my second Book. From these primary shadows there result certain shaded rays which are diffused through the atmosphere, and these vary in character according to that of the primary shadows whence they are derived. I shall therefore call these shadows derived shadows because they are produced by other shadows and the third Book will treat of these. Again, these derived shadows, where they are intercepted by various objects, produce effects as various as the places where they are cast, and of this I will treat in the fourth Book. And since all round the derived shadows, where the

derived shadows are intercepted, there is always a space where the light falls and by reflected dispersion is thrown back towards its cause, it meets the original shadow and mingles with it and modifies it somewhat in its nature; and on this I will compose my fifth Book. Besides this, in the sixth Book I will investigate the many and various diversities of reflections resulting from these rays which will modify the original shadow by imparting some of the various colors from the different objects whence these reflected rays are derived. Again, the seventh Book will treat of the various distances that may exist between the spot where the reflected rays fall and that where they originate, and the various shades of color which they will acquire in falling on opaque bodies.

First I will treat of light falling through windows, which I will call restricted light, and then I will treat of light in the open country, to which I will give the name of diffused light. Then I will treat of the light of luminous bodies.

Of painting. The conditions of shadow and light as seen by the eye are 3. Of these the first is when the eye and the light are on the same side of the object seen. The 2nd is when the eye is in front of the object and the light 'is behind it. The 3rd is when the eye is in front of the object and the light is on one side, in such a way as that a line drawn from the object to the eye and one from the object to the light should form a right angle where they meet.

Of painting. Of the three kinds of light that illuminate opaque bodies. The first kind of light which may illuminate opaque bodies is called direct light—as that of the sun or any other light from a window or flame. The second is diffused universal light, such as we see in cloudy weather or in mist and the like. The 3rd is subdued light, that is, when the sun is entirely below the horizon, either in the evening or morning.

Of light. The lights which may illuminate opaque bodies are of 4 kinds. These are: diffused light, as that of the atmosphere, within our horizon. And direct, as that of the sun, or of a window or door or other opening. The third is reflected light; and there is a 4th which is that which passes through semitransparent bodies, as linen or paper or the like, but not transparent like glass, or crystal or other diaphanous bodies, which produce the same effect as though nothing intervened between the shaded object and the light that falls upon it; and this we will discuss fully in our discourse.

Shadow is the diminution alike of light and of darkness, and stands between darkness and light.

A shadow may be infinitely dark, and also of infinite degrees of absence of darkness.

The beginnings and ends of shadow lie between the light and darkness and may be infinitely diminished and infinitely increased.

Shadow is the means by which bodies display their form.

The forms of bodies could not be understood in detail but for shadow.

Of the nature of shadow. Shadow partakes of the nature of universal matter. All such matters are more powerful in their beginning and grow weaker towards the end; I say at the beginning, whatever their form or condition may be and whether visible or invisible. And it is not from small beginnings that they grow to a great size in time; as it might be a great oak which has a feeble beginning from a small acorn. Yet I may say that the oak is most powerful at its beginning, that is, where it springs from the earth, which is where it is largest—darkness, then, is the strongest degree of shadow and light is its least. Therefore, O Painter, make your shadow darkest close to the object that casts it, and make the end of it fading into light, seeming to have no end.

Light is the chaser away of darkness. Shade is the obstruction of light. Primary light is that which falls on objects and causes light and shade. And derived lights are those portions of a body which are illuminated by the primary light. A primary shadow is that side of a body on which the light cannot fall.

The general distribution of shadow and light is that sum total of the rays thrown off by a shaded or illuminated body passing through the air without any interference and the spot which intercepts and cuts off the distribution of the dark and light rays.

And the eye can best distinguish the forms of objects when it is placed between the shaded and the illuminated parts.

Perspective. If you transmit the rays of the sun through a hole in the shape of a star you will see a beautiful effect of perspective in the spot where the sun's rays fall.

Of painting. When you represent in your work shadows which you can only discern with difficulty, and of which you cannot distinguish the edges, so that you apprehend them confusedly, you must not make them sharp or definite lest your work should have a wooden effect.

A dark object seen against a bright background will appear smaller than it is.

A light object will look larger when it is seen against a background darker than itself.

THEORY OF COLORS

A shadow is always affected by the color of the surface on which it is cast.

An image produced in a mirror is affected by the color of the mirror.

Of light and shade. Every portion of the surface of a body is varied in hue by the reflected color of the object that may be opposite to it.

Why beautiful colors must be in the highest light. Since we see that the quality of color is known only by means of light, it is to be supposed that where there is most light the true character of a color in light will be best seen, and where there is most shadow the color will be affected by the tone of that. Hence, O Painter! remember to show the true quality of colors in bright lights.

The adversary. The variety of colors in shadow must be as great as that of the colors in the objects in that shadow.

The answer. Colors seen in shadow will display less variety in proportion as the shadows in which they lie are deeper. And evidence of this is to be had by looking from an open space into the doorways of dark and shadowy churches, where the pictures which are painted in various colors all look of uniform darkness.

Hence at a considerable distance all the shadows of different colors will appear of the same darkness.

It is the light side of an object in light and shade which shows the true color.

Of the colors in the feathers of certain birds. There are many birds in various regions of the world on whose feathers we see the most splendid colors produced as they move, as we see in our own country in the feathers of peacocks or on the necks of ducks or pigeons, etc.

Again, on the surface of antique glass found underground and on the roots of turnips kept for some time at the bottom of wells or other stagnant waters we see that each root displays colors similar to those of the real rainbow. They may also be seen when oil has been placed on the top of water and in the solar rays reflected from the surface of a diamond or beryl; again, through the angular facet of a beryl every dark object against a background of the atmosphere or anything else equally pale-colored is surrounded by these rainbow colors between the atmosphere and the dark body; and in many other circumstances which I will not mention, as these suffice for my purpose.

PERSPECTIVE OF COLOR AND AERIAL PERSPECTIVE

The variety of color in objects cannot be discerned at a great distance, excepting in those parts which are directly lighted up by the solar rays.

Of the visibility of colors. Which color strikes most? An object at a distance is most conspicuous when it is lightest, and the darkest is least visible.

Of the edges [*outlines*] *of shadows.* Some have misty and ill-defined edges, others distinct ones.

No opaque body can be devoid of light and shade, except it is in a mist, on ground covered with snow, or when snow is falling on the open country which has no light on it and is surrounded with darkness.

And this occurs only in spherical bodies, because in other bodies which have limbs and parts, those sides of limbs which face each other reflect on each other the accidental hue and tone of their surface.

Of aerial perspective. There is another kind of perspective which I call Aerial Perspective, because by the atmosphere we are able to distinguish the variations in distance of different buildings, which appear placed on a single line; as, for instance, when we see several buildings beyond a wall, all of which, as they appear above the top of the wall, look of the same size, while you wish to represent them in a picture as

more remote one than another and to give the effect of a some-
what dense atmosphere. You know that in an atmosphere of
equal density the remotest objects seen through it, as moun-
tains, in consequence of the great quantity of atmosphere be-
tween your eye and them—appear blue and almost of the same
hue as the atmosphere itself when the sun is in the east.
Hence you must make the nearest building above the wall of
its real color; but the more distant ones make less defined
and bluer. Those you wish should look farthest away you
must make proportionately bluer; thus, if one is to be five
times as distant, make it five times bluer. And by this rule
the buildings which above a given line appear of the same
size, will plainly be distinguished as to which are the more
remote and which larger than the others.

Of the color of the atmosphere. I say that the blueness we
see in the atmosphere is not intrinsic color, but is caused by
warm vapor evaporated in minute insensible atoms on which
the solar rays fall, rendering them luminous against the in-
finite darkness of the fiery sphere which lies beyond and in-
cludes it. And this may be seen, as I saw it, by anyone going
up Monboso, a peak of the Alps which divide France from
Italy. The base of this mountain gives birth to the four rivers
which flow in four different directions through the whole of
Europe. And no mountain has its base at so great a height as
this, which lifts itself almost above the clouds; and snow
seldom falls there, but only hail in the summer, when the
clouds are highest. And this hail lies unmelted there, so that
if it were not for the absorption of the rising and falling
clouds, which does not happen twice in an age, an enormous
mass of ice would be piled up there by the hail, and in the
middle of July I found it very considerable. There I saw
above me the dark sky, and the sun as it fell on the mountain
was far brighter here than in the plains below, because a
smaller extent of atmosphere lay between the summit of the
mountain and the sun. Again as an illustration of the color of
the atmosphere I will mention the smoke of old and dry wood,
which, as it comes out of a chimney, appears to turn very
blue, when seen between the eye and the dark distance. But as
it rises, and comes between the eye and the bright atmosphere,
it at once shows of an ashy gray color; and this happens
because it no longer has darkness beyond it, but this bright
and luminous space. If the smoke is from young, green wood,
it will not appear blue, because, not being transparent and

being full of superabundant moisture, it has the effect of condensed clouds which take distinct lights and shadows like a solid body. The same occurs with the atmosphere, which when overcharged with moisture appears white, and the small amount of heated moisture makes it dark, of a dark blue color; and this will suffice us so far as concerns the color of the atmosphere; though it might be added that, if this transparent blue were the natural color of the atmosphere, it would follow that wherever a larger mass of air intervened between the eye and the element of fire, the azure color would be more intense; as we see in blue glass and in sapphires, which are darker in proportion as they are larger. But the atmosphere in such circumstances behaves in an opposite manner, inasmuch as where a greater quantity of it lies between the eye and the sphere of fire, it is seen much whiter. This occurs towards the horizon. And the less the extent of atmosphere between the eye and the sphere of fire, the deeper is the blue color, as may be seen even on low plains. Hence it follows, as I say, that the atmosphere assumes this azure hue by reason of the particles of moisture which catch the rays of the sun. Again, we may note the difference in particles of dust, or particles of smoke, in the sunbeams admitted through holes into a dark chamber, when the former will look ash gray and the thin smoke will appear of a most beautiful blue; and it may be seen again in the dark shadows of distant mountains when the air between the eye and those shadows will look very blue, though the brightest parts of those mountains will not differ much from their true color. But if anyone wishes for a final proof let him paint a board with various colors, among them an intense black; and over all let him lay a very thin and transparent coating of white. He will then see that this transparent white will nowhere show a more beautiful blue than over the black—but it must be very thin and finely ground.

Experience shows us that the air must have darkness beyond it and hence it appears blue. If you produce a small quantity of smoke from dry wood and the rays of the sun fall on this smoke, and if you then place behind the smoke a piece of black velvet on which the sun does not shine, you will see that all the smoke which is between the eye and the black stuff will appear of a beautiful blue color. And if instead of the velvet you place a white cloth smoke, that is too thick smoke, hinders, and too thin smoke does not produce, the perfection of this blue color. Hence a moderate amount of smoke produces the finest blue. Water violently ejected in a fine spray

and in a dark chamber where the sunbeams are admitted produces these blue rays and the more vividly if it is distilled water, and thin smoke looks blue. This I mention in order to show that the blueness of the atmosphere is caused by the darkness beyond it, and these instances are given for those who cannot confirm my experience on Monboso.

When the smoke from dry wood is seen between the eye of the spectator and some dark space or object it will look blue. Thus the sky looks blue by reason of the darkness beyond it. And if you look towards the horizon of the sky, you will see the atmosphere is not blue, and this is caused by its density. And thus at each degree, as you raise your eyes above the horizon up to the sky over your head, you will see the atmosphere look darker blue and this is because a smaller density of air lies between your eye and the outer darkness. And if you go to the top of a high mountain the sky will look proportionately darker above you as the atmosphere becomes rarer between you and the outer darkness; and this will be more visible each degree of increasing height till at last we should find darkness.

That smoke will look bluest which rises from the driest wood and which is nearest to the fire and is seen against the darkest background, and with the sunlight upon it.

In the morning the mist is denser above than below, because the sun draws it upwards; hence tall buildings, even if the summit is at the same distance as the base, have the summit invisible. Therefore, also, the sky looks darkest in color overhead, and towards the horizon it is not blue but rather between smoke and dust color.

The atmosphere, when full of mist, is quite devoid of blueness, and only appears of the color of clouds, which shine white when the weather is fine. And the more you turn to the west the darker it will be, and the brighter as you look to the east. And the verdure of the fields is bluish in a thin mist, but grows gray in a dense one.

The buildings in the west will only show their illuminated side, where the sun shines, and the mist hides the rest. When the sun rises and chases away the haze, the hills on the side where it lifts begin to grow clearer, and look blue, and seem to smoke with the vanishing mists; and the buildings reveal their lights and shadows; through the thinner vapor they show only their lights and through the thicker air nothing at all. This is when the movement of the mist makes it part

horizontally, and then the edges of the mist will be indistinct against the blue of the sky, and towards the earth it will look almost like dust blown up. In proportion as the atmosphere is dense the buildings of a city and the trees in a landscape will look fewer, because only the tallest and largest will be seen.

Darkness affects everything with its hue, and the more an object differs from darkness, the more we see its real and natural color. The mountains will look few, because only those will be seen which are farthest apart; since, at such a distance, the density increases to such a degree that it causes a brightness by which the darkness of the hills becomes divided and vanishes indeed towards the top. There is less mist between lower and nearer hills and yet little is to be distinguished, and least towards the bottom.

ON THE PROPORTIONS AND ON THE MOVEMENTS
OF THE HUMAN FIGURE

Every man at three years old is half the full height he will grow to at last.

If a man 2 braccia * high is too small, one of four is too tall, the medium being what is admirable. Between 2 and 4 comes 3; therefore take a man of 3 braccia in height and measure him by the rule I will give you. If you tell me that I may be mistaken, and judge a man to be well proportioned who does not conform to this division, I answer that you must look at many men of 3 braccia, and out of the larger number who are alike in their limbs choose one of those who are most graceful and take your measurements. The length of the hand is ⅓ of a braccio and this is found 9 times in man. And the face is the same, and from the pit of the throat to the shoulder, and from the shoulder to the nipple, and from one nipple to the other, and from each nipple to the pit of the throat.

The distance from the attachment of one ear to the other is equal to that from the meeting of the eyebrows to the chin, and in a fine face the width of the mouth is equal to the length from the parting of the lips to the bottom of the chin.

From the eyebrow to the junction of the lip with the chin, and the angle of the jaw and the upper angle where the ear

* The standard Florentine braccio was about 23 inches.

joins the temple, will be a perfect square. And each side by itself is half the head.

The hollow of the cheekbone occurs halfway between the tip of the nose and the top of the jawbone, which is the lower angle of the setting on of the ear, in the frame represented.

From the angle of the eye socket to the ear is as far as the length of the ear, or the third of the face.

From the top of the head to the bottom of the chin is ⅛, and from the roots of the hair to the chin is ⅑ of the distance from the roots of the hair to the ground. The greatest width of the face is equal to the space between the mouth and the roots of the hair and is 1/12 of the whole height. From the top of the ear to the top of the head is equal to the distance from the bottom of the chin to the lachrymatory duct of the eye; and also equal to the distance from the angle of the chin to that of the jaw; that is, 1/16 of the whole. The small cartilage which projects over the opening of the ear towards the nose is halfway between the nape and the eyebrow; the thickness of the neck in profile is equal to the space between the chin and the eyes, and to the space between the chin and the jaw, and it is 1/16 of the height of the man.

The distance between the centers of the pupils of the eyes is ⅓ of the face. The space between the outer corners of the eyes, that is, where the eye ends in the eye socket which contains it, thus the outer corners, is half the face.

The greatest width of the face at the line of the eyes is equal to the distance from the roots of the hair in front to the parting of the lips.

The nose will make a double square; that is the width of the nose at the nostrils goes twice into the length from the tip of the nose to the eyebrows. And, in the same way, in profile the distance from the extreme side of the nostril where it joins the cheek to the tip of the nose is equal to the width of the nose in front from one nostril to the other. If you divide the whole length of the nose—that is, from the tip to the insertion of the eyebrows—into 4 equal parts, you will find that one of these parts extends from the tip of the nostrils to the base of the nose, and the upper division lies between the inner corner of the eye and the insertion of the eyebrows; and the two middle parts together are equal to the length of the eye from the inner to the outer corner.

The foot is as much longer than the hand as the thickness of the arm at the wrist where it is thinnest seen facing.

Again, you will find that the foot is as much longer than the hand as the space between the inner angle of the little toe to the last projection of the big toe, if you measure along the length of the foot.

The palm of the hand without the fingers goes twice into the length of the foot without the toes.

If you hold your hand with the 5 fingers straight out and close together you will find it to be of the same width as the widest part of the foot, that is, where it is joined on to the toes.

And if you measure from the prominence of the inner ankle to the end of the great toe you will find this measure to be as long as the whole hand.

From the top angle of the foot to the insertion of the toes is equal to the hand from wrist joint to the tip of the thumb.

The smallest width of the hand is equal to the smallest width of the foot between its joint into the leg and the insertion of the toes.

The width of the heel at the lower part is equal to that of the arm where it joins the hand; and also to the leg where it is thinnest when viewed in front.

The length of the longest toe, from its first division from the great toe to its tip, is the fourth of the foot from the center of the anklebone to the tip, and it is equal to the width of the mouth. The distance between the mouth and the chin is equal to that of the knuckles and of the three middle fingers and to the length of their first joints if the hand is spread, and equal to the distance from the joint of the thumb to the outset of the nails, that is, the fourth part of the hand and of the face.

The space between the extreme poles inside and outside the foot called the ankle or anklebone is equal to the space between the mouth and the inner corner of the eye.

The whole length of the foot will lie between the elbow and the wrist and between the elbow and the inner angle of the arm towards the breast when the arm is folded. The foot is as long as the whole head of a man, that is, from under the chin to the topmost part of the head.

The length of the foot from the end of the toes to the heel goes twice into that from the heel to the knee, that is, where the leg bone [fibula] joins the thigh bone [femur].

In kneeling down a man will lose the fourth part of his height.

When a man kneels down with his hands folded on his breast the navel will mark half his height and likewise the points of the elbows.

Half the height of a man who sits—that is from the seat to the top of the head—will be where the arms fold below the breast, and below the shoulders. The seated portion—that is from the seat to the top of the head—will be more than half the man's whole height by the length of the scrotum.

The cubit is one fourth of the height of a man and is equal to the greatest width of the shoulders. From the joint of one shoulder to the other is two faces and is equal to the distance from the top of the breast to the navel. From this point to the genitals is a face's length.

The width of a man under the arms is the same as at the hips.

A man's width across the hips is equal to the distance from the top of the hip to the bottom of the buttock, when a man stands equally balanced on both feet; and there is the same distance from the top of the hip to the armpit. The waist, or narrower part above the hips, will be halfway between the armpits and the bottom of the buttock.

Observe the altered position of the shoulder in all the movements of the arm, going up and down, inwards and outwards, to the back and to the front, and also in circular movements and any others.

And do the same with reference to the neck, hands, and feet, and the breast above the hips, etc.

Of painting. Note in the motions and attitudes of figures how the limbs vary, and their feeling, for the shoulder blades in the motions of the arms and shoulders vary the line of the backbone very much. And you will find all the causes of this in my book of Anatomy.

Of painting. Indicate which are the muscles, and which the tendons, which become prominent or retreat in the different movements of each limb; or which do neither but are passive. And remember that these indications of action are of the first importance and necessity in any painter or sculptor who professes to be a master, etc.

And indicate the same in a child, and from birth to decrepitude at every stage of its life; as infancy, childhood, boyhood, youth, etc.

And in each express the alterations in the limbs and joints, which swell and which grow thinner.

Of the different measurements of boys and men. There is a great difference in the length between the joints in men and boys, for, in man, from the top of the shoulder by the neck to the elbow, and from the elbow to the tip of the thumb and from one shoulder to the other, is in each instance two heads, while in a boy it is but one because Nature constructs in us the mass which is the home of the intellect, before forming that which contains the vital elements.

Of the agreement of the proportion of the limbs. And again, remember to be very careful in giving your figures limbs, that they must appear to agree with the size of the body and likewise to the age. Thus a youth has limbs that are not very muscular nor strongly veined, and the surface is delicate and round, and tender in color. In man the limbs are sinewy and muscular, while in old men the surface is wrinkled, rugged, and knotty, and the sinews very prominent.

How a man proceeds to raise himself to his feet, when he is sitting on level ground.

A man when walking has his head in advance of his feet.

A man when walking across a long level plain first leans rather backwards and then as much forwards.

A man when running throws less weight on his legs than when standing still. And in the same way a horse which is running feels less the weight of the man he carries. Hence many persons think it wonderful that, in running, the horse can rest on one single foot. From this it may be stated that when a weight is in progressive motion the more rapid it is the less is the perpendicular weight towards the center.

A man coming downhill takes little steps, because the weight rests upon the hinder foot, while a man mounting takes wide steps, because his weight rests on the foremost foot.

Observe the motion of the surface of the water, which resembles that of hair, and has two motions, of which one goes on with the flow of the surface, the other forms the lines of the eddies; thus the water forms eddying whirlpools one

part of which is due to the impetus of the principal current and the other to the incidental motion and return flow.

Of the nature of the folds in drapery. That part of a fold which is farthest from the ends where it is confined will fall most nearly in its natural form.

Everything by nature tends to remain at rest. Drapery, being of equal density and thickness on its wrong side and on its right, has a tendency to lie flat; therefore when you give it a fold or plait forcing it out of its flatness, note well the result of the constraint in the part where it is most confined; and the part which is farthest from this constraint you will see relapses most into the natural state; that is to say lies free and flowing.

Of small folds in draperies. How figures dressed in a cloak should not show the shape so much as that the cloak looks as if it were next the flesh; since you surely cannot wish the cloak to be next the flesh, for you must suppose that between the flesh and the cloak there are other garments which prevent the forms of the limbs appearing distinctly through the cloak. And those limbs which you allow to be seen you must make thicker so that the other garments may appear to be under the cloak. But only give something of the true thickness of the limbs to a nymph or an angel, which are represented in thin draperies, pressed and clinging to the limbs of the figures by the action of the wind.

You ought not to give to drapery a great confusion of many folds, but rather only introduce them where they are held by the hands or the arms; the rest you may let fall simply where it is its nature to flow; and do not let the nude forms be broken by too many details and interrupted folds.

How draperies should be drawn from nature: that is to say if you want to represent woolen cloth draw the folds from that; and if it is to be silk, or fine cloth or coarse, or of linen or of crape, vary the folds in each and do not represent dresses, as many do, from models covered with paper or thin leather which will deceive you greatly.

BOTANY FOR PAINTERS AND ELEMENTS OF LANDSCAPE PAINTING

Trees. Small, lofty, straggling, thick, that is, as to foliage, dark, light, russet, branched at the top; some directed towards the eye, some downwards; with white stems; this transparent

in the air, that not; some standing close together, some scattered.

Of the scars on trees. The scars on trees grow to a greater thickness than is required by the sap of the limb which nourishes them.

Why, frequently, timber has veins that are not straight. When the branches which grow the second year above the branch of the preceding year are not of equal thickness above the antecedent branches, but are on one side, then the vigor of the lower branch is diverted to nourish the one above it, although it may be somewhat on one side.

But if the ramifications are equal in their growth, the veins of the main stem will be straight [parallel] and equidistant at every degree of the height of the plant.

Wherefore, O Painter! you, who do not know these laws! in order to escape the blame of those who understand them, it will be well that you should represent everything from nature, and not despise such study as those do who work (only) for money.

Of the ramifications of plants. The plants which spread very much have the angles of the spaces which divide their branches more obtuse in proportion as their point of origin is lower down; that is, nearer to the thickest and oldest portion of the tree. Therefore in the youngest portions of the tree the angles of ramification are more acute.

A description of the elm. The ramification of the elm has the largest branch at the top. The first and the last but one are smaller, when the main trunk is straight.

The space between the insertion of one leaf to the next is half the extreme length of the leaf or somewhat less, for the leaves are at an interval which is about ⅛ of the width of the leaf.

The elm has more leaves near the top of the boughs than at the base; and the broad surface of the leaves varies little as to angle and aspect.

In the walnut tree the leaves which are distributed on the shoots of this year are further apart from each other and more numerous in proportion as the branch from which this shoot springs is a young one. And they are inserted more closely and less in number when the shoot that bears them springs from an old branch. Its fruits are borne at the ends

of the shoots. And its largest boughs are the lowest on the boughs they spring from. And this arises from the weight of its sap, which is more apt to descend than to rise, and consequently the branches which spring from them and rise towards the sky are small and slender; and when the shoot turns towards the sky its leaves spread out from it at an angle with an equal distribution of their tips; and if the shoot turns to the horizon the leaves lie flat; and this arises from the fact that leaves, without exception, turn their underside to the earth.

The shoots are smaller in proportion as they spring nearer to the base of the bough they spring from.

You will see in the lower branches of the elder, which puts forth leaves two and two placed crosswise at right angles one above another, that if the stem rises straight up towards the sky this order never fails; and its largest leaves are on the thickest part of the stem and the smallest on the slenderest part, that is, towards the top. But, to return to the lower branches, I say that the leaves on these are placed on them crosswise like those on the upper branches; and as, by the law of all leaves, they are compelled to turn their upper surface towards the sky to catch the dew at night, it is necessary that those so placed should twist round and no longer form a cross.

A leaf always turns its upper side towards the sky so that it may the better receive, on all its surface, the dew which drops gently from the atmosphere. And these leaves are so distributed on the plant as that one shall cover the other as little as possible, but shall lie alternately one above another as may be seen in the ivy which covers the walls. And this alternation serves two ends; that is, to leave intervals by which the air and sun may penetrate between them. The 2nd reason is that the drops which fall from the first leaf may fall onto the 4th or—in other trees—onto the 6th.

Every shoot and every fruit is produced above the insertion in the axil of its leaf which serves it as a mother, giving it water from the rain and moisture from the dew which falls at night from above, and often it protects them against the too great heat of the rays of the sun.

Young plants have more transparent leaves and a more lustrous bark than old ones; and particularly the walnut is lighter colored in May than in September.

The eye and the light which falls upon it from the opposite side.

And its shadows are in the same positions as those were of the opposite side. Therefore, O Painter! when you do trees close at hand, remember that if the eye is almost under the tree you will see its leaves some on the upper and some on the under side, and the upper side will be bluer in proportion as they are seen more foreshortened, and the same leaf sometimes shows part of the right side and part of the under side, whence you must make it of two colors.

The shadows of plants are never black, for where the atmosphere penetrates there can never be utter darkness.

Never paint leaves transparent to the sun, because they are confused; and this is because on the transparency of one leaf will be seen the shadow of another leaf which is above it. This shadow has a distinct outline and a certain depth of shade and sometimes is as much as half or a third of the leaf which is shaded; and consequently such an arrangement is very confused and the imitation of it should be avoided.

The light shines least through a leaf when it falls upon it at an acute angle.

Of dark leaves in front of transparent ones. When the leaves are interposed between the light and the eye, then that which is nearest to the eye will be the darkest, and the most distant will be the lightest, not being seen against the atmosphere; and this is seen in the leaves which are away from the center of the tree, that is towards the light.

Of the lights on dark leaves. The lights on those leaves which are darkest will be most near to the color of the atmosphere that is reflected in them. And the cause of this is that the light on the illuminated portion mingles with the dark hue to compose a blue color; and this light is produced by the blueness of the atmosphere which is reflected in the smooth surface of these leaves and adds to the blue hue which this light usually produces when it falls on dark objects.

Of the lights on leaves of a yellowish green. But leaves of a green verging on yellow when they reflect the atmosphere do not produce a reflection verging on blue, inasmuch as everything which appears in a mirror takes some color from that mirror, hence the blue of the atmosphere being reflected in the yellow of the leaf appears green, because blue and

yellow mixed together make a very fine green color, therefore the luster of light leaves verging on yellow will be greenish yellow.

The trees in a landscape are of various kinds of green, inasmuch as some verge towards blackness, as firs, pines, cypresses, laurels, box, and the like. Some tend to yellow, such as walnuts and pears, vines and verdure. Some are both yellowish and dark, as chestnuts, holm oak. Some turn red in autumn, as the service tree, pomegranate, vine, and cherry; and some are whitish, as the willow, olive, reeds, and the like.

Trees are of various forms. . . .

Of depicting a forest scene. The trees and plants which are most thickly branched with slender branches ought to have less dark shadow than those trees and plants which, having broader leaves, will cast more shadow.

From whence to depict a landscape. Landscapes should be represented so that the trees may be half in light and half in shadow; but it is better to do them when the sun is covered with clouds, for then the trees are lighted by the general light of the sky, and the general darkness of the earth. And then they are darkest in certain parts in proportion as those parts are nearest to the middle of the tree and to the earth.

Of meadows. If the sun is in the east the verdure of the meadows and of other small plants is of a most beautiful green from being transparent to the sun; this does not occur in the meadows to the west, and in those to the south and north the grass is of a moderately brilliant green.

Of trees to the east. When the sun is in the east the trees seen towards the east will have the light which surrounds them all round their shadows, excepting on the side towards the earth; unless the tree has been pruned below in the past year. And the trees to the south and north will be half in shade and half in light, and more or less in shade or in light in proportion as they are more or less to the east or to the west.

The position of the eye above or below varies the shadows and lights in trees, inasmuch as the eye placed above sees the tree with a little shadow, and the eye placed below with a great deal of shadow.

The color of the green in plants varies as much as their species.

Of trees to the east. When the sun is in the east the trees are darker towards the middle while their edges are light.

Reeds in light show but little, but between light and shadow they stand out well. To represent a landscape choose that the sun shall be at noon and look towards the west or east and then draw. And if you turn towards the north, every object placed on that side will have no shadow, particularly those which are nearest to the direction of the shadow of your head. And if you turn towards the south every object on that side will be wholly in shadow. All the trees which are towards the sun and have the atmosphere for their background are dark, and the other trees which lie against that darkness will be black [very dark] in the middle and lighter towards the edges.

In the composition of leafy trees be careful not to repeat too often the same color of one tree against the same color of another behind it; but vary it with a lighter, or a darker, or a stronger green.

The landscape has a finer azure tone when, in fine weather, the sun is at noon than at any other time of the day, because the air is purified of moisture; and looking at it under that aspect you will see the trees of a beautiful green at the outside and the shadows dark towards the middle; and in the remoter distance the atmosphere which comes between you and them looks more beautiful when there is something dark beyond. And still the azure is most beautiful. The objects seen from the side on which the sun shines will not show you their shadows. But, if you are lower than the sun, you can see what is not seen by the sun and that will be all in shade. The leaves of the trees which come between you and the sun are of two principal colors, which are a splendid luster of green, and the reflection of the atmosphere which lights up the objects which cannot be seen by the sun, and the shaded portions which only face the earth, and the darkest which are surrounded by something that is not dark. The trees in the landscape which are between you and the sun are far more beautiful than those you see when you are between the sun and them; and this is so because those which face the sun show their leaves as transparent towards the ends of their branches, and those that are not transparent—that is at the

ends—reflect the light; and the shadows are dark because they
are not concealed by anything.

The trees, when you place yourself between them and the
sun, will only display to you their light and natural color,
which, in itself, is not very strong, and besides this some re-
flected lights which, being against a background which does
not differ very much from themselves in tone, are not con-
spicuous; and if you are lower down than they are situated,
they may also show those portions on which the light of the
sun does not fall and these will be dark.

In the wind. But if you are on the side whence the wind
blows you will see the trees look very much lighter than on the
other sides, and this happens because the wind turns up the
under side of the leaves, which, in all trees, is much whiter
than the upper sides; and, more especially, they will be very
light indeed if the wind blows from the quarter where the sun
is, and if you have your back turned to it.

Of trees and lights on them. The best method of practice
in representing country scenes, or I should say landscapes with
their trees, is to choose them so that the sun is covered with
clouds; so that the landscape receives a universal light and
not the direct light of the sun, which makes the shadows sharp
and too strongly different from the lights.

Of landscapes. The colors of the shadows in mountains at
a great distance take a most lovely blue, much purer than their
illuminated portions. And from this it follows that when
the rock of a mountain is reddish the illuminated portions are
violet and the more they are lighted the more they display
their proper color.

Of light and shadow in a town. When the sun is in the east
and the eye is above the center of a town, the eye will see the
southern part of the town with its roofs half in shade and
half in light, and the same towards the north; the eastern side
will be all in shadow and the western will be all in light.

Of representing wind. In representing wind, besides the
bending of the boughs and the reversing of their leaves
towards the quarter whence the wind comes, you should also
represent them amid clouds of fine dust mingled with the
troubled air.

When clouds come between the sun and the eye all the upper edges of their round forms are light, and towards the middle they are dark, and this happens because towards the top these edges have the sun above them while you are below them; and the same thing happens with the position of the branches of trees; and again the clouds, like the trees, being somewhat transparent, are lighted up in part, and at the edges they show thinner.

But, when the eye is between the cloud and the sun, the cloud has the contrary effect to the former, for the edges of its mass are dark and it is light towards the middle; and this happens because you see the same side as faces the sun, and because the edges have some transparency and reveal to the eye that portion which is hidden beyond them, and which, as it does not catch the sunlight like that portion turned towards it, is necessarily somewhat darker. Again, it may be that you see the details of these rounded masses from the lower side, while the sun shines on the upper side, and as they are not so situated as to reflect the light of the sun, as in the first instance, they remain dark.

The black clouds which are often seen higher up than those which are illuminated by the sun are shaded by other clouds, lying between them and the sun.

Again, the rounded forms of the clouds that face the sun show their edges dark because they lie against the light background; and to see that this is true, you may look at the top of any cloud that is wholly light because it lies against the blue of the atmosphere, which is darker than the cloud.

All the flowers which turn towards the sun perfect their seeds; but not the others; that is to say those which get only the reflection of the sun.

THE PRACTICE OF PAINTING

A warning concerning youths wishing to be painters. Many are they who have a taste and love for drawing, but no talent; and this will be discernible in boys who are not diligent and never finish their drawings with shading.

The youth should first learn perspective, then the proportions of objects. Then he may copy from some good master, to accustom himself to fine forms. Then from nature, to confirm by practice the rules he has learned. Then see for a time the works of various masters. Then get the habit of putting his art into practice and work.

Of drawing. Which is best, to draw from nature or from the antique? and which is more difficult to do, outlines or light and shade?

It is better to imitate the antique than modern work.

Of painting. It is indispensable to a Painter who would be thoroughly familiar with the limbs in all the positions and actions of which they are capable, in the nude, to know the anatomy of the sinews, bones, muscles, and tendons so that, in their various movements and exertions, he may know which nerve or muscle is the cause of each movement and show those only as prominent and thickened, and not the others all over the limb, as many do who, to seem great draftsmen, draw their nude figures looking like wood, devoid of grace; so that you would think you were looking at a sack of walnuts rather than the human form, or a bundle of radishes rather than the muscles of figures.

What rules should be given to boys learning to paint. We know for certain that sight is one of the most rapid actions we can perform. In an instant we see an infinite number of forms, still we only take in thoroughly one object at a time. Supposing that you, Reader, were to glance rapidly at the whole of this written page, you would instantly perceive that it was covered with various letters; but you could not, in the time, recognize what the letters were, nor what they were meant to tell. Hence you would need to see them word by word, line by line, to be able to understand the letters. Again, if you wish to go to the top of a building you must go up step by step; otherwise it will be impossible that you should reach the top. Thus I say to you, whom nature prompts to pursue this art, if you wish to have a sound knowledge of the forms of objects, begin with the details of them, and do not go on to the second step till you have the first well fixed in memory and in practice. And if you do otherwise you will throw away your time, or certainly greatly prolong your studies. And remember to acquire diligence rather than rapidity.

Of the life of the painter in the country. A painter needs such mathematics as belong to painting, and the absence of all companions who are alienated from his studies; his brain must be easily impressed by the variety of objects which successively come before him, and also free from other cares.

And if, when considering and defining one subject, a second subject intervenes—as happens when an object occupies the mind—then he must decide which of these cases is the more difficult to work out, and follow that up until it becomes quite clear, and then work out the explanation of the other. And above all he must keep his mind as clear as the surface of a mirror, which assumes colors as various as those of the different objects. And his companions should be like him as to their studies, and if such cannot be found he should keep his speculations to himself alone, so that at last he will find no more useful company than his own.

Of the life of the painter in his studio. To the end that well-being of the body may not injure that of the mind, the painter or draftsman must remain solitary, and particularly when intent on those studies and reflections which will constantly rise up before his eye, giving materials to be well stored in the memory. While you are alone you are entirely your own master and if you have one companion you are but half your own, and the less so in proportion to the indiscretion of his behavior. And if you have many companions you will fall deeper into the same trouble. If you should say: "I will go my own way and withdraw apart, the better to study the forms of natural objects," I tell you, you will not be able to help often listening to their chatter. And so, since one cannot serve two masters, you will badly fill the part of a companion, and carry out your studies of art even worse. And if you say: "I will withdraw so far that their words cannot reach me and they cannot disturb me," I can tell you that you will be thought mad. But, you see, you will at any rate be alone. And if you must have companionship find it in your studio. This may assist you to have the advantages which arise from various speculations. All other company may be highly mischievous.

Of whether it is better to draw with companions or not. I say and insist that drawing in company is much better than alone, for many reasons. The first is that you would be ashamed to be seen behindhand among the students, and such shame will lead you to careful study. Secondly, a wholesome emulation will stimulate you to be among those who are more praised than yourself, and this praise of others will spur you on. Another is that you can learn from the drawings of others who do better than yourself; and if you are better than they, you can profit by your contempt for their defects, while the praise of others will incite you to farther merits.

Of studying, in the dark, when you wake, or in bed before you go to sleep. I myself have proved it to be of no small use, when in bed in the dark, to recall in fancy the external details of forms previously studied, or other noteworthy things conceived by subtle speculation; and this is certainly an admirable exercise, and useful for impressing things on the memory.

Of the time for studying selection of subjects. Winter evenings ought to be employed by young students in looking over the things prepared during the summer; that is, all the drawings from the nude done in the summer should be brought together and a choice made of the best studies of limbs and bodies among them, to apply in practice and commit to memory.

Of positions. After this in the following summer you should select someone who is well grown and who has not been brought up in doublets, and so may not be of stiff carriage, and make him go through a number of agile and graceful actions; and if his muscles do not show plainly within the outlines of his limbs that does not matter at all. It is enough that you can see good attitudes and you can correct the drawing of the limbs by those you studied in the winter.

That a painter is not admirable unless he is universal. Of some it may distinctly be said that they are under a delusion who call that painter a good master who can do nothing well but a head or a figure. Certainly this is no great achievement; after studying one single thing for a lifetime who would not have attained some perfection in it? But, since we know that painting embraces and includes in itself every object produced by nature or resulting from the fortuitous actions of men, in short, all that the eye can see, he seems to me but a poor master who can only do a figure well. For do you not perceive how many and various actions are performed by men only; how many different animals there are, as well as trees, plants, flowers, with many mountainous regions and plains, springs, and rivers, cities with public and private buildings, machines, too, fit for the purposes of men, divers costumes, decorations and arts? And all these things ought to be regarded as of equal importance and value by the man who can be termed a good painter.

Painting. The mind of the painter must resemble a mirror, which always takes the color of the object it reflects and is

completely occupied by the images of as many objects as are in front of it. Therefore you must know, O Painter! that you cannot be a good one if you are not the universal master of representing by your art every kind of form produced by nature. And this you will not know how to do if you do not see them, and retain them in your mind. Hence as you go through the fields, turn your attention to various objects, and, in turn, look now at this thing and now at that, collecting a store of divers facts selected and chosen from those of less value. But do not do as some painters who, when they are wearied with exercising their fancy, dismiss their work from their thoughts and take exercise in walking for relaxation but still keep fatigue in their mind and, though they see various objects around them, do not apprehend them; but, even when they meet friends or relations and are saluted by them, although they see and hear them, take no more cognizance of them than if they had met so much empty air.

A way of developing and arousing the mind to various inventions. I cannot forbear to mention among these precepts a new device for study which, although it may seem but trivial and almost ludicrous, is nevertheless extremely useful in arousing the mind to various inventions. And this is, when you look at a wall spotted with stains, or with a mixture of stones, if you have to devise some scene, you may discover a resemblance to various landscapes, beautified with mountains, rivers, rocks, trees, plains, wide valleys and hills in varied arrangement; or again you may see battles and figures in action; or strange faces and costumes, and an endless variety of objects, which you could reduce to complete and well-drawn forms. And these appear on such walls confusedly, like the sound of bells in whose jangle you may find any name or word you choose to imagine.

THE ARTIST'S STUDIO

Small rooms or dwellings discipline the mind, large ones weaken it.

Which light is best for drawing from nature; whether high or low, or large or small, or strong and broad, or strong and small, or broad and weak or small and weak?

Of the quality of the light. A broad light high up and not too strong will render the details of objects very agreeable.

That the light for drawing from nature should be high up. The light for drawing from nature should come from the north in order that it may not vary. And if you have it from the south, keep the window screened with cloth, so that with the sun shining the whole day the light may not vary. The height of the light should be so arranged as that every object shall cast a shadow on the ground of the same length as itself.

The kind of light requisite for painting light and shade. An object will display the greatest difference of light and shade when it is seen in the strongest light, as by sunlight, or, at night, by the light of a fire. But this should not be much used in painting because the works remain crude and ungraceful.

An object seen in a moderate light displays little difference in the light and shade; and this is the case towards evening or when the day is cloudy, and works then painted are tender and every kind of face becomes graceful. Thus, in everything extremes are to be avoided: too much light gives crudeness; too little prevents our seeing. The medium is best.

Of selecting the light which gives most grace to faces. If you should have a courtyard that you can at pleasure cover with a linen awning that light will be good. Or when you want to take a portrait do it in dull weather, or as evening falls, making the sitter stand with his back to one of the walls of the courtyard. Note in the streets, as evening falls, the faces of the men and women, and when the weather is dull, what softness and delicacy you may perceive in them. Hence, O Painter! have a court arranged with the walls tinted black and a narrow roof projecting within the walls. It should be 10 braccia wide and 20 braccia long and 10 braccia high and covered with a linen awning; or else paint a work towards evening or when it is cloudy or misty, and this is a perfect light.

How the mirror is the master and guide of painters. When you want to see if your picture corresponds throughout with the objects you have drawn from nature, take a mirror and look in that at the reflection of the real things, and compare the reflected image with your picture, and consider whether

the subject of the two images duly corresponds in both, particularly studying the mirror. You should take the mirror for your guide—that is to say a flat mirror—because on its surface the objects appear in many respects as in a painting. Thus you see, in a painting done on a flat surface, objects which appear in relief, and in the mirror—also a flat surface —they look the same. The picture has one plane surface and the same with the mirror. The picture is intangible, in so far as that which appears round and prominent cannot be grasped in the hands; and it is the same with the mirror. And since you can see that the mirror, by means of outlines, shadows and lights, makes objects appear in relief, you, who have in your colors far stronger lights and shades than those in the mirror, can certainly, if you compose your picture well, make that also look like a natural scene reflected in a large mirror.

Of judging your own pictures. We know very well that errors are better recognized in the works of others than in our own; and that often, while reproving little faults in others, you may ignore great ones in yourself. To avoid such ignorance, in the first place make yourself a master of perspective, then acquire perfect knowledge of the proportions of men and other animals, and also study good architecture, that is so far as concerns the forms of buildings and other objects which are on the face of the earth; these forms are infinite, and the better you know them the more admirable will your work be. And in cases where you lack experience do not shrink from drawing them from nature. But, to carry out my promise above in the title—I say that when you paint you should have a flat mirror and often look at your work as reflected in it, when you will see it reversed, and it will appear to you like some other painter's work, so you will be better able to judge of its faults than in any other way. Again, it is well that you should often leave off work and take a little relaxation, because, when you come back to it you are a better judge; for sitting too close at work may greatly deceive you. Again, it is good to retire to a distance because the work looks smaller and your eye takes in more of it at a glance and sees more easily the discords or disproportion in the limbs and colors of the objects.

That a painter ought to be curious to hear the opinions of everyone on his work. Certainly while a man is painting he ought not to shrink from hearing every opinion. For we know very well that a man, though he may not be a painter, is

familiar with the forms of other men and very capable of judging whether they are humpbacked, or have one shoulder higher or lower than the other, or too big a mouth or nose, and other defects; and, as we know that men are competent to judge of the works of nature, how much more ought we to admit that they can judge of our errors; since you know how much a man may be deceived in his own work. And if you are not conscious of this in yourself study it in others and profit by their faults. Therefore be curious to hear with patience the opinions of others, consider and weigh well whether those who find fault have ground or not for blame, and if so, amend, but if not, make as though you had not heard, or if he should be a man you esteem show him by argument the cause of his mistake.

Of the way to draw figures for historical pictures. The painter must always study on the wall on which he is to picture a story the height of the position where he wishes to arrange his figures; and when drawing his studies for them from nature he must place himself with his eye as much below the object he is drawing as, in the picture, it will have to be above the eye of the spectator. Otherwise the work will look wrong.

Why groups of figures one above another are to be avoided. The universal practice which painters adopt on the walls of chapels is greatly and reasonably to be condemned, inasmuch as they represent one historical subject on one level with a landscape and buildings, and then go up a step and paint another, varying the point of sight, and then a third and a fourth, in such a way as that on one wall there are 4 points of sight, which is supreme folly in such painters. We know that the point of sight is opposite the eye of the spectator of the scene; and if you would have me tell you how to represent the life of a saint divided into several pictures on one and the same wall, I answer that you must set out the foreground with its point of sight on a level with the eye of the spectator of the scene, and upon this plane represent the more important part of the story large and then, diminishing by degrees the figures, and the buildings on various hills and open spaces, you can represent all the events of the history. And on the remainder of the wall up to the top put trees, large as compared with the figures, or angels if they are ap-

propriate to the story, or birds or clouds or similar objects; otherwise do not trouble yourself with it for your whole work will be wrong.

PRACTICAL HINTS ON LIGHT AND SHADE
AND AERIAL PERSPECTIVE

Why faces at a distance look dark. We see quite plainly that all the images of visible objects that lie before us, whether large or small, reach our sense by the minute aperture of the eye; and if through so small a passage the image can pass of the vast extent of sky and earth, the face of a man—being by comparison with such large images almost nothing by reason of the distance which diminishes it—fills up so little of the eye that it is indistinguishable. Having, also, to be transmitted from the surface to the sense through a dark medium, that is to say the crystalline lens which looks dark, this image, not being strong in color, becomes affected by this darkness on its passage, and on reaching the sense it appears dark; no other reason can in any way be assigned. If the point in the eye is black, it is because it is full of a transparent humor as clear as air and acts like a perforation in a board; on looking into it it appears dark and the objects seen through the bright air and a dark one become confused in this darkness.

The reason why small figures should not be made finished. I say that the reason that objects appear diminished in size is because they are remote from the eye; this being the case it is evident that there must be a great extent of atmosphere between the eye and the objects and this air interferes with the distinctness of the forms of the object. Hence the minute details of these objects will be indistinguishable and unrecognizable. Therefore, O Painter, make your smaller figures merely indicated and not highly finished, otherwise you will produce effects the opposite to nature, your supreme guide. The object is small by reason of the great distance between it and the eye, this great distance is filled with air, that mass of air forms a dense body which intervenes and prevents the eye seeing the minute details of objects.

ON PORTRAIT AND FIGURE PAINTING

Of the way to learn to compose figures in groups in historical pictures. When you have well learned perspective and have by heart the parts and forms of objects, you must go

about, and constantly, as you go, observe, note, and consider the circumstances and behavior of men in talking, quarreling, or laughing or fighting together: the action of the men themselves and the actions of the bystanders, who separate them or who look on. And take a note of them with slight strokes thus, in a little book which you should always carry with you. And it should be of tinted paper, that it may not be rubbed out, but change the old when full for a new one; since these things should not be rubbed out but preserved with great care; for the forms and positions of objects are so infinite that the memory is incapable of retaining them, wherefore keep these sketches as your guides and masters.

Of a method of keeping in mind the form of a face. If you want to acquire facility for bearing in mind the expression of a face, first make yourself familiar with a variety of forms of several heads, eyes, noses, mouths, chins and cheeks and necks and shoulders. And to put a case: noses are of 10 types: straight, bulbous, hollow, prominent above or below the middle, aquiline, regular, flat, round or pointed. These hold good as to profile. In full face they are of 11 types; these are either thick in the middle, or thin in the middle, with the tip thick and the root narrow, or narrow at the tip and wide at the root; with the nostrils wide or narrow, high or low, and the openings wide or hidden by the point; and you will find an equal variety in the other details; which things you must draw from nature and fix them in your mind. Or else, when you have to draw a face by heart, carry with you a little book in which you have noted such features; and when you have cast a glance at the face of the person you wish to draw, you can look, in private, which nose or mouth is most like, or there make a little mark to recognize it again at home. Of grotesque faces I need say nothing, because they are kept in mind without difficulty.

Precepts in painting. Let your sketches of historical pictures be swift and the working out of the limbs not be carried too far, but limited to the position of the limbs, which you can afterwards finish as you please and at your leisure.

The sorest misfortune is when your views are in advance of your work.

Of composing historical pictures. Of not considering the limbs in the figures in historical pictures; as many do who, in the wish to represent the whole of a figure, spoil their compositions. And when you place one figure behind another take

care to draw the whole of it so that the limbs which come in front of the nearer figures may stand out in their natural size and place.

Old men ought to be represented with slow and heavy movements, their legs bent at the knees, when they stand still, and their feet placed parallel and apart; bending low with the head leaning forward, and their arms but little extended.

Women must be represented in modest attitudes, their legs close together, their arms closely folded, their heads inclined and somewhat on one side.

Old women should be represented with eager, swift, and furious gestures, like infernal furies; but the action should be more violent in their arms and head than in their legs.

Little children, with lively and contorted movements when sitting, and, when standing still, in shy and timid attitudes.

How an angry man is to be drawn. You must make an angry person holding someone by the hair, wrenching his head against the ground, and with one knee on his ribs; his right arm and fist raised on high. His hair must be thrown up, his brow downcast and knit, his teeth clenched and the two corners of his mouth grimly set; his neck swelled and bent forward as he leans over his foe, and full of furrows.

How you should make an imaginary animal look natural. You know that you cannot invent animals without limbs, each of which, in itself, must resemble those of some other animal. Hence if you wish to make an animal, imagined by you, appear natural—let us say a dragon—take for its head that of a mastiff or hound, with the eyes of a cat, the ears of a porcupine, the nose of a greyhound, the brow of a lion, the temples of an old cock, the neck of a water tortoise.

Of the delusions which arise in judging of the limbs. A painter who has clumsy hands will paint similar hands in his works, and the same will occur with any limb, unless long study has taught him to avoid it. Therefore, O Painter, look carefully what part is most ill-favored in your own person and take particular pains to correct it in your studies. For if you are coarse, your figures will seem the same and devoid of charm; and it is the same with any part that may be good or poor in yourself; it will be shown in some degree in your figures.

Of the selection of beautiful faces. It seems to me to be no small charm in a painter when he gives his figures a pleasing air, and this grace, if he have it not by nature, he may acquire by incidental study in this way: look about you and take the best parts of many beautiful faces, of which the beauty is confirmed rather by public fame than by your own judgment; for you might be mistaken and choose faces which have some resemblance to your own. For it would seem that such resemblances often please us; and if you should be ugly, you would select faces that were not beautiful and you would then make ugly faces, as many painters do. For often a master's work resembles himself. So select beauties as I tell you, and fix them in your mind.

Of undulating movements and equipoise in figures and other animals. When representing a human figure or some graceful animal, be careful to avoid a wooden stiffness; that is to say make them move with equipoise and balance so as not to look like a piece of wood; but those you want to represent as strong you must not make so, excepting in the turn of the head.

Of grace in the limbs. The limbs should be adapted to the body with grace and with reference to the effect that you wish the figure to produce. And if you wish to produce a figure that shall of itself look light and graceful you must make the limbs elegant and extended, and without too much display of the muscles; and those few that are needed for your purpose you must indicate softly, that is, not very prominent and without strong shadows; the limbs, and particularly the arms, easy; that is, none of the limbs should be in a straight line with the adjoining parts. And if the hips, which are the pole of a man, are by reason of his position placed so that the right is higher than the left, make the point of the higher shoulder in a perpendicular line above the highest prominence of the hip, and let this right shoulder be lower than the left. Let the pit of the throat always be over the center of the joint of the foot on which the man is leaning. The leg which is free should have the knee lower than the other, and near the other leg. The positions of the head and arms are endless and I shall therefore not enlarge on any rules for them. Still, let them be easy and pleasing, with various turns and twists, and the joints gracefully bent, that they may not look like pieces of wood.

Of representing a man speaking to a multitude. When you wish to represent a man speaking to a number of people, consider the matter of which he has to treat and adapt his action to the subject. Thus, if he speaks persuasively, let his action be appropriate to it. If the matter in hand be to set forth an argument, let the speaker with the fingers of the right hand hold one finger of the left hand, having the two smaller ones closed; and his face alert, and turned towards the people with mouth a little open, to look as though he spoke; and if he is sitting let him appear as though about to rise, with his head forward. If you represent him standing make him leaning slightly forward with body and head towards the people. These you must represent as silent and attentive, all looking at the orator's face with gestures of admiration; and make some old men in astonishment at the things they hear, with the corners of their mouths pulled down and drawn in, their cheeks full of furrows, and their eyebrows raised, and wrinkling the forehead where they meet. Again, some sitting with their fingers clasped holding their weary knees. Again, some bent old man, with one knee crossed over the other; on which let him hold his hand with his other elbow resting in it and the hand supporting his bearded chin.

Of the disposition of limbs. As regards the disposition of limbs in movement you will have to consider that when you wish to represent a man who, by some chance, has to turn backwards or to one side, you must not make him move his feet and all his limbs towards the side to which he turns his head. Rather must you make the action proceed by degrees and through the different joints; that is, those of the foot, the knee, and the hip, and the neck. And if you set him on the right leg, you must make the left knee bend inwards, and let his foot be slightly raised on the outside, and the left shoulder be somewhat lower than the right, while the nape of the neck is in a line directly over the outer ankle of the left foot. And the left shoulder will be in a perpendicular line above the toes of the right foot. And always set your figures so that the side to which the head turns is not the side to which the breast faces, since nature for our convenience has made us with a neck which bends with ease in many directions, the eye wishing to turn to various points, the different joints are partly obedient to it. And if at any time you make a man sitting with his arms at work on something which is sideways to him, make the upper part of his body turn upon the hips.

When you draw the nude always sketch the whole figure and then finish those limbs which seem to you the best, but make them act with the other limbs; otherwise you will get a habit of never putting the limbs well together on the body.

Never make the head turn the same way as the torso, nor the arm and leg move together on the same side. And if the face is turned to the right shoulder, make all the parts lower on the left side than on the right; and when you turn the body with the breast outwards, if the head turns to the left side make the parts on the right side higher than those on the left.

The motions of men must be such as suggest their dignity or their baseness.

Of painting. With regard to any action which you give in a picture to an old man or to a young one, you must make it more energetic in the young man in proportion as he is stronger than the old one; and in the same way with a young man and an infant.

Of the action of the figures. Represent your figures in such action as may be fitted to express what purpose is in the mind of each; otherwise your art will not be admirable.

SUGGESTIONS FOR COMPOSITIONS

Of the way of representing a battle. First you must represent the smoke of artillery mingling in the air with the dust and tossed up by the movement of horses and the combatants. And this mixture you must express thus: the dust, being a thing of earth, has weight; and although from its fineness it is easily tossed up and mingles with the air, it nevertheless readily falls again. It is the finest part that rises highest; hence that part will be least seen and will look almost of the same color as the air. The higher the smoke mixed with the dust-laden air rises towards a certain level, the more it will look like a dark cloud; and it will be seen that at the top, where the smoke is more separate from the dust, the smoke will assume a bluish tinge and the dust will tend to its color. This mixture of air, smoke and dust will look much lighter on the side whence the light comes than on the opposite side. The more the combatants are in this turmoil the less will they be seen, and the less contrast will there be in their lights and

shadows. Their faces and figures and their appearance, and the musketeers as well as those near them, you must make of a glowing red. And this glow will diminish in proportion as it is remote from its cause. The figures which are between you and the light, if they be at a distance, will appear dark on a light background, and the lower part of their legs near the ground will be least visible, because there the dust is coarsest and densest. And if you introduce horses galloping outside the crowd, make the little clouds of dust distant from each other in proportion to the strides made by the horses; and the clouds which are furthest removed from the horses should be least visible; make them high and spreading and thin, and the nearer ones will be more conspicuous and smaller and denser. The air must be full of arrows in every direction, some shooting upwards, some falling, some flying level. The balls from the guns must have a train of smoke following their flight. The figures in the foreground you must make with dust on the hair and eyebrows and on other flat places likely to retain it. The conquerors you will make rushing onwards with their hair and other light things flying on the wind, with their brows bent down, and with the opposite limbs thrust forward; that is, where a man puts forward the right foot the left arm must be advanced. And if you make anyone fallen, you must show the place where he has slipped and been dragged along the dust into blood-stained mire; and in the half-liquid earth around show the print of the tramping of men and horses who have passed that way. Make also a horse dragging the dead body of his master, and leaving behind him, in the dust and mud, the track where the body was dragged along. You must make the conquered and beaten pale, their brows raised and knit, and the skin above their brows furrowed with pain, the sides of the nose with wrinkles going in an arch from the nostrils to the eyes, and make the nostrils drawn up—which is the cause of the lines of which I speak—and the lips arched upwards and discovering the upper teeth, and the teeth apart as with crying out and lamentation. And make someone shielding his terrified eyes with one hand, the palm towards the enemy, while the other rests on the ground to support his half-raised body. Others represent shouting with their mouths open, and running away. You must scatter arms of all sorts among the feet of the combatants, as broken shields, lances, broken swords, and other such objects. And you must make the dead partly or entirely covered with dust, which is changed into crimson mire where it has

mingled with the flowing blood whose color shows it issuing in a sinuous stream from the corpse. Others must be represented in the agonies of death grinding their teeth, rolling their eyes, with their fists clenched against their bodies and their legs contorted. Some might be shown disarmed and beaten down by the enemy, turning upon the foe, with teeth and nails, to take an inhuman and bitter revenge. You might see some riderless horse rushing among the enemy, with his mane flying in the wind, and doing no little mischief with his heels. Some maimed warrior may be seen fallen to the earth, covering himself with his shield, while the enemy, bending over him, tries to deal him a deathstroke. There again might be seen a number of men fallen in a heap over a dead horse. You would see some of the victors leaving the fight and issuing from the crowd, rubbing their eyes and cheeks with both hands to clean them of the dirt made by their watering eyes smarting from the dust and smoke. The reserves may be seen standing, hopeful but cautious, with watchful eyes, shading them with their hands and gazing through the dense and murky confusion, attentive to the commands of their captain. The captain himself, his staff raised, hurries towards these auxiliaries, pointing to the spot where they are most needed. And there may be a river into which horses are galloping, churning up the water all round them into turbulent waves of foam and water, tossed into the air and among the legs and bodies of the horses. And there must not be a level spot that is not trampled with gore.

Of the way to represent a night scene. That which is entirely bereft of light is all darkness; given a night under these conditions and that you want to represent a night scene—arrange that there shall be a great fire, then the objects which are nearest to this fire will be most tinged with its color; for those objects which are nearest to a colored light participate most in its nature; as, therefore, you give the fire a red color, you must make all the objects illuminated by it ruddy; while those which are farther from the fire are more tinted by the black hue of night. The figures which are seen against the fire look dark in the glare of the firelight because that side of the objects which you see is tinged by the darkness of the night and not by the fire; and those who stand at the side are half dark and half red; while those who are visible beyond the edges of the flame will be fully lighted by the ruddy glow against a black background. As to their gestures, make those

which are near it screen themselves with their hands and cloaks as a defense against the intense heat, and with their faces turned away as if about to retire. Of those farther off represent several as raising their hands to screen their eyes, hurt by the intolerable glare.

How to represent a tempest. If you wish to represent a tempest consider and arrange well its effects as seen, when the wind, blowing over the face of the sea and earth, removes and carries with it such things as are not fixed to the general mass. And to represent the storm accurately you must first show the clouds scattered and torn, and flying with the wind, accompanied by clouds of sand blown up from the seashore, and boughs and leaves swept along by the strength and fury of the blast and scattered with other light objects through the air. Trees and plants must be bent to the ground, almost as if they would follow the course of the gale, with their branches twisted out of their natural growth and their leaves tossed and turned about. Of the men who are there some must have fallen to the ground and be entangled in their garments, and hardly to be recognized for the dust, while those who remain standing may be behind some tree, with their arms round it that the wind may not tear them away; others with their hands over their eyes for the dust, bending to the ground with their clothes and hair streaming in the wind. Let the sea be rough and tempestuous and full of foam whirled among the lofty waves, while the wind flings the lighter spray through the stormy air, till it resembles a dense and swathing mist. Of the ships that are therein some should be shown with rent sails and the tatters fluttering through the air, with ropes broken and masts split and fallen. And the ship itself lying in the trough of the sea and wrecked by the fury of the waves with the men shrieking and clinging to the fragments of the vessel. Make the clouds driven by the impetuosity of the wind and flung against the lofty mountaintops, and wreathed and torn like waves beating upon rocks; the air itself terrible from the deep darkness caused by the dust and fog and heavy clouds.

Description of the deluge. Let there be first represented the summit of a rugged mountain with valleys surrounding its base, and on its sides let the surface of the soil be seen to slide, together with the small roots of the bushes, denuding great portions of the surrounding rocks. And descending ruin-

ous from these precipices in its boisterous course, let it dash along and lay bare the twisted and gnarled roots of large trees overthrowing their roots upwards; and let the mountains, as they are scoured bare, discover the profound fissures made in them by ancient earthquakes. The base of the mountains may be in great part clothed and covered with ruins of shrubs, hurled down from the sides of their lofty peaks, which will be mixed with mud, roots, boughs of trees, with all sorts of leaves thrust in with the mud and earth and stones. And into the depth of some valley may have fallen the fragments of a mountain forming a shore to the swollen waters of its river; which, having already burst its banks, will rush on in monstrous waves; and the greatest will strike upon and destroy the walls of the cities and farm-houses in the valley. Then the ruins of the high buildings in these cities will throw up a great dust, rising up in shape like smoke or wreathed clouds against the falling rain. But the swollen waters will sweep round the pool which contains them, striking in eddying whirlpools against the different obstacles, and leaping into the air in muddy foam; then, falling back, the beaten water will again be dashed into the air. And the whirling waves which fly from the place of concussion, and whose impetus moves them across other eddies going in a contrary direction, after their recoil will be tossed up into the air but without dashing off from the surface. Where the water issues from the pool the spent waves will be seen spreading out towards the outlet; and there falling or pouring through the air and gaining weight and impetus they will strike on the water below, piercing it and rushing furiously to reach its depth; from which being thrown back it returns to the surface of the lake, carrying up the air that was submerged with it; and this remains at the outlet in foam mingled with logs of wood and other matters lighter than water. Round these again are formed the beginnings of waves which increase the more in circumference as they acquire more movement; and this movement rises less high in proportion as they acquire a broader base and thus they are less conspicuous as they die away. But if these waves rebound from various objects they then return in direct opposition to the others following them, observing the same law of increase in their curve as they have already acquired in the movement they started with. The rain, as it falls from the clouds, is of the same color as those clouds, that is, in its shaded side; unless indeed the sun's rays should break through them; in that case the

rain will appear less dark than the clouds. And if the
heavy masses of ruin of large mountains or of grand build-
ings fall into the vast pools of water, a great quantity
will be flung into the air and its movement will be in a con-
trary direction to that of the object which struck the water;
that is to say: the angle of reflection will be equal to the angle
of incidence. Of the objects carried down by the current, those
which are heaviest, or rather largest in mass, will keep farthest
from the two opposite shores. The water in the eddies revolves
more swiftly in proportion as it is nearer to their center. The
crests of the waves of the sea tumble to their bases, falling
with friction on the bubbles of their sides; and this friction
grinds the falling water into minute particles, and this, being
converted into a dense mist, mingles with the gale in the
manner of curling smoke and wreathing clouds, and at last
it rises into the air and is converted into clouds. But the rain
which falls through the atmosphere, being driven and tossed
by the winds, becomes rarer or denser according to the rarity
or density of the winds that buffet it, and thus there is gener-
ated in the atmosphere a moisture formed of the transparent
particles of the rain which is near to the eye of the spectator.
The waves of the sea which break on the slope of the moun-
tains which bound it will foam from the velocity with which
they fall against these hills; in rushing back they will meet the
next wave as it comes and after a loud noise return in a great
flood to the sea whence they came. Let great numbers of
inhabitants—men and animals of all kinds—be seen driven
by the rising of the deluge to the peaks of the mountains in
the midst of the waters aforesaid.

The wave of the sea at Piombino is all foaming water.

Of the water which leaps up from the spot where great
masses fall on its surface. Of the winds of Piombino at Piom-
bino. Eddies of wind and rain with boughs and shrubs mixed
in the air. Emptying the boats of the rain water.

The tremendous fury of the wind driven by the falling in
of the mountains on the caves within—by the falling of the
mountains which served as roofs to these caverns.

A stone flung through the air leaves on the eye which sees
it the impression of its motion, and the same effect is pro-
duced by the drops of water which fall from the clouds when
it rains.

A mountain falling on a town will fling up dust in the form
of clouds; but the color of this dust will differ from that of
the clouds. Where the rain is thickest let the color of the dust

be less conspicuous and where the dust is thickest let the rain be less conspicuous. And where the rain is mingled with the wind and with the dust the clouds created by the rain must be more transparent than those of dust alone. And when flames of fire are mingled with clouds of smoke and water, very opaque and dark clouds will be formed. And the rest of this subject will be treated in detail in the Book on Painting.

People were to be seen eagerly embarking victuals on various kinds of hastily made barks. But little of the waves was visible in those places where the dark clouds and rain were reflected.

But where the flashes caused by the bolts of heaven were reflected, there were seen as many bright spots, caused by the image of the flashes, as there were waves to reflect them to the eye of the spectator.

The number of the images produced by the flash of lightning on the waves of the water was multiplied in proportion to the distance of the spectator's eye.

So also the number of the images was diminished in proportion as they were nearer the eye which saw them, as it has been proved in the definition of the luminosity of the moon, and of our marine horizon when the sun's rays are reflected in it and the eye which receives the reflection is remote from the sea.

THE ARTIST'S MATERIALS

Fire. If you want to make a fire which will set a hall in a blaze without injury, do this: first perfume the hall with a dense smoke of incense or some other odoriferous substance: it is a good trick to play. Or boil ten pounds of brandy to evaporation, but see that the hall is completely closed and throw up some powdered varnish among the fumes and this powder will be supported by the smoke; then go into the room suddenly with a lighted torch and at once it will be in a blaze.

Fire. Close a room tightly and have a brazier of brass or iron with fire in it and sprinkle on it two pints of brandy, a little at a time, so that it may be converted into smoke. Then make someone come in with a light and suddenly you will see the room in a blaze like a flash of lightning, and it will do no harm to anyone.

What is fair in men, passes away, but not so in art.

He who despises painting loves neither philosophy nor nature. If you condemn painting, which is the only imitator of all visible works of nature, you will certainly despise a subtle invention which brings philosophy and subtle speculation to the consideration of the nature of all forms—seas and plains, trees, animals, plants, and flowers—which are surrounded by shade and light. And this is true knowledge and the legitimate issue of nature; for painting is born of nature—or, to speak more correctly, we will say it is the grandchild of nature; for all visible things are produced by nature, and these her children have given birth to painting. Hence we may justly call it the grandchild of nature and related to God.

That painting surpasses all human works by the subtle considerations belonging to it. The eye, which is called the window of the soul, is the principal means by which the central sense can most completely and abundantly appreciate the infinite works of nature; and the ear is the second, which acquires dignity by hearing of the things the eye has seen. If you, historians, or poets, or mathematicians, had not seen things with your eyes you could not report of them in writing. And if you, O poet, tell a story with your pen, the painter with his brush can tell it more easily, with simpler completeness and less tedious to be understood. And if you call painting dumb poetry, the painter may call poetry blind painting. Now which is the worse defect? to be blind or dumb? Though the poet is as free as the painter in the invention of his fictions they are not so satisfactory to men as paintings; for, though poetry is able to describe forms, actions, and places in words, the painter deals with the actual similitude of the forms, in order to represent them. Now tell me which is the nearer to the actual man: the name of the man or the image of the man. The name of the man differs in different countries, but his form is never changed but by death.

That sculpture is less intellectual than painting, and lacks many characteristics of nature. I myself, having exercised myself no less in sculpture than in painting and doing both one

and the other in the same degree, it seems to me that I can, without invidiousness, pronounce an opinion as to which of the two is of the greatest merit and difficulty and perfection. In the first place sculpture requires a certain light, that is, from above; a picture carries everywhere with it its own light and shade. Thus sculpture owes its importance to light and shade, and the sculptor is aided in this by the nature of the relief which is inherent in it, while the painter whose art expresses the accidental aspects of nature, places his effects in the spots where nature must necessarily produce them. The sculptor cannot diversify his work by the various natural colors of objects; painting is not defective in any particular. The sculptor when he uses perspective cannot make it in any way appear true; that of the painter can appear as if a hundred miles beyond the picture itself. Their works have no aerial perspective whatever, they cannot represent transparent bodies, they cannot represent luminous bodies, nor reflected lights, nor lustrous bodies—as mirrors and the like polished surfaces—nor mists, nor dark skies, nor an infinite number of things which need not be told for fear of tedium. As regards the power of resisting time, though they have this resistance, a picture painted on thick copper covered with white enamel on which it is painted with enamel colors and then put into the fire again and baked, far exceeds sculpture in permanence. It may be said that if a mistake is made it is not easy to remedy it; it is but a poor argument to try to prove that a work be the nobler because oversights are irremediable; I should rather say that it will be more difficult to improve the mind of the master who makes such mistakes than to repair the work he has spoiled.

Though you may be able to tell or write the exact description of forms, the painter can so depict them that they will appear alive, with the shadow and light which show the expression of a face; which you cannot accomplish with the pen though it can be achieved by the brush.

That painting declines and deteriorates from age to age, when painters have no other standard than painting already done. Hence the painter will produce pictures of small merit if he takes for his standard the pictures of others. But if he will study from natural objects he will bear good fruit; as was seen in the painters after the Romans who always imitated one another and so their art constantly declined from age to

age. After these came Giotto the Florentine who—not content with imitating the works of Cimabue his master—being born in the mountains and in a solitude inhabited only by goats and such beasts, and being guided by nature to his art, began by drawing on the rocks the movements of the goats of which he was keeper. And thus he began to draw all the animals which were to be found in the country, and in such wise that after much study he excelled not only all the masters of his time but all those of many bygone ages. Afterwards this art declined again, because everyone imitated the pictures that were already done; thus it went on from century to century until Tomaso, of Florence, nicknamed Masaccio, showed by his perfect works how those who take for their standard anyone but nature—the mistress of all masters—weary themselves in vain. And I would say about these mathematical studies that those who only study the authorities and not the works of nature are descendants but not sons of nature, the mistress of all good authors. Oh! how great is the folly of those who blame those who learn from nature, setting aside those authorities who themselves were the disciples of nature.

That the first drawing was a simple line drawn round the shadow of a man cast by the sun on a wall.

STUDIES AND SKETCHES FOR PICTURES
AND DECORATIONS

Notes for THE LAST SUPPER. One who was drinking and has left the glass in its position and turned his head towards the speaker.

Another, twisting the fingers of his hands together, turns with stern brows to his companion. Another with his hands spread open shows the palms, and shrugs his shoulders up to his ears, making a mouth of astonishment.

Another speaks into his neighbor's ear, and he, as he listens to him, turns towards him to lend an ear, while he holds a knife in one hand, and in the other the loaf half cut through by the knife. Another who has turned, holding a knife in his hand, upsets with his hand a glass on the table.

Another lays his hand on the table and is looking. Another blows upon his mouthful. Another leans forward to see the speaker, shading his eyes with his hand. Another draws back

behind the one who leans forward, and sees the speaker between the wall and the man who is leaning.

Christ.

Count Giovanni, the one with the Cardinal of Mortaro.

Notes for THE BATTLE OF ANGHIARI.

Florentines	Niccolò da Pisa
Neri di Gino Capponi	Conte Francesco
Bernardetto de' Medici	Micheletto,
	Pietro Gian Paolo
	Guelfo Orsino,
	Messer Rinaldo degli Albizzi

Begin with the address of Niccolò Piccinino to the soldiers and the banished Florentines, among whom are Messer Rinaldo degli Albizzi and other Florentines. Then let it be shown how he first mounted on horseback in armor; and the whole army came after him—40 squadrons of cavalry, and 2,000 foot soldiers went with him. Very early in the morning the Patriarch went up a hill to reconnoiter the country, that is the hills, fields, and the valley watered by a river; and from thence he beheld Niccolò Piccinino coming from Borgo San Sepolcro with his people, and with a great dust; and perceiving them he returned to the camp of his own people and addressed them. Having spoken he prayed to God with clasped hands, when there appeared a cloud in which Saint Peter appeared and spoke to the Patriarch. —500 cavalry were sent forward by the Patriarch to hinder or check the rush of the enemy. In the foremost troop Francesco the son of Niccolò Piccinino was the first to attack the bridge which was held by the Patriarch and the Florentines. Beyond the bridge to his left he sent forward some infantry to engage ours, who drove them back, among whom was their captain Micheletto, whose lot it was to be that day at the head of the army. Here, at this bridge, there is a severe struggle; our men conquer and the enemy is repulsed. Here Guido and Astorre, his brother, the Lord of Faenza, with a great number of men, re-formed and renewed the fight, and rushed upon the Florentines with such force that they recovered the bridge and pushed forward as far as the tents. But Simonetto advanced with 600 horse, and fell upon the enemy and drove them back once more from the place, and recaptured the bridge; and behind him came more men with 2,000 horse soldiers. And thus for a long time they fought with varying fortune. But then the Patriarch, in

order to divert the enemy, sent forward Niccolò da Pisa and
Napoleone Orsino, a beardless lad, followed by a great multi-
tude of men, and then was done another great feat of arms.
At the same time Niccolò Piccinino urged forward the rem-
nant of his men, who once more made ours give way; and if
it had not been that the Patriarch set himself at their head
and, by his words and deeds, controlled the captains, our
soldiers would have taken to flight. The Patriarch had some
artillery placed on the hill and with these he dispersed the
enemy's infantry; and the disorder was so complete that
Niccolò began to call back his son and all his men, and they
took to flight towards Borgo. And then began a great slaughter
of men; none escaped but the foremost of those who had fled
or who hid themselves. The battle continued until sunset,
when the Patriarch gave his mind to recalling his men and
burying the dead, and afterwards a trophy was erected.

Chapter 2

THE SCULPTOR

*That Leonardo was a sculptor we know from his own notes
and from the innumerable sketches for his two great equestrian
projects, the memorials to the condottiere Francesco Sforza,
of which a full-scale model was actually completed, and to
Giangiacomo Trivulzio, a noble Milanese who supported the
cause of the French king against the Sforzas and set aside
the sum of 4,000 ducats in his will for a monumental tomb
to be erected in the Church of San Nazaro in his memory.
The bronze collected for the casting of the first was eventually,
in 1494, given to Ercole d'Este and made into cannon. But
specifications for casting, estimates, the recurring notes on
fine horses to be used as models, as well as Leonardo's own
statement in his famous letter to Lodovico that he could carry
out sculpture in bronze, marble, or clay, indicate that he
learned this art as well as painting in Verrocchio's workshop.
Yet there is no surviving sculpture which can definitely be
stated to have come from his hand alone.*

*To identify the characteristics of Leonardo's drawings, par-
ticularly his delight in intricate, flowing movement, in the
sculpture commissions known to have been executed in Ver-
rocchio's studio when Leonardo was at work there, provides an
agreeable exercise in attribution, the Doubting Thomas in Or
San Michele; the silver relief in the Opera del Duomo; the
David in the Bargello; the tomb of Cosimo de' Medici's sons,*

Piero and Giovanni, in San Lorenzo; all in Florence, being among them.

Of a statue. If you wish to make a figure in marble, first make one of clay, and when you have finished it, let it dry and place it in a case which should be large enough, after the figure is taken out of it, to receive also the marble from which you intend to reveal the figure in imitation of the one in clay. After you have put the clay figure into this said case, have little rods which will slip exactly into the holes in it, and thrust them so far in at each hole that each white rod may touch the figure in different parts of it. And color the portion of the rod that remains outside black, and mark each rod and each hole with a countersign so that each may fit into its place. Then take the clay figure out of this case and put in your piece of marble, taking off so much of the marble that all your rods may be hidden in the holes as far as their marks; and to be the better able to do this, make the case so that it can be lifted up; but the bottom of it will always remain under the marble and in this way it can be lifted with tools with great ease.

Some have erred in teaching sculptors to measure the limbs of their figures with threads as if they thought that these limbs were equally round in every part where these threads were wound about them.

Measurement and division of a statue. Divide the head into 12 degrees, and each degree divide into 12 points, and each point into 12 minutes, and the minutes into minims, and the minims into semi-minims.

Degree—point—minute—minim.

Sculptured figures which appear in motion will, in their standing position, actually look as if they were falling forward.

NOTES ON THE CASTING OF THE SFORZA MONUMENT

Three braces which bind the mold. If you want to make simple casts quickly, make them in a box of river sand wetted with vinegar.

When you shall have made the mold upon the horse you must make the thickness of the metal in clay.

Observe in alloying how many hours are wanted for each hundredweight. In casting each one keep the furnace and its

fire well stopped up. Let the inside of all the molds be wetted with linseed oil or oil of turpentine, and then take a handful of powdered borax and Greek pitch with brandy, and pitch the mold over outside so that being underground the damp may not damage it.

To manage the large mold make a model of the small mold, make a small room in proportion.

Make the vents in the mold while it is on the horse.

Hold the hoofs in the tongs, and cast them with fish glue. Weigh the parts of the mold and the quantity of metal it will take to fill them, and give so much to the furnace that it may afford to each part its amount of metal; and this you may know by weighing the clay of each part of the mold to which the quantity in the furnace must correspond. And this is done in order that the furnace for the legs when filled may not have to furnish metal from the legs to help out the head, which would be impossible. Cast at the same casting as the horse the little door.

The mold for the horse. Make the horse on legs of iron, strong and well set on a good foundation; then grease it and cover it with a coating, leaving each coat to dry thoroughly layer by layer; and this will thicken it by the breadth of three fingers. Now fix and bind it with iron as may be necessary. Moreover, take off the mold and then make the thickness. Then fill the mold by degrees and make it good throughout; encircle and bind it with its irons and bake it inside where it has to touch the bronze.

Of making the mold in pieces. Draw upon the horse, when finished, all the pieces of the mold with which you wish to cover the horse, and in laying on the clay cut it in every piece, so that when the mold is finished you can take it off, and then recompose it in its former position with its joins by the countersigns.

The square blocks *a b* will be between the cover and the core, that is, in the hollow where the melted bronze is to be; and these square blocks of bronze will support the intervals between the mold and the cover at an equal distance, and for this reason these squares are of great importance.

The clay should be mixed with sand.

Take wax, to return what is not used and to pay for what is used.

Dry it in layers.

Make the outside mold of plaster, to save time in drying

and the expense in wood; and with this plaster enclose the irons [props] both outside and inside to a thickness of two fingers; make terra cotta.

And this mold can be made in one day; half a boatload of plaster will serve you.

Good.

Dam it up again with glue and clay, or white of egg, and bricks and rubbish.

Messer Galeazzo's big genet.

Measurement of the Sicilian horse, the leg from behind, seen in front, lifted and extended.

Again, the bronze horse may be taken in hand, which is to be to the immortal glory and eternal honor of the happy memory of the prince your father, and of the illustrious house of Sforza.

On the 23rd of April, 1490, I began this book, and recommenced the horse.

Of the horse I will say nothing because I know the times.

During ten years the works on the marbles have been going on; I will not wait for my payment beyond the time when my works are finished.

The monument to Messer Giovanni Jacomo Da Trevulzo.

COST OF THE MAKING AND MATERIALS FOR THE HORSE.

A courser, as large as life, with the rider, requires for the cost of the metal duc. 500

And for cost of the ironwork which is inside the model, and charcoal, and wood, and the pit to cast it in, and for binding the mold, and including the furnace where it is to be cast duc. 200

To make the model in clay and then in wax duc. 432

To the laborers for polishing it when it is cast

 duc. 450

in all duc. 1582

COST OF THE MARBLE OF THE MONUMENT.

Cost of the marble according to the drawing. The piece of marble under the horse which is 4 braccia long, 2 braccia and 2 inches wide, and 9 inches thick,

58 hundredweight, at 4 lire and 10 soldi per hundredweight duc. 58

And for 13 braccia and 6 inches of cornice, 7 in. wide and 4 in. thick, 24 hundredweight . . duc. 24

And for the frieze and architrave, which is 4 br. and 6 in. long, 2 br. wide, and 6 in. thick, 29 hundredweight duc. 20

And for the capitals made of metal, which are 8, 5 in. square and 2 in. thick, at the price of 15 ducats each, will come to duc. 122

And for 8 columns of 2 br. 7 in., 4½ in. thick, 20 hundredweight duc. 20

And for 8 bases which are 5½ in. square and 2 in. high, 5 hundt duc. 5

And for the slab of the tombstone 4 br. 10 in. long, 2 br. 4½ in. wide, 36 hundredweight . duc. 36

And for 8 pedestal feet each 8 br. long and 6½ in. wide and 6½ in. thick, 20 hundredweight come to
duc. 20

And for the cornice below, which is 4 br. and 10 in. long, and 2 br. and 5 in. wide, and 4 in. thick, 32 hundt duc. 32

And for the stone of which the figure of the deceased is to be made, which is 3 br. and 8 in. long, and 1 br. and 6 in. wide, and 9 in. thick, 30 hundt
duc. 30

And for the stone on which the figure lies, which is 3 br. and 4 in. long and 1 br. and 2 in. wide and 4½ in. thick duc. 16

And for the squares of marble placed between the pedestals, which are 8, and are 9 br. long and 9 in. wide and 3 in. thick, 8 hundredweight . . . duc. 8

in all duc. 389

COST OF THE WORK IN MARBLE.

Round the base on which the horse stands there are 8 figures at 25 ducats each duc. 200

And on the same base there are 8 festoons with some other ornaments, and of these there are 4 at the price of 15 ducats each, and 4 at the price of 8 ducats each duc. 92

And for squaring the stones duc. 6

Again, for the large cornice which goes below the base on which the horse stands, which is 13 br. and 6 in., at 2 duc. per br. duc. 27

And for 12 br. of frieze at 5 duc. per br. . duc. 60

And for 12 br. of architrave at 1½ duc. per br. duc. 18

And for 3 rosettes which will be the soffit of the monument, at 20 ducats each duc. 60

And for 8 fluted columns at 8 ducats each . duc. 64

And for 8 bases at 1 ducat each duc. 8

And for 8 pedestals, of which 4 are at 10 duc. each, which go above the angles; and 4 at 6 duc. each duc. 64

And for squaring and carving the molding of the pedestals at 2 duc. each, and there are 8 . . duc. 16

And for 6 square blocks with figures and trophies, at 25 duc. each duc. 150

And for carving the molding of the stone under the figure of the deceased duc. 40

For the statue of the deceased, to do it well duc. 100

For 6 harpies with candelabra, at 25 ducats each duc. 150

For squaring the stone on which the statue lies, and carving the molding duc. 20

in all duc. 1075

The sum total of everything added together amounts to duc. 3046

Such as the mold is, so will the cast be.

To know the condition of the fire. You may know when the fire is good and fit for your purpose by a clear flame, and if you see the tips of the flames dull and ending in much smoke do not trust it, and particularly when the flux metal is almost fluid.

Of alloying the metal. Metal for guns must invariably be made with 6 or even 8 per cent, that is 6 of tin to one hundred of copper, for the less you put in, the stronger will the gun be.

When the tin should be added to the copper. The tin should be put in with the copper when the copper is reduced to a fluid.

How to hasten the melting. You can hasten the melting when ⅔ of the copper is fluid; you can then, with a stick of chestnutwood, repeatedly stir what of copper remains entire amidst what is melted.

Chapter 3

THE ARCHITECT

Interest in architecture was no oddity among Renaissance painters, it was in fact expected of them. The combination of art and technical knowledge which is the very essence of architectural ability made it a field of immense appeal to Leonardo, and he evidently projected an entire book on the subject. Like most of his literary plans this came to nothing, and the architectural notes and sketches remain jumbled in with all the rest.

These scattered notes include many on structure, on stresses and strains in the construction of arches, on the remedying of cracks and fissures and of their original cause. Actually, however, Leonardo cannot be described as a practical builder but rather as a theorist in the architectural field. We know, however, that he did plan and presumably supervise construction of a Pavilion for the Duchess's garden in Milan, hot-water-heating systems for her baths, stables for the Duke, and undoubtedly his various patrons, particularly the Sforzas, actually employed him in alterations and repairs for their castles, fortresses, and the great buildings of all sorts which they proposed to erect to the glory of their house.

Although he was consulted on the solution of architectural problems involved in several churches there is no evidence that any of the rather grandiose domed churches he sketched so often were ever built. He was interested in the acoustical problems of churches, and in town planning, then of much concern as a means of preventing epidemics of the plague.

The roads *m* are 6 braccia higher than the roads *p s*, and each road must be 20 braccia wide and have ½ braccio slope from the sides towards the middle, and in the middle let there be at every braccio an opening, one braccio long and one finger wide, where the rain water may run off into hollows made on the same level as *p s*. And on each side at the extremity of the width of the said road let there be an arcade, 6 braccia broad, on columns; and understand that he who would go through the whole place by the high-level streets can use them for this purpose, and he who would go by the low level can do the same. By the high streets no vehicles and similar objects should circulate, but they are exclusively for the use of gentlemen. The carts and burdens for the use and convenience of the inhabitants have to go by the low ones. One house must turn its back to the other, leaving the lower streets between them. Provisions, such as wood, wine, and such things, are carried in by the doors *n*, and privies, stables, and other fetid matter must be emptied away underground. From one arch to the next must be 300 braccia, each street receiving its light through the openings of the upper streets, and at each arch must be a winding stair on a circular plan because the corners of square ones are always fouled; they must be wide, and at the first vault there must be a door entering into public privies and the said stairs lead from the upper to the lower streets and the high-level streets begin outside the city gates and slope up till at these gates they have attained the height of 6 braccia. Let such a city be built near the sea or a large river in order that the dirt of the city may be carried off by the water.

On moving houses. Let the houses be moved and arranged in order; and this will be done with facility because such houses are at first made in pieces on the open places, and can then be fitted together with their timbers in the site where they are to be permanent.

Let the men of the country or the village partly inhabit the new houses when the court is absent.

PLANS FOR CANALS AND STREETS IN A TOWN

The front *a m* will give light to the rooms; *a e* will be 6 braccia—*a b* 8 braccia—*b e* 30 braccia, in order that the rooms under the porticoes may be lighted; *c d f* is the place where the boats come to the houses to be unloaded. In order to render this arrangement practicable, and in order that the inundation

of the rivers may not penetrate into the cellars, it is necessary to choose an appropriate situation, such as a spot near a river which can be diverted into canals in which the level of the water will not vary either by inundations or drought. The construction is shown below; and make choice of a fine river, which the rains do not render muddy, such as the Ticino, the Adda, and many others. The construction to oblige the waters to keep constantly at the same level will be a sort of dock, as shown below, situated at the entrance of the town; or better still, some way within, in order that the enemy may not destroy it.

Let the width of the streets be equal to the average height of the houses.

The main underground channel does not receive turbid water, but that water runs in the ditches outside the town with four mills at the entrance and four at the outlet; and this may be done by damming the water above Romorantin.

There should be fountains made in each piazza.

CASTLES AND VILLAS

The palace of the prince must have a piazza in front of it.

Houses intended for dancing or any kind of jumping or any other movements with a multitude of people must be on the ground floor; for I have already witnessed the destruction of some, causing death to many persons, and above all let every wall, be it ever so thin, rest on the ground or on arches with a good foundation.

Let the mezzanines of the dwellings be divided by walls made of very thin bricks, and without wood on account of fire.

Let all the privies have ventilation by shafts in the thickness of the walls, so as to exhale by the roofs.

The mezzanines should be vaulted, and the vaults will be stronger in proportion as they are of small size.

The ties of oak must be enclosed in the walls in order to be protected from fire.

The privies must be numerous and going one into the other in order that the stench may not penetrate into the dwellings, and all their doors must shut off themselves with counter-poises.

The main division of the façade of this palace is into two

portions; that is to say the width of the courtyard must be half the whole façade; the 2nd . . .

ECCLESIASTICAL ARCHITECTURE

A building should always be detached on all sides so that its form may be seen.

Here there cannot and ought not to be any campanile; on the contrary, it must stand apart like that of the Cathedral and of San Giovanni at Florence, and of the Cathedral at Pisa, where the campanile is quite detached as well as the dome. Thus each can display its own perfection. If, however, you wish to join it to the church, make the lantern serve for the campanile as in the church at Chiaravalle.

It never looks well to see the roofs of a church; they should rather be flat and the water should run off by gutters made in the frieze.

Description of an unknown temple. Twelve flights of steps led up to the great temple, which was eight hundred braccia in circumference and built on an octagonal plan. At the corners were eight large plinths, one braccio and a half high, and three wide, and six long at the bottom, with an angle in the middle; on these were eight great pillars, standing on the plinths as a foundation, and twenty-four braccia high. And on the top of these were eight capitals three braccia long and six wide, above which were the architrave, frieze, and cornice, four braccia and a half high, and this was carried on in a straight line from one pillar to the next and so, continuing for eight hundred braccia, surrounded the whole temple, from pillar to pillar. To support this entablature there were ten large columns of the same height as the pillars, three braccia thick above their bases, which were one braccio and a half high.

The ascent to this temple was by twelve flights of steps, and the temple was on the twelfth, of an octagonal form, and at each angle rose a large pillar; and between the pillars were placed ten columns of the same height as the pillars, rising at once from the pavement to a height of twenty-eight braccia and a half; and at this height the architrave, frieze, and cornice were placed which surrounded the temple, having a length of eight hundred braccia. At the same height, and within the temple at the same level, and all round the center of the temple at a distance of 24 braccia farther in, are pillars corresponding to the eight pillars in the angles, and

columns corresponding to those placed in the outer spaces. These rise to the same height as the former ones, and over these the continuous architrave returns towards the outer row of pillars and columns.

PALACE ARCHITECTURE

For making a clean stable. The manner in which one must arrange a stable. You must first divide its width in 3 parts, its depth matters not; and let these 3 divisions be equal and 6 braccia broad for each part and 10 high, and the middle part shall be for the use of the stablemasters; the 2 side ones for the horses, each of which must be 6 braccia in width and 6 in length, and be half a braccio higher at the head than behind. Let the manger be at 2 braccia from the ground, to the bottom of the rack, 3 braccia, and the top of it 4 braccia. Now, in order to attain to what I promise, that is to make this place, contrary to the general custom, clean and neat: as to the upper part of the stable, i.e., where the hay is, that part must have at its outer end a window 6 braccia high and 6 broad, through which by simple means the hay is brought up to the loft, and let this be erected in a place 6 braccia wide, and as long as the stable. The other two parts, which are on either side of this, are again divided; those nearest to the hayloft are 4 braccia, and only for the use and circulation of the servants belonging to the stable; the other two, which reach to the outer walls, are 2 braccia, and these are made for the purpose of giving hay to the mangers, by means of funnels, narrow at the top and wide over the manger, in order that the hay should not choke them. They must be well plastered and clean. As to the giving the horses water, the troughs must be of stone and above them cisterns of water. The mangers may be opened as boxes are uncovered by raising the lids.

The way to construct a framework for decorating buildings. The way in which the poles ought to be placed for tying bunches of juniper on to them. These poles must lie close to the framework of the vaulting, and tie the bunches on osier withes, so as to clip them even afterwards with shears.

Let the distance from one circle to another be half a braccio; and the juniper sprigs must lie top downwards, beginning from below.

Round this column tie four poles to which willows about as

thick as a finger must be nailed, and then begin from the bottom and work upwards with bunches of juniper sprigs, the tops downwards, that is, upside down.

ARCHITECTURAL DESIGNS

Concerning architraves of one or several pieces. An architrave of several pieces is stronger than that of one single piece, if those pieces are placed with their length in the direction of the center of the world. This is proved because stones have their grain or fiber generated in the contrary direction, i.e., in the direction of the opposite horizons of the hemisphere, and this is contrary to fibers of the plants which have . . .

THEORETICAL WRITINGS ON ARCHITECTURE

On fissures in walls. First write the treatise on the causes of the giving way of walls, and then, separately, treat of the remedies.

Parallel fissures constantly occur in buildings which are erected on a hillside, when the hill is composed of stratified rocks with an oblique stratification, because water and other moisture often penetrates these oblique seams, carrying in greasy and slippery soil; and as the strata are not continuous down to the bottom of the valley, the rocks slide in the direction of the slope, and the motion does not cease till they have reached the bottom of the valley, carrying with them, as though in a boat, that portion of the building which is separated by them from the rest. The remedy for this is always to build thick piers under the wall which is slipping, with arches from one to another, and with a good scarp, and let the piers have a firm foundation in the strata that are not broken up.

In order to find the solid part of these strata, it is necessary to make a shaft at the foot of the wall of great depth through the strata; and in this shaft, on the side from which the hill slopes, smooth and flatten a space one palm wide from the top to the bottom; and after some time this smooth portion made on the side of the shaft will show plainly which part of the hill is moving.

The cracks in walls will never be parallel unless the part of the wall that separates from the remainder does not slip down.

What is the law by which buildings have stability? The stability of buildings is the result of the contrary law to the two former cases. That is to say that the walls must be all built up equally, and by degrees, to equal heights all round the building, and the whole thickness at once, whatever kind of walls they may be. And although a thin wall dries more quickly than a thick one it will not necessarily give way under the added weight day by day, and thus, although a thin wall dries more quickly than a thick one, it will not give way under the weight which the latter may acquire from day to day. Because if double the amount of it dries in one day, one of double the thickness will dry in two days or thereabouts; thus the small addition of weight will be balanced by the smaller difference of time.

The adversary says that *a*, which projects, slips down.

How to prognosticate the causes of cracks in any sort of wall. The part of the wall which does not slip is that in which the obliquity projects and overhangs the portion which has parted from it and slipped down.

On the situation of foundations and in what places they are a cause of ruin. When the crevice in the wall is wider at the top than at the bottom, it is a manifest sign that the cause of the fissure in the wall is remote from the perpendicular line through the crevice.

Of cracks in walls which are wide at the bottom and narrow at the top, and of their causes. That wall which does not dry uniformly in an equal time always cracks.

A wall, though of equal thickness, will not dry with equal quickness if it is not everywhere in contact with the same medium. Thus, if one side of a wall were in contact with a damp slope and the other were in contact with the air, then this latter side shrinks on every side, while the wet part would remain of the same size as before; that side which dries in the air will shrink or diminish and the side which is kept damp will not dry. And the dry portion will break away readily from the damp portion, because the damp part not shrinking in the same proportion does not cohere and follow the movement of the part which dries continuously.

Of arched cracks, wide at the top and narrow below. Arched cracks, wide at the top and narrow below, are found in walled-up doors, which shrink more in their height than in their breadth, and in proportion as their height is greater than their width, and as the joints of the mortar are more numerous in the height than in the width.

Any crack made in a concave wall is wide below and narrow at the top.

1. That which gets wet increases in proportion to the moisture it imbibes.

2. And a wet object shrinks, while drying, in proportion to the amount of moisture which evaporates from it.

Of the causes of fissures in the walls of public and private buildings. The walls give way in cracks, some of which are more or less vertical and others are oblique. The cracks which are in a vertical direction are caused by the joining of new walls with old walls, whether straight or with indentations fitting on to those of the old wall; for, as these indentations cannot bear the too great weight of the wall added on to them, it is inevitable that they should break, and give way to the settling of the new wall, which will shrink one braccio in every ten, more or less, according to the greater or smaller quantity of mortar used between the stones of the masonry, and whether this mortar is more or less liquid. And observe that the walls should always be built first and then faced with the stones intended to face them. For, if you do not proceed thus, since the wall settles more than the stone facing, the projections left on the sides of the wall must inevitably give way; because the stones used for facing the wall being larger than those over which they are laid, they will necessarily have less mortar laid between the joints, and consequently they settle less; and this cannot happen if the facing is added after the wall is dry.

Of stones which disjoin themselves from their mortar. Stones laid in regular courses from bottom to top and built up with an equal quantity of mortar settle equally throughout, when the moisture that made the mortar soft evaporates.

By what is said above it is proved that the small extent of the new wall will settle but little. The proportion will in fact be that of the thinness of the mortar in relation to the number of courses or to the quantity of mortar laid between the stones above the different levels of the old wall.

On the shrinking of damp bodies of different thickness and width. The window *a* is the cause of the crack at *b;* and this crack is increased by the pressure of *n* and *m* which sink or penetrate into the soil in which foundations are built more than the lighter portion at *b*. Besides, the old foundation under *b* has already settled, and this the piers *n* and *m* have not yet done. Hence the part *b* does not settle down perpendicularly; on the contrary, it is thrown outwards obliquely,

and it cannot on the contrary be thrown inwards, because a portion like this, separated from the main wall, is larger outside than inside, and the main wall, where it is broken, is of the same shape and is also larger outside than inside; therefore, if this separate portion were to fall inwards the larger would have to pass through the smaller—which is impossible. Hence it is evident that the portion of the semicircular wall when disunited from the main wall will be thrust outwards, and not inwards as the adversary says.

When a dome or a half-dome is crushed from above by an excess of weight the vault will give way, forming a crack which diminishes towards the top and is wide below, narrow on the inner side and wide outside; as is the case with the outer husk of a pomegranate, divided into many parts lengthwise; for the more it is pressed in the direction of its length, that part of the joints will open most which is most distant from the cause of the pressure; and for that reason the arches of the vaults of any apse should never be more loaded than the arches of the principal building. Because that which weighs most presses most on the parts below, and they sink into the foundations; but this cannot happen to lighter structures like the said apses.

Which of these two cubes will shrink the more uniformly: the cube *a* resting on the pavement, or the cube *b* suspended in the air, when both cubes are equal in weight and bulk, and of clay mixed with equal quantities of water?

The cube placed on the pavement diminishes more in height than in breadth, which the cube above, hanging in the air, cannot do. Thus it is proved. The cube shown above is better shown here below.

The final result of the two cylinders of damp clay, that is, *a* and *b*, will be the pyramidal figures below *c* and *d*. This is proved thus: The cylinder *a* resting on a block of stone being made of clay mixed with a great deal of water will sink by its weight, which presses on its base, and in proportion as it settles and spreads all the parts will be somewhat nearer to the base because that is charged with the whole weight, etc.; and the case will be the same with the weight of *b* which will stretch lengthwise in proportion as the weight at the bottom is increased and the greatest tension will be the neighborhood of the weight which is suspended by it.

What is an arch? The arch is nothing else than a force originated by two weaknesses, for the arch in buildings is composed of two segments of a circle, each of which being very weak in itself tends to fall; but as each opposes this tendency in the other, the two weaknesses combine to form one strength.

Of the kind of pressure in arches. As the arch is a composite force it remains in equilibrium because the thrust is equal from both sides; and if one of the segments weighs more than the other the stability is lost, because the greater pressure will outweigh the lesser.

Of distributing the pressure above an arch. Next to giving the segments of the circle equal weight it is necessary to load them equally, or you will fall into the same defect as before.

Where an arch breaks. An arch breaks at the part which lies below halfway from the center.

Second rupture of the arch. If the excess of weight be placed in the middle of the arch at the point *a*, that weight tends to fall towards *b*, and the arch breaks at ⅔ of its height at *c e;* and *g e* is as many times stronger than *e a*, as *m o* goes into *m n*.

On the strength of the arch. The way to give stability to the arch is to fill the spandrils with good masonry up to the level of its summit.

On the loading of round arches.

On the proper manner of loading the pointed arch.

On the evil effects of loading the pointed arch directly above its crown.

An experiment to show that a weight placed on an arch does not discharge itself entirely on its columns; on the contrary the greater the weight placed on the arches, the less the arch transmits the weight to the columns. The experiment is the following. Let a man be placed on a steelyard in the middle of the shaft of a well, then let him spread out his hands and feet between the walls of the well, and you will see him weigh much less on the steelyard; give him a weight on the shoulders, you will see by experiment, that the greater the weight you

give him the greater effort he will make in spreading his arms and legs and in pressing against the wall, and the less weight will be thrown on the steelyard.

ON FOUNDATIONS, THE NATURE OF THE GROUND AND SUPPORTS

The first and most important thing is stability.

As to the foundations of the component parts of temples and other public buildings, the depths of the foundations must bear the same proportions to one another as the weight of material which is to be placed upon them.

Every part of the depth of earth in a given space is composed of layers, and each layer is composed of heavier or lighter materials, the lowest being the heaviest. And this can be proved, because these layers have been formed by the sediment from water carried down to the sea, by the current of rivers which flow into it. The heaviest part of this sediment was that which was first thrown down, and so on by degrees; and this is the action of water when it becomes stagnant, having first brought down the mud whence it first flowed. And such layers of soil are seen in the banks of rivers, where their constant flow has cut through them and divided one slope from the other to a great depth; where in gravelly strata the waters have run off, the materials have, in consequence, dried and been converted into hard stone, and this happened most in what was the finest mud; whence we conclude that every portion of the surface of the earth was once at the center of the earth, and vice versa, etc.

Of the supports. A pillar of which the thickness is increased will gain more than its due strength, in direct proportion to what it loses in relative height. Example: If a pillar should be nine times as high as it is broad—that is to say, if it is one braccio thick, according to rule it should be nine braccia high—then, if you place 100 such pillars together in a mass this will be ten braccia broad and 9 high; and if the first pillar could carry 10,000 pounds the second being only about as high as it is wide, and thus lacking 8 parts of its proper length, it—that is to say, each pillar thus united—will bear eight times more than when disconnected; that is to say, that if at first it would carry ten thousand pounds, it would now carry 90 thousand.

That angle will offer the greatest resistance which is most acute, and the most obtuse will be the weakest.

On the length of beams. That beam which is more than 20 times as long as its greatest thickness will be of brief duration and will break in half; and remember, that the part built into the wall should be steeped in hot pitch and filleted with oak boards likewise so steeped. Each beam must pass through its walls and be secured beyond the walls with sufficient chaining, because in consequence of earthquakes the beams are often seen to come out of the walls and bring down the walls and floors; whilst if they are chained they will hold the walls strongly together and the walls will hold the floors. Again I remind you never to put plaster over timber. Since by expansion and shrinking of the timber produced by damp and dryness such floors often crack, and once cracked their divisions gradually produce dust and an ugly effect. Again remember not to lay a floor on beams supported on arches; for, in time the floor which is made on beams settles somewhat in the middle while that part of the floor which rests on the arches remains in its place; hence, floors laid over two kinds of supports look, in time, as if they were made in hills.

Chapter 4

THE MILITARY AND HYDRAULIC ENGINEER

Of the thirty-six possible services which Leonardo lists in his famous letter to Lodovico Sforza, thirty are suggestions for technical works, and six only are within the artistic province which we commonly think of as being Leonardo's. This wide variety of suggestions for the fields of military engineering and hydraulics was no idle effort to establish himself as something he was not. Judging from the notes and specifications which appear in his writing, and from the sketches, he could produce engines for offense, defense, and equipment for military excavations, mining, supply, as well as for ordnance. Projectile throwers, aerial bombs, breech-loading cannon, catapults, machines for the detection of mines, military bridges, firearms rifled to impart a spin to bullets, wheel-lock pistols, steam cannon, are among his inventions or improvements on existing devices. There are many more which cannot be listed here.

In hydraulics, a subject of endless fascination to him until the day of his death in France, he was generations ahead of his times. His miter locks, which were used for centuries on the Martesana canal, which is part of the irrigation system for the Lombardy plain, were the first modern form of lock and of enormous importance in the development of canal engineering. He also devised innumerable ways of employing hydraulic power, such as water lifts, ventilators, screws, bilge pumps, curved cylinder pumps, grinding mills, counterweight pumps, double-action force pumps, water wheels—the list stretches almost indefinitely.

The order of the book. Place at the beginning what a river can effect.

A book of driving back armies by the force of a flood made by releasing waters.

A book showing how the waters safely bring down timber cut in the mountains.

A book of boats driven against the impetus of rivers.

A book of raising large bridges higher. Simply by the swelling of the waters.

A book of guarding against the impetus of rivers so that towns may not be damaged by them.

Canal of Florence. Sluices should be made in the valley of la Chiana at Arezzo, so that when, in the summer, the Arno lacks water, the canal may not remain dry: and let this canal be 20 braccia wide at the bottom, and at the top 30, and 2 braccia deep, or 4, so that two of these braccia may flow to the mills and the meadows, which will benefit the country; and Prato, Pistoia, and Pisa, as well as Florence, will gain two hundred thousand ducats a year, and will lend a hand and money to this useful work; and the Lucchese the same, for the lake of Sesto will be navigable; I shall direct it to Prato and Pistoia, and cut through Serravalle and make an issue into the lake; for there will be no need of locks or supports, which are not lasting and so will always be giving trouble in working at them and keeping them up.

And know that in digging this canal where it is 4 braccia deep, it will cost 4 dinari the square braccio; for twice the depth 6 dinari, if you are making 4 braccia and there are but 2 banks; that is to say one from the bottom of the trench to the surface of the edges of it, and the other from these edges to the top of the ridge of earth which will be raised on the margin of the bank. And if this bank were of double the depth only the first bank will be increased, that is 4 braccia increased by half the first cost; that is to say that if at first 4 dinari were paid for 2 banks, for 3 it would come to 6, at 2 dinari the bank, if the trench measured 16 braccia at the bottom; again, if the trench were 16 braccia wide and 4 deep, coming to 4 soldi for the work, 4 Milan dinari the square braccio; a trench which was 32 braccia at the bottom would come to 8 dinari the square braccio.

By guiding the Arno above and below a treasure will be found in each acre of ground by whomsoever will.

They do not know why the Arno will never remain in a channel. It is because the rivers which flow into it deposit earth where they enter, and wear it away on the opposite side, bending the river in that direction. The Arno flows for 6 miles between la Caprona and Leghorn; and for 12 through the marshes, which extend 32 miles, and 16 from la Caprona up the river, which makes 48; by the Arno from Florence beyond 16 miles; to Vico 16 miles, and the canal is 5; from Florence to Fucechio it is 40 miles by the river Arno.

56 miles by the Arno from Florence to Vico; by the Pistoia canal it is 44 miles. Thus it is 12 miles shorter by the canal than by the Arno.

That the river which is to be turned from one place to another must be coaxed and not treated roughly or with violence; and to do this a sort of floodgate should be made in the river, and then, lower down, one in front of it and in like manner a third, fourth, and fifth, so that the river may discharge itself into the channel given to it, or that by this means it may be diverted from the place it has damaged, as was done in Flanders—as I was told by Niccolò di Forsore.

How to protect and repair the banks washed by the water, as below the island of Cocomeri.

On the 2nd day of February 1494. At the Sforzesca I drew twenty-five steps ⅔ braccio to each, and 8 braccia wide.

Again if the lowest part of the bank which lies across the current of the waters is made in deep and wide steps, after the manner of stairs, the waters, which, in their course, usually fall perpendicularly from the top of such a place to the bottom, and wear away the foundations of this bank, can no longer descend with a blow of too great a force; and I find the example of this in the stairs down which the water falls in the fields at Sforzesca at Vigevano over which the running water falls for a height of 50 braccia.

Stair of Vigevano below La Sforzesca, 130 steps, ¼ braccio high and ½ braccio wide, down which the water falls, so as not to wear away anything at the end of its fall; by these steps so much soil has come down that it has dried up a pool; that is to say, it has filled it up and a pool of great depth has been turned into meadows.

In many places there are streams of water which swell for six hours and ebb for six hours; and I, for my part, have

seen one above the lake of Como called Fonte Pliniana, which increases and ebbs, as I have said, in such a way as to turn the stones of two mills; and when it fails it falls so low that it is like looking at water in a deep pit.

The water may be dammed up above the level of Romorantin to such a height that in its fall it may be used for numerous mills.

The river at Villefranche may be conducted to Romorantin, which may be done by the inhabitants; and the timber of which their houses are built may be carried in boats to Romorantin. The river may be dammed up at such a height that the waters may be brought back to Romorantin with a convenient fall.

As to whether it is better that the water should all be raised in a single turn or in two?

The answer is that in one single turn the wheel could not support all the water that it can raise in two turns, because at the half turn of the wheel it would be raising 100 pounds and no more; and if it had to raise the whole 200 pounds in one turn, it could not raise them unless the wheel were of double the diameter, and if the diameter were doubled, the time of its revolution would be doubled; therefore it is better and a greater advantage in expense to make such a wheel of half the size.

The going down of the hub of the wheel must not be so low as to touch the surface of the water, because by touching the water its momentum will be lessened. . . .

And if on the contrary the conduit for the water were ten times the size of the pipe for the water escaping from it, and if it had ten times less motion, what would be its office? This is answered by the 9th of this which says that the water would rise in the pipe whence it first flows, to a tenth part of its original height.

A trabocco is four braccia, and one mile is three thousand of the said braccia. Each braccio is divided into 12 inches; and the water in the canals has a fall in every hundred trabocchi of two of these inches; therefore 14 inches of fall are necessary in two thousand eight hundred braccia of flow in these canals; it follows that 15 inches of fall give the required momentum to the currents of the waters in the said canals, that is one braccio and a half in the mile. And from this it may be concluded that the water taken from the river

of Villefranche and lent to the river of Romorantin will . . .
Where one river by reason of its low level cannot flow into
the other, it will be necessary to dam it up, so that it may
acquire a fall into the other, which was previously the
higher.

The eve of Saint Antony I returned from Romorantin to
Amboise, and the King went away two days before from
Romorantin.

From Romorantin as far as the bridge at Saudre it is called
the Saudre, and from that bridge as far as Tours it is called
the Cher.

I would test the level of the channel which is to lead from
the Loire to Romorantin, with a channel one braccio wide
and one braccio deep.

*On movements—to know how much a ship advances in an
hour.* The ancients used various devices to ascertain the
distance gone by a ship each hour, among which Vitruvius
gives one in his work on Architecture which is just as falla-
cious as all the others; and this is a mill wheel which touches
the waves of the sea at one end and in each complete revolu-
tion describes a straight line which represents the circum-
ference of the wheel extended to a straightness. But this
invention is of no worth excepting on the smooth and
motionless surface of lakes. But if the water moves together
with the ship at an equal rate, then the wheel remains motion-
less; and if the motion of the water is more or less rapid
than that of the ship, then neither has the wheel the same
motion as the ship, so that this invention is of but little use.
There is another method tried by experiment with a known
distance between one island and another; and this is done by
a board under the pressure of wind which is more or less
oblique according as the wind strikes on it with more or less
swiftness. This is in Battista Alberti.

Greek fire. Take charcoal of willow, and saltpeter, and
sulphuric acid, and sulphur, and pitch, with frankincense and
camphor, and Ethiopian wool, and boil them all together.
This fire is so ready to burn that it clings to the timbers even
under water. And add to this composition liquid varnish, and
bituminous oil, and turpentine and strong vinegar, and mix
all together and dry it in the sun, or in an oven when the
bread is taken out; and then stick it round hempen or other

tow, molding it into a round form, and studding it all over with very sharp nails. You must leave in this ball an opening to serve as a fuse, and cover it with rosin and sulphur.

Again, this fire, stuck at the top of a long plank which has one braccio length of the end pointed with iron that it may not be burnt by the said fire, is good for avoiding and keeping off the ships, so as not to be overwhelmed by their onset.

Again, throw vessels of glass full of pitch on to the enemy's ships when the men in them are intent on the battle; and then by throwing similar burning balls upon them you have it in your power to burn all their ships.

Chapter 5

THE INVENTOR

Leonardo's whole personality, as we reconstruct it from his drawings, his notebooks, and what little we know of him from other sources, is a series of contradictions. "That superbly gifted technician," whose versatility alone would make him one of the greatest geniuses of all time, is represented in the index of the recent History of Technology *by a staggering number of references, yet, because his writings remained largely uncirculated, and were extremely difficult to decipher, he exerted little or no influence on subsequent generations of scientists. Uneducated, incapable of adequate expression in words of the ideas flashing through his extraordinary mind, his notes often incoherent and without conclusions, he still must be credited with an impressive number of inventions. Among them are a screw-cutting machine, a coin stamper, a pile driver, a windlass, a lathe, a reverberatory furnace, an automatic turnspit, a lens grinder and polisher, projection and refraction apparatus, a flyer spindle, nap-raising machine, cloth shearer, two types of cordage mills, a hodometer. He also invented a wheelbarrow, a flying machine, helicopter, and parachute, a parabolic compass not thought of by anyone else until two centuries later, suggested the flexible chain or sprocket drive, made improvement in machines having an axis drive (ball bearings), invented a three-legged stool, a hinge with spiral spring for shutting doors, secret or unpickable locks, rotating chimney tops for smoke pipes.*

Mint at Rome. It can also be made without a spring. But the screw above must always be joined to the part of the movable sheath.

All coins which do not have the rim complete are not to be accepted as good; and to secure the perfection of their rim it is requisite that, in the first place, all the coins should be a perfect circle; and to do this a coin must before all be made perfect in weight, and size, and thickness. Therefore have several plates of metal made of the same size and thickness, all drawn through the same gauge so as to come out in strips. And out of these strips you will stamp the coins, quite round, as sieves are made for sorting chestnuts; and these coins can then be stamped in the way indicated above; etc.

The hollow of the die must be uniformly wider above than below, but imperceptibly.

This cuts the coins perfectly round and of the exact thickness and weight; and saves the man who cuts and weighs, and the man who makes the coins round. Hence it passes only through the hands of the gauger and of the stamper, and the coins are very superior.

Powder for medals. The incombustible growth of soot on wicks reduced to powder, burnt tin and all the metals, alum, isinglass, smoke from a brass forge, each ingredient to be moistened, with brandy or malmsey, or strong malt vinegar, white wine or distilled extract of turpentine, or oil; but there should be little moisture, and cast in molds.

Small boats. The small boats used by the Assyrians were made of thin laths of willow plaited over rods also of willow, and bent into the form of a boat. They were daubed with fine mud soaked with oil or with turpentine, and reduced to a kind of mud which resisted the water and was not displaced by blows and always remained fresh; and they covered this sort of boat with the skins .of oxen in safely crossing the river Sicuris of Spain, as is reported by Lucan.

How an army ought to cross rivers by swimming with air bags. . . . How fishes swim; of the way in which they jump out of the water, as may be seen with dolphins; and it seems a wonderful thing to make a leap from a thing which does not resist but slips away. Of the swimming of animals of a long form, such as eels and the like. Of the mode of swimming against currents and in the rapid falls of rivers. Of the mode of swimming of fishes of a round form. How it is that animals which have not long hindquarters cannot swim. How it is that all other animals which have feet with toes, know by nature how to swim, excepting man. In what way man ought to learn to swim. Of the way in which man may rest

on the water. How man may protect himself against whirl-pools or eddies in the water, which drag him down. How a man dragged to the bottom must seek the reflux which will throw him up from the depths. How he ought to move his arms. How to swim on his back. How he can and how he cannot stay under water unless he can hold his breath. How by means of a certain machine many people may stay some time under water. How and why I do not describe my method of remaining under water, or how long I can stay without eating; and I do not publish nor divulge these by reason of the evil nature of men who would use them as means of destruction at the bottom of the sea, by sending ships to the bottom, and sinking them together with the men in them. And although I will impart others, there is no danger in them; because the mouth of the tube, by which you breathe, is above the water supported on bags or corks.

A method of escaping in a tempest and shipwreck at sea. Have a coat made of leather, which must be double across the breast, that is having a space between of about a finger breadth. Thus it will be double from the waist to the knee; and the leather must be quite airtight. When you want to leap into the sea, blow out the skirt of your coat through the double layers of the breast; and jump into the sea, and allow yourself to be carried by the waves; when you see no shore near, give your attention to the sea you are in, and always keep in your mouth the air tube which leads down into the coat; and if now and again you require to take a breath of fresh air, and the foam prevents you, you may draw a breath of the air within the coat.

Just as on a frozen river a man may run without moving his feet, so a car might be made that would slide by itself.

A definition as to why a man who slides on ice does not fall.

Man when flying must stand free from the waist upwards so as to be able to balance himself as he does in a boat so that the center of gravity in himself and in the machine may counterbalance each other, and be shifted as necessity demands for the changes of its center of resistance.

Remember that your flying machine must imitate no other than the bat, because the web is what by its union gives the armor or strength to the wings.

If you imitate the wings of feathered birds, you will find a much stronger structure, because they are perforated; that is, their feathers are separate and the air passes through them. But the bat is aided by the web that connects the whole and is not perforated.

To escape the peril of destruction. Destruction to such a machine may occur in two ways; of which the first is the breaking of the machine. The second would be when the machine should turn on its edge or nearly on its edge, because it ought always to descend in a highly oblique direction, and almost exactly balanced on its center. As regards the first— the breaking of the machine—that may be prevented by making it as strong as possible; and in whichever direction it may tend to turn over, one center must be very far from the other; that is, in a machine 30 braccia long the centers must be 4 braccia one from the other.

An object offers as much resistance to the air as the air does to the object. You may see that the beating of its wings against the air supports a heavy eagle in the highest and rarest atmosphere, close to the sphere of elemental fire. Again you may see the air in motion over the sea fill the swelling sails and drive heavily laden ships. From these instances, and the reasons given, a man with wings large enough and duly connected might learn to overcome the resistance of the air, and by conquering it, succeed in subjugating it and rising above it.

Chapter 6

THE ANATOMIST

Whatever his other scientific achievements, Leonardo's anatomical researches and the drawings in which he recorded them are unique. Two men, Leonardo the Florentine and Vesalius of Brussels, are the founders of modern anatomy. Vasari's statement that Leonardo was aided by the much younger Marc Antonio dalla Torre does not seem probable when dated drawings, indicating Leonardo's progress at a given point, are checked with the dates of dalla Torre's life.

Leonardo was fearless in his research, at a time when ecclesiastical and magical taboos still intimidated his contemporaries. In his anatomical dissections his often restated belief in the primary value of observation, and his willingness to repeat his dissections rather than content himself with one single example, establish his drawings as important scientific documents. From his use of Arabic terms we can deduce that he had read the early Arabic works on anatomy; he seems to have known Galen but not to have read him. He seems also to have been influenced by Avicenna and Mondino.

Despite many errors—such, for instance, as his drawing of the heart septum with pores which do not exist—the outstanding discoveries which must be credited to him include the inclination of the pelvis, the frontal and maxillary sinuses, the moderator band of the heart, the bronchial arteries, arterial sclerosis. He also rediscovered the thyroid gland and the unilocular structure of the uterus. All of these discoveries are recorded in drawings of extraordinary beauty and power. His researches in embryology and the entire process of reproduction were also remarkable, and years ahead of his time.

I wish to work miracles;—it may be that I shall possess less than other men of more peaceful lives, or than those who want to grow rich in a day. I may live for a long time in great poverty, as always happens, and to all eternity will happen, to alchemists, the would-be creators of gold and silver, and to engineers who would have dead water stir itself into life and perpetual motion, and to those supreme fools, the necromancer and the enchanter.

And you, who say that it would be better to watch an anatomist at work than to see these drawings, you would be right, if it were possible to observe all the things which are demonstrated in such drawings in a single figure, in which you, with all your cleverness, will not see or obtain knowledge of more than some few veins, to obtain a true and perfect knowledge of which I have dissected more than ten human bodies, destroying all the other members, and removing the very minutest particles of the flesh by which these veins are surrounded, without causing them to bleed, excepting the insensible bleeding of the capillary veins; and as one single body would not last so long, since it was necessary to proceed with several bodies by degrees, until I came to an end and had a complete knowledge; this I repeated twice, to learn the differences.

And if you should have a love for such things you might be prevented by loathing, and if that did not prevent you, you might be deterred by the fear of living in the night hours in the company of those corpses, quartered and flayed and horrible to see. And if this did not prevent you, perhaps you might not be able to draw so well as is necessary for such a demonstration; or, if you had the skill in drawing, it might not be combined with knowledge of perspective; and if it were so, you might not understand the methods of geometrical demonstration and the method of the calculation of forces and of the strength of the muscles; patience also may be wanting, so that you lack perseverance. As to whether all these things were found in me or not, the hundred and twenty books composed by me will give verdict Yes or No. In these I have been hindered neither by avarice nor negligence, but simply by want of time. Farewell.

Of the order of the book. This work must begin with the

conception of man, and describe the nature of the womb and how the fetus lives in it, up to what stage it resides there, and in what way it quickens into life and feeds. Also its growth and what interval there is between one stage of growth and another. What it is that forces it out from the body of the mother, and for what reasons it sometimes comes out of the mother's womb before the due time.

Then I will describe which are the members, which, after the boy is born, grow more than the others, and determine the proportions of a boy of one year.

Then describe the fully grown man and woman, with their proportions, and the nature of their complexions, color, and physiognomy.

Then how they are composed of veins, tendons, muscles, and bones. This I shall do at the end of the book. Then, in four drawings, represent four universal conditions of men. That is, mirth, with various acts of laughter, and describe the cause of laughter. Weeping in various aspects with its causes. Contention, with various acts of killing; flight, fear, ferocity, boldness, murder, and everything pertaining to such cases. Then represent labor, with pulling, thrusting, carrying, stopping, supporting, and such like things.

Further I would describe attitudes and movements. Then perspective, concerning the functions and effects of the eye; and of hearing—here I will speak of music; and treat of the other senses.

And then describe the nature of the 5 senses.

This mechanism of man we will demonstrate in . . . figures; of which the three first will show the ramification of the bones; that is: first one in front view to show their height and position and shape: the second will be seen in profile and will show the depth of the whole and of the parts, and their position. The third figure will be a demonstration of the bones of the back parts. Then I will make three other figures from the same point of view, with the bones sawn across, in which will be shown their thickness and hollowness. Three other figures of the bones complete, and of the nerves which rise from the nape of the neck, and in what limbs they ramify. And three others of the bones and veins, and where they ramify. Then three figures with the muscles and three with the skin, and their proper proportions; and three of woman, to illustrate the womb and the menstrual veins which go to the breasts.

The order of the book. This depicting of mine of the

human body will be as clear to you as if you had the natural man before you; and the reason is that if you wish thoroughly to know the parts of man, anatomically, you or your eye require to see it from different aspects, considering it from below and from above and from its sides, turning it about and seeking the origin of each member; and in this way the natural anatomy is sufficient for your comprehension. But you must understand that this amount of knowledge will not continue to satisfy you; seeing the very confusion that must result from the combination of tissues, with veins, arteries, nerves, sinews, muscles, bones, and blood which, of itself, tinges every part the same color. And the veins, which discharge this blood, are not discerned by reason of their smallness. Moreover, integrity of the tissues, in the process of the investigating the parts within them, is inevitably destroyed, and their transparent substance being tinged with blood does not allow you to recognize the parts covered by them, from the similarity of their blood-stained hue; and you cannot know everything of the one without confusing and destroying the other. Hence, some further anatomy drawings become necessary. Of which you want three to give full knowledge of the veins and arteries, everything else being destroyed with the greatest care. And three others to display the tissues; and three for the sinews and muscles and ligaments; and three for the bones and cartilages; and three for the anatomy of the bones, which have to be sawn to show which are hollow and which are not, which have marrow and which are spongy, and which are thick from the outside inwards, and which are thin. And some are extremely thin in some parts and thick in others, and in some parts hollow or filled up with bone, or full of marrow, or spongy. And all these conditions are sometimes found in one and the same bone, and in some bones none of them. And three you must have for the woman, in which there is much that is mysterious by reason of the womb and the fetus. Therefore by my drawings every part will be known to you, and all by means of demonstrations from three different points of view of each part; for when you have seen a limb from the front, with any muscles, sinews, or veins which take their rise from the opposite side, the same limb will be shown to you in a side view or from behind, exactly as if you had that same limb in your hand and were turning it from side to side until you had acquired a full comprehension of all you wished to know. In the same

way there will be put before you three or four demonstrations of each limb, from various points of view, so that you will be left with a true and complete knowledge of all you wish to learn of the human figure.

Thus, in fifteen entire figures, you will have set before you the cosmography of this lesser world on the same plan as, before me, was adopted by Ptolemy in his cosmography; and so I will afterwards divide them into limbs as he divided the whole world into provinces; then I will speak of the function of each part in every direction, putting before your eyes a description of the whole form and substance of man, as regards his movements from place to place, by means of his different parts. And thus, if it please our great Author, I may demonstrate the nature of men, and their customs in the way I describe his figure.

And remember that the anatomy of the nerves will not give the position of their ramifications, nor show you which muscles they branch into, by means of bodies dissected in running water or in lime water; though indeed their origin and starting point may be seen without such water as well as with it. But their ramifications, when under running water, cling and unite—just like flax or hemp carded for spinning—all into a skein, in a way which makes it impossible to trace in which muscles or by what ramification the nerves are distributed among those muscles.

Remember that to be certain of the point of origin of any muscle, you must pull the sinew from which the muscle springs in such a way as to see that muscle move, and where it is attached to the ligaments of the bones.

Which nerve causes the motion of the eye so that the motion of one eye moves the other?

Of frowning the brows, of raising the brows, of lowering the brows—of closing the eyes, of opening the eyes—of raising the nostrils, of opening the lips, with the teeth shut, of pouting with the lips, of smiling, of astonishment.

Describe the beginning of man when it is caused in the womb and why an eight months' child does not live. What sneezing is. What yawning is. Falling sickness, spasms, paralysis, shivering with cold, sweating, fatigue, hunger, sleepiness, thirst, lust.

Of the nerve which is the cause of movement from the shoulder to the elbow, of the movement from the elbow to the hand, from the joint of the hand to the springing of the fingers. From the springing of the fingers to the middle joints, and from the middle joints to the last.

Of the nerve which causes the movement of the thigh, and from the knee to the foot and from the joint of the foot to the toes and then to the middle of the toes and of the rotary motion of the leg.

Anatomy. Which nerves or sinews of the hand are those which close and part the fingers and toes laterally?

Make the rule and give the measurement of each muscle, and give the reasons of all their functions, and in which way they work and what makes them work, etc.

First draw the spine of the back; then clothe it by degrees, one after the other, with each of its muscles and put in the nerves and arteries and veins to each muscle by itself; and besides these note the vertebrae to which they are attached; which of the intestines come in contact with them; and which bones and other organs, etc.

The most prominent parts of lean people are most prominent in the muscular, and equally so in fat persons. But concerning the difference in the forms of the muscles in fat persons as compared with muscular persons, it shall be described below.

Describe which muscles disappear in growing fat, and which become visible in growing lean.

And observe that that part which on the surface of a fat person is most concave, when he grows lean becomes more prominent.

Where the muscles separate one from another you must give profiles and where they coalesce. . . .

Of the human figure. Which is the part in man, which, as he grows fatter, never gains flesh?

Or what part which as a man grows lean never falls away with a too perceptible diminution? And among the parts which grow fat which is that which grows fattest?

Among those which grow lean which is that which grows leanest?

In very strong men which are the muscles which are thickest and most prominent?

In your anatomy you must represent all the stages of the limbs from man's creation to his death, and then till the death of the bone; and which part of him is first decayed and which is preserved the longest.

And in the same way of extreme leanness and extreme fatness.

Anatomy. There are eleven elementary tissues: cartilage, bones, nerves, veins, arteries, fascia, ligament and sinews, skin, muscle, and fat.

Of the head. The divisions of the head are 10, viz., 5 external and 5 internal; the external are the hair, skin, muscle, fascia, and the skull; the internal are the dura mater, the pia mater, which enclose the brain. The pia mater and the dura mater come again underneath and enclose the brain; then the rete mirabile, and the occipital bone, which supports the brain from which the nerves spring.

Physiological problems. Of the cause of breathing, of the cause of the motion of the heart, of the cause of vomiting, of the cause of the descent of food from the stomach, of the cause of emptying the intestines.

Of the cause of the movement of the superfluous matter through the intestines.

Of the cause of swallowing, of the cause of coughing, of the cause of yawning, of the cause of sneezing, of the cause of limbs getting asleep.

Of the cause of losing sensibility in any limb.

Of the cause of tickling.

Of the cause of lust and other appetites of the body, of the cause of urine and also of all the natural excretions of the body.

The tears come from the heart and not from the brain.

Define all the parts of which the body is composed, beginning with the skin with its outer cuticle which is often chapped by the influence of the sun.

ZOOLOGY AND COMPARATIVE ANATOMY

Man. The description of man, which includes that of such creatures as are of almost the same species, as apes, monkeys, and the like, which are many.

The Lion and its kindred, as panthers, ounces, tigers, leopards, wolves, lynxes, Spanish cats, common cats, and the like.

The Horse and its kindred, as mule, ass, and the like, with incisor teeth above and below.

The Bull and its allies with horns and without upper incisors, as the buffalo, stag, fallow deer, roebuck, sheep, goat, wild goats, musk deer, chamois, giraffe.

If at night your eye is placed between the light and the eye of a cat, it will see the eye look like fire.

Of the nature of sight. I say that sight is exercised by all animals, by the medium of light; and if anyone adduces, as against this, the sight of nocturnal animals, I must say that this in the same way is subject to the very same natural laws. For it will easily be understood that the senses which receive the images of things do not project from themselves any visual virtue. On the contrary, the atmospheric medium which exists between the object and the sense incorporates in itself the figure of things, and by its contact with the sense transmits the object to it. If the object—whether by sound or by odor—presents its spiritual force to the ear or the nose, then light is not required and does not act. The forms of objects do not send their images into the air if they are not illuminated; and the eye being thus constituted cannot receive that from the air which the air does not possess, although it touches its surface. If you choose to say that there are many animals that prey at night, I answer that when the little light which suffices the nature of their eyes is wanting, they direct themselves by their strong sense of hearing and of smell, which are not impeded by the darkness, and in which they are very far superior to man. If you make a cat leap, by daylight, among a quantity of jars and crocks you will see them unbroken, but if you do the same at night, many will be broken. Night birds do not fly about unless the moon shines full or in part; rather do they feed between sundown and the total darkness of the night.

No body can be apprehended without light and shade, and light and shade are caused by light.

The Common Sense is that which judges of things offered to it by the other senses. The ancient speculators have concluded that that part of man which constitutes his judgment is caused by a central organ to which the other five senses refer everything by means of impressibility; and to this center they have given the name Common Sense. And they say that

this Sense is situated in the center of the head between Sensation and Memory. And this name of Common Sense is given to it solely because it is the common judge of all the other five senses, i.e., Seeing, Hearing, Touch, Taste, and Smell. This Common Sense is acted upon by means of Sensation, which is placed as a medium between it and the Senses. Sensation is acted upon by means of the images of things presented to it by the external instruments, that is to say, the senses which are the medium between external things and Sensation. In the same way the senses are acted upon by objects. Surrounding things transmit their images to the senses and the senses transfer them to the Sensation. Sensation sends them to the Common Sense, and by it they are stamped upon the memory and are there more or less retained according to the importance or force of the impression. That sense is most rapid in its function which is nearest to the sensitive medium, and the eye, being the highest, is the chief of the others. Of this then only we will speak, and the others we will leave in order not to make our matter too long. Experience tells us that the eye apprehends ten different natures of things, that is: light and darkness, one being the cause of the perception of the nine others, and the other its absence: color and substance, form and place, distance and nearness, motion and stillness.

Though human ingenuity may make various inventions which, by the help of various machines answering the same end, it will never devise any inventions more beautiful, nor more simple, nor more to the purpose, than Nature does; because in her inventions nothing is wanting, and nothing is superfluous, and she needs no counterpoise when she makes limbs proper for motion in the bodies of animals. But she puts into them the soul of the body, which forms them, that is, the soul of the mother which first constructs in the womb the form of the man and in due time awakens the soul that is to inhabit it. And this at first lies dormant and under the tutelage of the soul of the mother, who nourishes and vivifies it by the umbilical vein, with all its spiritual parts, and this happens because this umbilicus is joined to the placenta and the cotyledons by which the child is attached to the mother. And these are the reasons why a wish, a strong craving, or a fright or any other mental suffering, in the mother, has more influence on the child than on the mother; for there are many cases when the child loses its life from them, etc.

This discourse is not in its place here. but will be wanted

for the one on the composition of animated bodies—and the rest of the definition of the soul I leave to the imaginations of friars, those fathers of the people who know all secrets by inspiration.

I leave alone the sacred books, for they are supreme truth.

How the nerves sometimes act of themselves without any commands from the other functions of the soul. This is most plainly seen; for you will see palsied and shivering persons move, and their trembling limbs, as their head and hands, quake without leave from their soul, and their soul with all its power cannot prevent their members from trembling. The same thing happens in falling sickness, or in parts that have been cut off, as in the tails of lizards. The idea or imagination is the helm and guiding rein of the senses, because the thing conceived of moves the sense. Pre-imagining is imagining the things that are to be. Post-imagining is imagining the things that are past.

How the body of animals is constantly dying and being renewed. The body of anything whatever that takes nourishment constantly dies and is constantly renewed; because nourishment can only enter into places where the former nourishment has expired, and if it has expired it no longer has life. And if you do not supply nourishment equal to the nourishment which is gone, life will fail in vigor, and if you take away this nourishment, the life is entirely destroyed. But if you restore as much as is destroyed day by day, then as much of the life is renewed as is consumed, just as the flame of the candle is fed by the nourishment afforded by the liquid of this candle, which flame continually with a rapid supply restores to it from below as much as is consumed in dying above: and from a brilliant light is converted in dying into murky smoke; and this death is continuous, as the smoke is continuous; and the continuance of the smoke is equal to the continuance of the nourishment, and in the same instant all the flame is dead and all regenerated, simultaneously with the movement of its own nourishment.

The waters return with constant motion from the lowest depths of the sea to the utmost height of the mountains, not obeying the nature of heavier bodies; and in this they resemble

the blood of animated beings which always moves from the sea of the heart and flows towards the top of the head; and here it may burst a vein, as may be seen when a vein bursts in the nose; all the blood rises from below to the level of the burst vein. When the water rushes out from the burst vein in the earth, it obeys the law of other bodies that are heavier than the air, since it always seeks low places.

Chapter 7

THE NATURALIST

Never in any other man, it is safe to say, has the painter's eye and the scientist's eye been so synthesized. Each interest, in Leonardo, fed the other, and yet we find his insatiable and all-touching curiosity both challenging and nourishing his desire for beauty. So complete is the dual nature of his thought that it is frequently hard to decide whether a given set of notes is a memorandum for the painter or the naturalist.

Leonardo records the first intimations of understanding the principle known as phyllotaxis (arrangement of leaves on a stem), the measurement of a tree's age by the concentric rings in the trunk; he observed the phenomenon of positive heliotropism and positive and negative geotropism, and noted sexual differentiation in plants. His drawings are miracles not only of close, sensitive botanical observation but of great beauty.

Mineralogy and geology also fascinated him endlessly, and his mind leaped ahead of contemporary thought to embrace conceptions of evolution which would be hard for most men to accept centuries later.

His study of human anatomy led him to painstaking dissections of animals as well, for purposes of comparison; he minutely observed and recorded the flight of birds, the construction of their wings and all the factors involved in flight, contrasting and comparing that of insects and bats.

No matter what manifestation of nature he drew, the genius of the draftsman whose first concern was form ended by expressing the whole principle of growth and force which

his brilliant scientist's mind grasped, in sketches which have never been surpassed and may still be studied with profit today.

There is to be seen, in the mountains of Parma and Piacenza, a multitude of shells and corals full of holes, still sticking to the rocks, and when I was at work on the great horse for Milan a large sackful of them which were found thereabout was brought to me into my workshop, by certain peasants.

Describe the tongue of the woodpecker and the jaw of the crocodile.

Of the flight of the 4th kind of butterflies that consume winged ants. Of the three principal positions of the wings of birds in downward flight.

Of the way in which the tail of a fish acts in propelling the fish; as in the eel, snake, and leech.

Of the palm of the hand. Then I will discourse of the hands of each animal to show in what they vary; as in the bear, which has the ligatures of the sinews of the toes joined above the instep.

A second demonstration inserted between anatomy and the treatise on the living being.

You will represent here for a comparison the legs of a frog, which have a great resemblance to the legs of man, both in the bones and in the muscles. Then, in continuation, the hind legs of the hare, which are very muscular, with strong active muscles, because they are not encumbered with fat.

Here I make a note to demonstrate the difference there is between man and the horse and in the same way with other animals. And first I will begin with the bones, and then will go on to all the muscles which spring from the bones without tendons and end in them in the same way, and then go on to those which start with a single tendon at one end.

Note on the bendings of joints and in what way the flesh grows upon them in their flexions or extensions; and of this most important study write a separate treatise: in the description of the movements of animals with four feet; among which is man, who likewise in his infancy crawls on all fours.

Of the way of walking in man. The walking of man is always after the universal manner of walking in animals with

4 legs, inasmuch as just as they move their feet crosswise after the manner of a horse in trotting, so man moves his 4 limbs crosswise; that is, if he puts forward his right foot in walking he puts forward, with it, his left arm and vice versa, invariably.

PHYSIOLOGY

I have found that in the composition of the human body as compared with the bodies of animals the organs of sense are duller and coarser. Thus it is composed of less ingenious instruments, and of spaces less capacious for receiving the faculties of sense. I have seen in the lion tribe that the sense of smell is connected with part of the substance of the brain which comes down the nostrils, which form a spacious receptacle for the sense of smell, which enters by a great number of cartilaginous vesicles with several passages leading up to where the brain, as before said, comes down.

The eyes in the lion tribe have a large part of the head for their sockets and the optic nerves communicate at once with the brain; but the contrary is to be seen in man, for the sockets of the eyes are but a small part of the head, and the optic nerves are very fine and long and weak, and by the weakness of their action we see by day but badly at night, while these animals can see as well at night as by day. The proof that they can see is that they prowl for prey at night and sleep by day, as nocturnal birds do also.

Of the eyes in animals. The eyes of all animals have their pupils adapted to dilate and diminish of their own accord in proportion to the greater or less light of the sun or other luminary. But in birds the variation is much greater; and particularly in nocturnal birds, such as horned owls, and in the eyes of one species of owl; in these the pupil dilates in such a way as to occupy nearly the whole eye, or diminishes to the size of a grain of millet, and always preserves the circular form. But in the lion tribe, as panthers, pards, ounces, tigers, lynxes, Spanish cats, and other similar animals, the pupil diminishes from the perfect circle to the figure of a pointed oval such as is shown in the margin. But man having a weaker sight than any other animal is less hurt by a very strong light and his pupil increases but little in dark places; but in the eyes of these nocturnal animals, the horned owl—a bird which

is the largest of all nocturnal birds—the power of vision increases so much that in the faintest nocturnal light (which we call darkness) it sees with much more distinctness than we do in the splendor of noonday, at which time these birds remain hidden in dark holes; or if indeed they are compelled to come out into the open air lighted up by the sun, they contract their pupils so much that their power of sight diminishes together with the quantity of light admitted.

Study the anatomy of various eyes and see which are the muscles which open and close the said pupils of the eyes of animals.

THE EARTH AS A PLANET

The equator, the line of the horizon, ecliptic, the meridian: These lines are those which in all their parts are equidistant from the center of the globe.

The earth is not in the center of the sun's orbit nor at the center of the universe, but in the center of its companion elements, and united with them. And anyone standing on the moon, when it and the sun are both beneath us, would see this our earth and the element of water upon it just as we see the moon, and the earth would light it as it lights us.

Force arises from dearth or abundance; it is the child of physical motion, and the grandchild of spiritual motion, and the mother and origin of gravity. Gravity is limited to the elements of water and earth; but his force is unlimited, and by it infinite worlds might be moved if instruments could be made by which the force be generated.

Force, with physical motion, and gravity, with resistance, are the four external powers on which all actions of mortals depend.

Force has its origin in spiritual motion; and this motion, flowing through the limbs of sentient animals, enlarges their muscles. Being enlarged by this current the muscles are shrunk in length and contract the tendons which are connected with them, and this is the cause of the force of the limbs in man.

The quality and quantity of the force of a man are able to give birth to other forces, which will be proportionally greater as the motions produced by them last longer.

Supposing the earth at our antipodes which supports the ocean were to rise and stand uncovered, far out of the sea,

but remaining almost level, by what means afterwards, in the course of time, would mountains and valleys be formed?

And the rocks with their various strata?

Mem: That I must first show the distance of the sun from the earth; and, by means of a ray passing through a small hole into a dark chamber, detect its real size; and besides this, by means of the aqueous sphere calculate the size of the globe. . . .

Here it will be shown that when the sun is in the meridian of our hemisphere, the antipodes to the east and to the west, alike, and at the same time, see the sun mirrored in their waters; and the same is equally true of the arctic and antarctic poles, if indeed they are inhabited.

In your discourse you must prove that the earth is a star much like the moon, and the glory of our universe; and then you must treat of the size of various stars, according to the authors.

In praise of the sun. If you look at the stars, cutting off the rays (as may be done by looking through a very small hole made with the extreme point of a very fine needle, placed so as almost to touch the eye), you will see those stars so minute that it would seem as though nothing could be smaller; it is in fact their great distance which is the reason of their diminution, for many of them are very many times larger than the star which is the earth with the water. Now reflect what this our star must look like at such a distance, and then consider how many stars might be added—both in longitude and latitude—between those stars which are scattered over the darkened sky. But I cannot forbear to condemn many of the ancients, who said that the sun was no larger than it appears; among these was Epicurus, and I believe that he founded his reason on the effects of a light placed in our atmosphere equidistant from the center of the earth. Anyone looking at it never sees it diminished in size at whatever distance; and the reasons of its size and power I shall reserve for Book 4. But I wonder greatly that Socrates should have depreciated that solar body, saying that it was of the nature of incandescent stone, and the one who opposed him as to that error was not far wrong. But I only wish I had words to serve me to blame those who are fain to extol the worship of men more than that of the sun; for in the whole universe there is nowhere to be seen a body of greater magnitude and power

than the sun. Its light gives light to all the celestial bodies which are distributed throughout the universe; and from it descends all vital force, for the heat that is in living beings comes from the soul [vital spark]; and there is no other center of heat and light in the universe, as will be shown in Book 4; and certainly those who have chosen to worship men as gods —as Jove, Saturn, Mars, and the like—have fallen into the gravest error, seeing that even if a man were as large as our earth, he would look no bigger than a little star which appears but as a speck in the universe; and seeing again that these men are mortal, and putrid and corrupt in their sepulchers.

The *Spera* and Marullus and many others praise the sun.

In my book I propose to show how the ocean and the other seas must, by means of the sun, make our world shine with the appearance of a moon, and to the remoter worlds it looks like a star; and this I shall prove.

Show first that every light at a distance from the eye throws out rays which appear to increase the size of the luminous body; and from this it follows that 2 . . .

The moon is cold and moist. Water is cold and moist. Thus our seas must appear to the moon as the moon does to us.

Of the moon and whether it is polished and spherical. The image of the sun in the moon is powerfully luminous, and is only on a small portion of its surface. And the proof may be seen by taking a ball of burnished gold and placing it in the dark with a light at some distance from it; and then, although it will illuminate about half of the ball, the eye will perceive its reflection only in a small part of its surface, and all the rest of the surface reflects the darkness which surrounds it; so that it is only in that spot that the image of the light is seen, and all the rest remains invisible, the eye being at a distance from the ball. The same thing would happen on the surface of the moon if it were polished, lustrous, and opaque, like all bodies with a reflecting surface.

Show how, if you were standing on the moon or on a star, our earth would seem to reflect the sun as the moon does.

And show that the image of the sun in the sea cannot appear one and undivided, as it appears in a perfectly plane mirror.

How shadows are lost at great distances, as is shown by the shadow side of the moon which is never seen.

Of the moon. The moon has no light in itself; but so much

of it as faces the sun is illuminated, and of that illumined portion we see so much as faces the earth. And the moon's night receives just as much light as is lent it by our waters as they reflect the image of the sun, which is mirrored in all those waters which are on the side towards the sun. The outside or surface of the waters forming the seas of the moon and the seas of our globe is always ruffled little or much, or more or less—and this roughness causes an extension of the numberless images of the sun which are repeated in the ridges and hollows, the sides and fronts, of the innumerable waves; that is to say, in as many different spots on each wave as our eyes find different positions to view them from. This could not happen if the aqueous sphere which covers a great part of the moon were uniformly spherical, for then the images of the sun would be one to each spectator, and its reflections would be separate and independent and its radiance would always appear circular; as is plainly to be seen in the gilt balls placed on the tops of high buildings. But if those gilt balls were rugged or composed of several little balls, like mulberries, which are a black fruit composed of minute round globules, then each portion of these little balls, when seen in the sun, would display to the eye the luster resulting from the reflection of the sun, and thus in one and the same body many tiny suns would be seen; and these often combine at a long distance and appear as one. The luster of the new moon is brighter and stronger than when the moon is full; and the reason of this is that the angle of incidence is more obtuse in the new than in the full moon, in which the angles of incidence and reflection are highly acute. The waves of the moon therefore mirror the sun in the hollows of the waves as well as on the ridges, and the sides remain in shadow. But at the sides of the moon the hollows of the waves do not catch the sunlight, but only their crests; and thus the images are fewer and more mixed up with the shadows in the hollows; and this intermingling of the shaded and illuminated spots comes to the eye with a mitigated splendor, so that the edges will be darker, because the curves of the sides of the waves are insufficient to reflect to the eye the rays that fall upon them. Now the new moon naturally reflects the solar rays more directly towards the eye from the crests of the waves than from any other part, as is shown by the form of the moon, whose rays *a* strike the waves *b* and are reflected in the line *b d*, the eye being situated at *d*. This cannot happen at the full moon, when the solar rays, being in

the west, fall on the extreme waters of the moon to the east from *n* to *m,* and are not reflected to the eye in the west, but are thrown back eastwards, with but slight deflection from the straight course of the solar ray; and thus the angle of incidence is very wide indeed.

The moon is an opaque and solid body and if, on the contrary, it were transparent, it would not receive the light of the sun.

The yellow or yolk of an egg remains in the middle of the albumen, without moving on either side; now it is either lighter or heavier than this albumen, or equal to it; if it is lighter, it ought to rise above all the albumen and stop in contact with the shell of the egg; and if it is heavier, it ought to sink, and if it is equal, it might just as well be at one of the ends, as in the middle or below.

The innumerable images of the solar rays reflected from the innumerable waves of the sea, as they fall upon those waves, are what cause us to see the very broad and continuous radiance on the surface of the sea.

The spots on the moon. Some have said that vapors rise from the moon, after the manner of clouds, and are interposed between the moon and our eyes. But, if this were the case, these spots would never be permanent, either as to position or form; and, seeing the moon from various aspects, even if these spots did not move they would change in form, as objects do which are seen from different sides.

Of the spots on the moon. Others say that the moon is composed of more or less transparent parts; as though one part were something like alabaster and others like crystal or glass. It would follow from this that the sun casting its rays on the less transparent portions, the light would remain on the surface, and so the denser part would be illuminated, and the transparent portions would display the shadow of their darker depths; and this is their account of the structure and nature of the moon. And this opinion has found favor with many philosophers, and particularly with Aristotle, and yet it is a false view—for, in the various phases and frequent changes of the moon and sun to our eyes, we should see these spots vary, at one time looking dark and at another light: they would be dark when the sun is in the west and the moon in the middle of the sky; for then the transparent hollows would be in shadow as far as the tops of the edges of those transparent hollows, because the sun could not then fling his rays into the mouth of the hollows, which, however, at

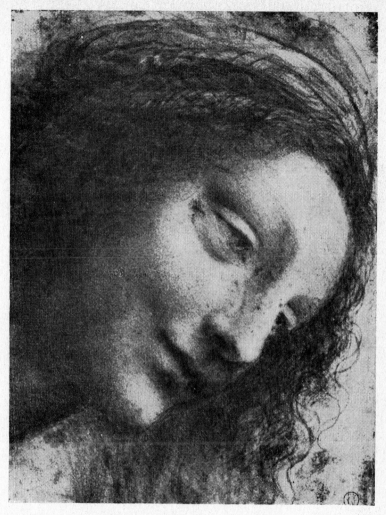

1. Head of the Virgin. Metropolitan Museum, New York.
Courtesy of the Metropolitan Museum of Art, Dick Fund, 1951

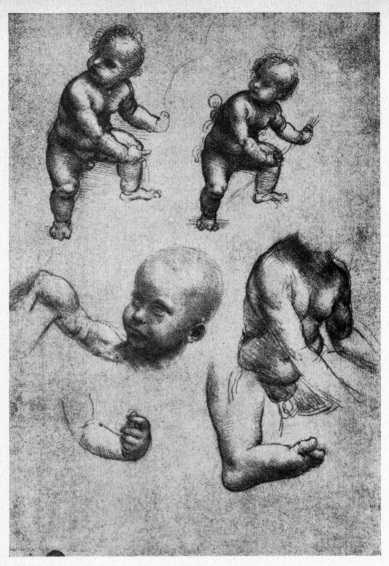

2. Study for the *Holy Family* in the Louvre. Academy, Venice.
Alinari

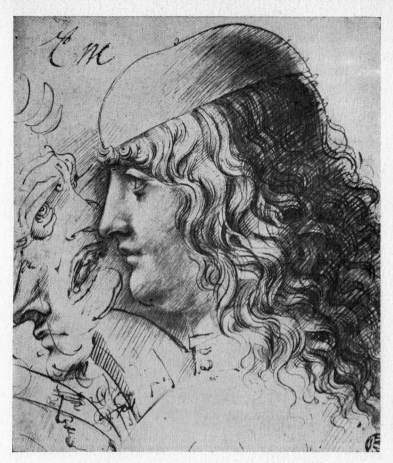

3. Profile of a youth. Louvre, Paris. *Alinari*

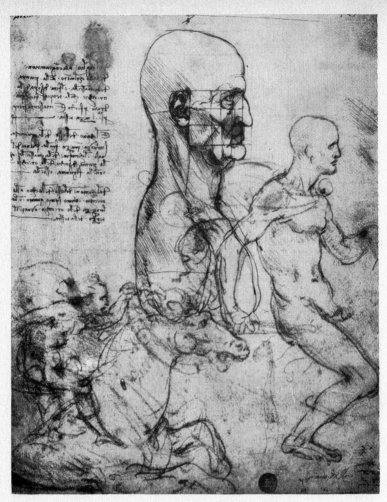

4. Studies for the *Battle of Anghiari*. Academy, Venice. *Alinari*

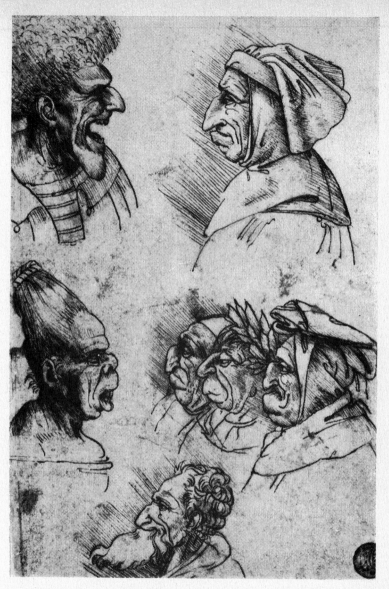

5. Caricature studies of heads. Academy, Venice. *Alinari*

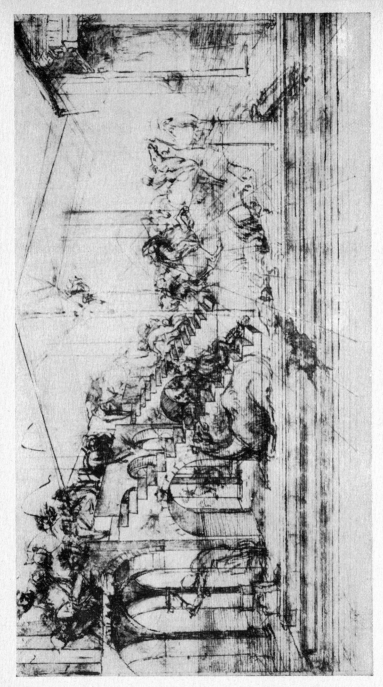

6. Perspective study for *Adoration of the Magi*. Uffizi, Florence. *Alinari*

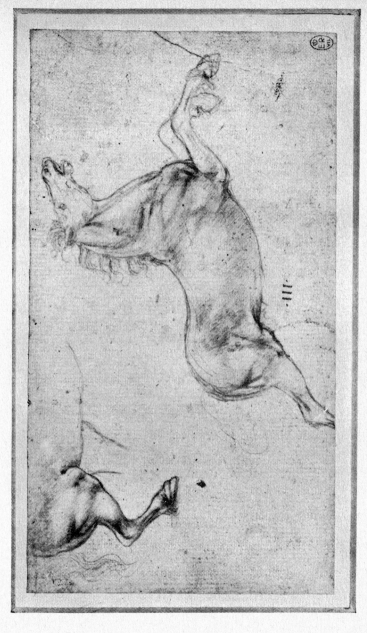

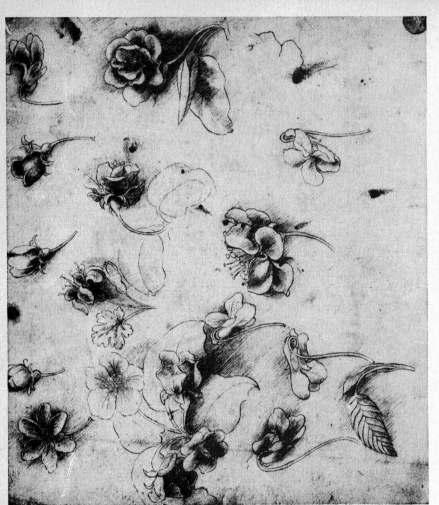

8. Flower studies. Academy, Venice. *Alinari*

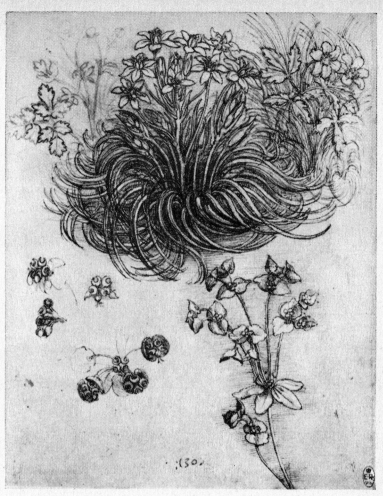

9. Star of Bethlehem and other plants. Royal Collection,
Windsor Castle, copyright reserved

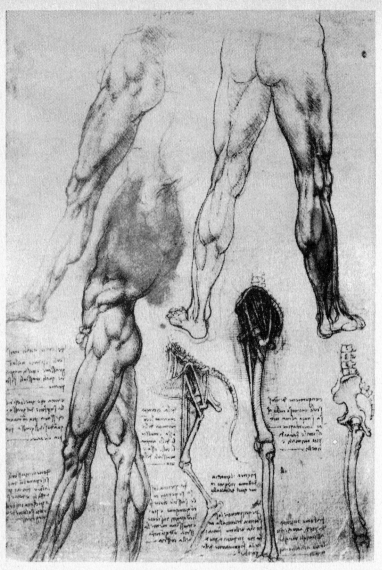

10. Anatomical studies. Royal Collection, Windsor Castle,
copyright reserved

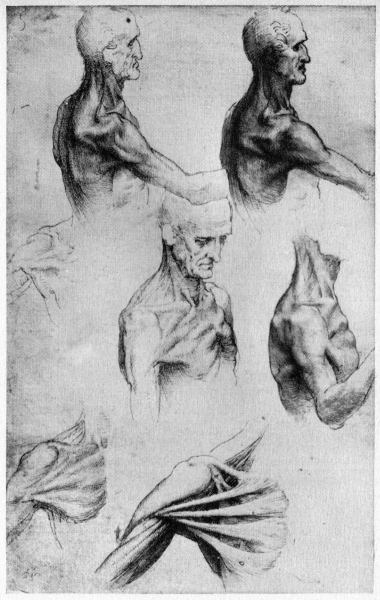

11. Anatomical studies. Royal Collection, Windsor Castle,
copyright reserved

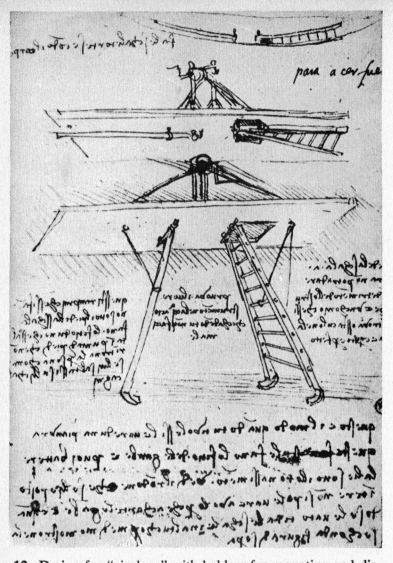

12. Design for "airplane" with ladders for mounting and dismounting. Ms. D, Institut de France, Paris

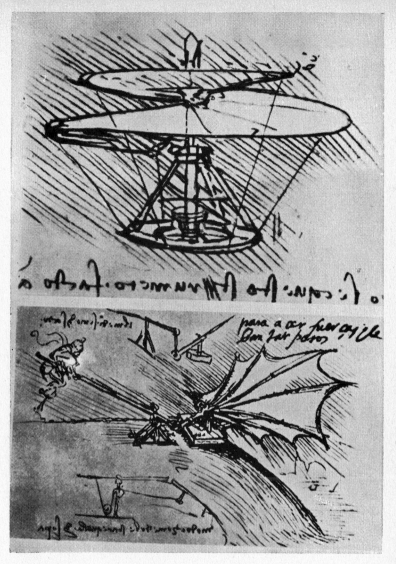

13. Sketch for helicopter, study of lifting power of a wing.
Ms. B, Institut de France, Paris

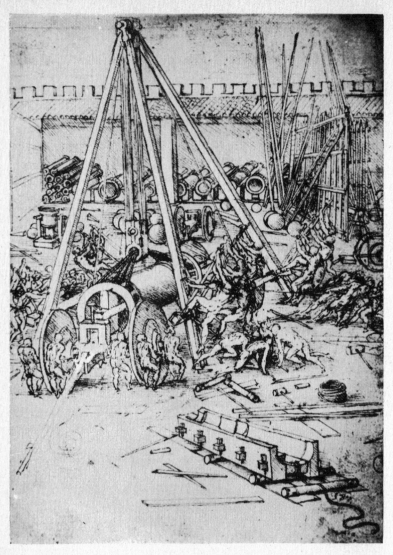

14. Machine for drawing cannon staves. Codex Atlantico,
Ambrosian Library, Milan

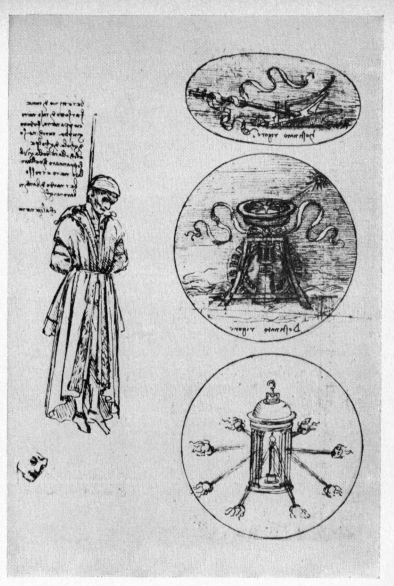

15. Sketch of the hanged Pazzi conspirator, with notes on his dress. Bonnat Collection, Bayonne

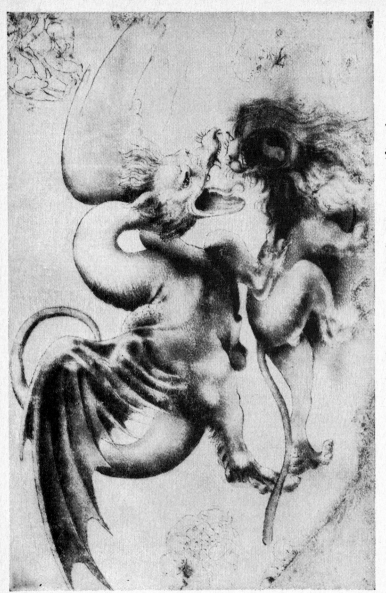

16. Dragon attacking a lion. Uffizi. Florence. *Alinari*

full moon, would be seen in bright light, at which time the moon is in the east and faces the sun in the west; then the sun would illuminate even the lowest depths of these transparent places and thus, as there would be no shadows cast, the moon at these times would not show us the spots in question; and so it would be, now more and now less, according to the changes in the position of the sun to the moon, and of the moon to our eyes, as I have said above.

If you keep the details of the spots of the moon under observation you will often find great variation in them, and this I myself have proved by drawing them. And this is caused by the clouds that rise from the waters in the moon, which come between the sun and those waters, and by their shadow deprive these waters of the sun's rays. Thus those waters remain dark, not being able to reflect the solar body.

How the spots on the moon must have varied from what they formerly were, by reason of the course of its waters.

Of halos round the moon. I have found that the circles which at night seem to surround the moon, of various sizes and degrees of density, are caused by various gradations in the densities of the vapors which exist at different altitudes between the moon and our eyes. And of these halos the largest and least red is caused by the lowest of these vapors; the second, smaller one, is higher up, and looks redder because it is seen through two vapors. And so on, as they are higher they will appear smaller and redder, because, between the eye and them, there is thicker vapor. Whence it is proved that where they are seen to be reddest, the vapors are most dense.

If you want to prove why the moon appears larger than it is when it reaches the horizon, take a lens which is highly convex on one surface and concave on the opposite, and place the concave side next the eye, and look at the object beyond the convex surface; by this means you will have produced an exact imitation of the atmosphere included beneath the sphere of fire and outside that of water; for this atmosphere is concave on the side next the earth, and convex towards the fire.

Construct glasses to see the moon magnified.

THE STARS

The stars are visible by night and not by day, because we are beneath the dense atmosphere, which is full of innumerable particles of moisture, each of which independently, when

the rays of the sun fall upon it, reflects a radiance, and so these numberless bright particles conceal the stars; and if it were not for this atmosphere the sky would always display the stars against its darkness.

Whether the stars have their light from the sun or in themselves. Some say that they shine of themselves, alleging that if Venus and Mercury had not a light of their own, when they come between our eye and the sun they would darken so much of the sun as they could cover from our eye. But this is false, for it is proved that a dark object against a luminous body is enveloped and entirely concealed by the lateral rays of the rest of that luminous body and so remains invisible. As may be seen when the sun is seen through the boughs of trees bare of their leaves, at some distance the branches do not conceal any portion of the sun from our eye. The same thing happens with the above-mentioned planets, which, though they have no light of their own, do not—as has been said—conceal any part of the sun from our eye.

WATER

These books contain in the beginning: Of the nature of water itself in its motions; the others treat of the effects of its currents, which change the world in its center and its shape.

Divisions of the book
Book 1 of water in itself.
Book 2 of the sea.
Book 3 of subterranean rivers.
Book 4 of rivers.
Book 5 of the nature of the abyss.
Book 6 of the obstacles.
Book 7 of gravels.
Book 8 of the surface of water.
Book 9 of the things placed therein.
Book 10 of the repairing of rivers.
Book 11 of conduits.
Book 12 of canals.
Book 13 of machines turned by water.
Book 14 of raising water.
Book 15 of matters worn away by water.

First you shall make a book treating of places occupied by fresh waters, and the second by salt waters, and the third,

how by the disappearance of these, our parts of the world were made lighter and in consequence more remote from the center of the world.

First write of all water, in each of its motions; then describe all its bottoms and their various materials, always referring to the propositions concerning the said waters; and let the order be good, for otherwise the work will be confused.

Describe all the forms taken by water from its greatest to its smallest wave, and their causes.

Book 9, of accidental risings of water.

A book of the ordering of rivers so as to preserve their banks.

A book of the mountains, which would level down and become land, if our hemisphere were to be uncovered by the water.

A book of the earth carried down by the waters to fill up the great abyss of the seas.

A book of the ways in which a tempest may of itself clear out filled-up seaports.

A book of the shores of rivers and of their permanency.

A book of how to deal with rivers, so that they may keep their bottom scoured by their own flow near the cities they pass.

A book of how to make or to repair the foundations for bridges over the rivers.

A book of the repairs which ought to be made in walls and banks of rivers where the water strikes them.

A book of the formation of hills of sand or gravel at great depths in water.

Water gives the first impetus to its motion.

A book of the leveling of waters by various means.

A book of diverting rivers from places where they do mischief.

A book of guiding rivers which occupy too much ground.

A book of parting rivers into several branches and making them fordable.

A book of the waters which with various currents pass through seas.

A book of deepening the beds of rivers by means of currents of water.

A book of controlling rivers so that the little beginnings of mischief, caused by them, may not increase.

A book of the various movements of waters passing through channels of different forms.

A book of preventing small rivers from diverting the larger one into which their waters run.

A book of the lowest level which can be found in the current of the surface of rivers.

Proves how the earth is not globular, and, not being globular, cannot have a common center. We see the Nile come from southern regions and traverse various provinces, running towards the north for a distance of 3,000 miles, and flow into the Mediterranean by the shores of Egypt; and if we will give to this a fall of ten braccia a mile, as is usually allowed to the course of rivers in general, we shall find that the Nile must have its mouth ten miles lower than its source. Again, we see the Rhine, the Rhone, and the Danube starting from the German parts, almost the center of Europe, and having a course one to the east, the other to the north, and the last to southern seas. And if you consider all this you will see that the plains of Europe in their aggregate are much higher than the high peaks of the maritime mountains; think then how much their tops must be above the seashores.

THE OCEAN

Of certain persons who say the waters were higher than the dry land. Certainly I wonder not a little at the common opinion, which is contrary to truth but held by the universal consent of the judgment of men. And this is that all are agreed that the surface of the sea is higher than the highest peaks of the mountains; and they allege many vain and childish reasons, against which I will allege only one simple and short reason: We see plainly that if we could remove the shores of the sea, it would invest the whole earth and make it a perfect sphere. Now, consider how much earth would be carried away to enable the waves of the sea to cover the world; therefore that which would be carried away must be higher than the seashore.

Why water is salt. Pliny says in his second book, chapter 103, that the water of the sea is salt because the heat of the sun dries up the moisture and drinks it up; and this gives to the wide stretching sea the savor of salt. But this cannot be admitted, because if the saltness of the sea were caused by the

heat of the sun, there can be no doubt that lakes, pools, and marshes would be so much the more salt, as their waters have less motion and are of less depth; but experience shows us, on the contrary, that these lakes have their waters quite free from salt. Again it is stated by Pliny in the same chapter that this saltness might originate because all the sweet and subtle portions which the heat attracts easily being taken away, the more bitter and coarser part will remain, and thus the water on the surface is fresher than at the bottom; but this is contradicted by the same reason given above, which is, that the same thing would happen in marshes and other waters which are dried up by the heat. Again, it has been said that the saltness of the sea is the sweat of the earth; to this it may be answered that all the springs of water which penetrate through the earth would then be salt. But the conclusion is, that the saltness of the sea must proceed from the many springs of water which, as they penetrate into the earth, find mines of salt and these they dissolve in part, and carry with them to the ocean and the other seas, whence the clouds, the begetters of rivers, never carry it up. And the sea would be salter in our times than ever it was at any time; and if the adversary were to say that in infinite time the sea would dry up or congeal into salt, to this I answer that this salt is restored to the earth by the setting free of that part of the earth which rises out of the sea with the salt it has acquired, and the rivers return it to the earth under the sea.

For the third and last reason we will say that salt is in all created things; and this we learn from water passed over the ashes and cinders of burnt things; and the urine of every animal, and the superfluities issuing from their bodies, and the earth into which all things are converted by corruption.

But—to put it better—given that the world is everlasting, it must be admitted that its population will also be eternal; hence the human species has eternally been and would be consumers of salt; and if all the mass of the earth were to be turned into salt, it would not suffice for all human food; whence we are forced to admit, either that the species of salt must be everlasting like the world, or that it dies and is born again like the men who devour it. But as experience teaches us that it does not die, as is evident by fire, which does not consume it, and by water which becomes salt in proportion to the quantity dissolved in it—and when it is evaporated the salt always remains in the original quantity—it must pass through the bodies of men either in the urine or the

sweat or other excretions where it is found again; and as much salt is thus got rid of as is carried every year into towns; therefore salt is dug in places where there is urine. —Sea hogs and sea winds are salt.

We will say that the rains which penetrate the earth are what is under the foundations of cities with their inhabitants, and are what restore through the internal passages of the earth the saltness taken from the sea; and that the change in the place of the sea, which had been over all the mountains, caused it to be left there in the mines found in those mountains, etc.

The waters of the salt sea are fresh at the greatest depths.

That the shores of the sea constantly acquire more soil towards the middle of the sea; that the rocks and promontories of the sea are constantly being ruined and worn away; that the Mediterranean seas will in time discover their bottom to the air, and all that will be left will be the channel of the greatest river that enters it; and this will run to the ocean and pour its waters into that with those of all the rivers that are its tributaries.

How the river Po in a short time might dry up the Adriatic Sea in the same way as it has dried up a large part of Lombardy.

Where there is a larger quantity of water, there is a greater flow and ebb, but the contrary in narrow waters.

Look whether the sea is at its greatest flow when the moon is halfway over our hemisphere [on the meridian].

Whether the flow and ebb are caused by the moon or sun, or are the breathing of this terrestrial machine. That the flow and ebb are different in different countries and seas.

Book 9 of the meeting of rivers and their flow and ebb. The cause is the same in the sea, where it is caused by the Strait of Gibraltar. And again it is caused by whirlpools.

That the flow and ebb are not general; for on the shore at Genoa there is none, at Venice two braccia, between England and Flanders 18 braccia. That in the straits of Sicily the current is very strong because all the waters from the rivers that flow into the Adriatic pass there.

In the West, near to Flanders, the sea rises and decreases every 6 hours about 20 braccia, and 22 when the moon is in its favor; but 20 braccia is the general rule, and this rule, as

it is evident, cannot have the moon for its cause. This variation in the increase of the sea every 6 hours may arise from the damming up of the waters, which are poured into the Mediterranean by the quantity of rivers from Africa, Asia, and Europe, which flow into that sea, and the waters which are given to it by those rivers; it pours them to the ocean through the Strait of Gibraltar, between Abila and Calpe. That ocean extends to the island of England and others farther north, and it becomes dammed up and kept high in various gulfs. These, being seas of which the surface is remote from the center of the earth, have acquired a weight, which as it is greater than the force of the incoming waters which cause it, gives this water an impetus in the contrary direction to that in which it came and it is borne back to meet the waters coming out of the straits; and this it does most against the Strait of Gibraltar; these, so long as this goes on, remain dammed up and all the water which is poured out meanwhile by the aforementioned rivers is pent up in the Mediterranean; and this might be assigned as the cause of its flow and ebb, as is shown in the 21st of the 4th of my theory.

SUBTERRANEAN WATER COURSES

Very large rivers flow underground.

In confirmation of why the water goes to the tops of mountains. I say that just as the natural heat of the blood in the veins keeps it in the head of man—for when the man is dead the cold blood sinks to the lower parts—and when the sun is hot on the head of a man the blood increases and rises so much, with other humors, that by pressure in the veins pains in the head are often caused; in the same way veins ramify through the body of the earth, and by the natural heat which is distributed throughout the containing body, the water is raised through the veins to the tops of mountains. And this water, which passes through a closed conduit inside the body of the mountain like a dead thing, cannot come forth from its low place unless it is warmed by the vital heat of the first vein. Again, the heat of the element of fire and, by day, the heat of the sun, have power to draw forth the moisture of the low parts of the mountains and to draw them up in the same way as it draws the clouds and collects their moisture from the bed of the sea.

That many springs of salt water are found at great distances from the sea; this might happen because such springs pass through some mine of salt, like that in Hungary where salt is hewn out of vast caverns, just as stone is hewn.

OF RIVERS

Of the origin of rivers. The body of the earth, like the bodies of animals, is intersected with ramifications of waters which are all in connection and are constituted to give nutriment and life to the earth and to its creatures. These come from the depth of the sea and, after many revolutions, have to return to it by the rivers created by the bursting of these springs; and if you choose to say that the rains of the winter or the melting of the snows in summer were the cause of the birth of rivers, I could mention the rivers which originate in the torrid countries of Africa, where it never rains—and still less snows—because the intense heat always melts into air all the clouds which are borne thither by the winds. And if you chose to say that such rivers as increase in July and August come from the snows which melt in May and June from the sun's approach to the snows on the mountains of Scythia, and that such meltings come down into certain valleys and form lakes, into which they enter by springs and subterranean caves to issue forth again at the sources of the Nile, this is false; because Scythia is lower than the sources of the Nile, and, besides, Scythia is only 400 miles from the Black Sea and the sources of the Nile are 3,000 miles distant from the sea of Egypt into which its waters flow.

GEOLOGICAL PROBLEMS

A doubtful point. Here a doubt arises, and that is: whether the deluge which happened at the time of Noah was universal or not. And it would seem not, for the reasons now to be given: we have it in the Bible that this deluge lasted 40 days and 40 nights of incessant and universal rain, and that this rain rose to ten cubits above the highest mountains in the world. And if it had been that the rain was universal, it would have covered our globe, which is spherical in form. And this spherical surface is equally distant in every part, from the center

of its sphere; hence, the sphere of the waters being under the same conditions, it is impossible that the water upon it should move, because water, in itself, does not move unless it falls; therefore how could the waters of such a deluge depart, if it is proved that it has no motion? And if it departed how could it move unless it went upwards? Here, then, natural reasons are wanting; hence to remove this doubt it is necessary to call in a miracle to aid us, or else to say that all this water was evaporated by the heat of the sun.

That in the drifts, among one and another, there are still to be found the traces of the worms which crawled upon them when they were not yet dry. And all marine clays still contain shells, and the shells are petrified together with the clay. From their firmness and unity some persons will have it that these animals were carried up to places remote from the sea by the deluge. Another sect of ignorant persons declare that Nature or Heaven created them in these places by celestial influences, as if in these places we did not also find the bones of fishes which have taken a long time to grow; and as if we could not count, in the shells of cockles and snails, the years and months of their life, as we do in the horns of bulls and oxen, and in the branches of plants that have never been cut in any part. Besides, having proved by these signs the length of their lives, it is evident, and it must be admitted, that these animals could not live without moving to fetch their food; and we find in them no instrument for penetrating the earth or the rock where we find them enclosed. But how could we find in a large snail shell the fragments and portions of many other sorts of shells, of various sorts, if they had not been thrown there, when dead, by the waves of the sea, like the other light objects which it throws on the earth? Why do we find so many fragments and whole shells between layer and layer of stone, if this had not formerly been covered on the shore by a layer of earth thrown up by the sea, and which was afterwards petrified? And if the deluge before mentioned had carried them to these parts of the sea, you might find these shells at the boundary of one drift but not at the boundary between many drifts. We must also account for the winters of the years during which the sea multiplied the drifts of sand and mud brought down by the neighboring rivers, by washing down the shores; and if you chose to say that there were several

deluges to produce these rifts and the shells among them, you would also have to affirm that such a deluge took place every year. Again, among the fragments of these shells, it must be presumed that in those places there were seacoasts, where all the shells were thrown up, broken, and divided, and never in pairs, since they are found alive in the sea, with two valves, each serving as a lid to the other; and in the drifts of rivers and on the shores of the sea they are found in fragments. And within the limits of the separate strata of rocks they are found, few in number and in pairs like those which were left by the sea, buried alive in the mud, which subsequently dried up and, in time, was petrified.

From the two lines of shells we are forced to say that the earth indignantly submerged under the sea and so the first layer was made; and then the deluge made the second.

ON THE ATMOSPHERE

That the brightness of the air is occasioned by the water which has dissolved itself in it into imperceptible molecules. These, being lighted by the sun from the opposite side, produce the brightness which is visible in the air: and the azure which is seen in it is caused by the darkness that is hidden beyond the air.

That the return eddies of wind at the mouth of certain valleys strike upon the waters and scoop them out in a great hollow, whirl the water into the air in the form of a column, and of the color of a cloud. And I saw this thing happen on a sand bank in the Arno, where the sand was hollowed out to a greater depth than the stature of a man; and with it the gravel was whirled round and flung about for a great space; it appeared in the air in the form of a great bell tower; and the top spread like the branches of a pine tree, and then it bent at the contact of the direct wind, which passed over from the mountains.

Why the current of Gibraltar is always greater to the west than to the east. The reason is that if you put together the mouths of the rivers which discharge into the Mediterranean Sea you would find the sum of water to be larger than that

which this sea pours through the straits into the ocean. You see Africa discharging its rivers that run northwards into this sea, and among them the Nile which runs through 3,000 miles of Africa; there is also the Bagrada river and the Schelif and others. Likewise Europe pours into it the Don and the Danube, the Po, the Rhone, the Arno, and the Tiber, so that evidently these rivers, with an infinite number of others of less fame, make its great breadth and depth and current; and the sea is not wider than 18 miles at the most westerly point of land where it divides Europe from Africa.

Chapter 8

THE OBSERVANT
TRAVELER

Exactly how much Leonardo traveled will probably never be known. The notebooks indicate familiarity with portions of the Near East which he could have visited, although there is no record of such trips. On the other hand, his easily fired imagination may have seized upon an account of some other man's travels and made them his own.

During his second period in Milan, however, there is no question but that he made numerous journeys, usually in the train of his patron or on business for him, in Italy, France, and Switzerland. That his perceptive eye missed no detail, whether of light effects, fossil remains, strange stratifications and formations of rock, the skeletons of trees, storms, clouds, plants, as he rode, the notebooks are full of evidence. Water-courses, their potential power, irrigation devices, anything in which his intense interest in hydraulics could be brought into play, always absorbed his attention. He saw mountains with an artist's eye, recalled how light fell at various times of day, at different seasons of the year, and how trees and their leaves altered in aspect and in color in sun, haze, mist, heat or cold. He watched animals, large and small, and he remembered bits of local lore or information, which the peasants told him, perhaps, while the cavalcade of war lord or prince or bishop with whom he traveled rested by some stream or at a country inn. He made notes of the prices of lodging and of meals.

One more enigma in this strange mind and man is that, of such an inexhaustibly furnished storehouse of material were produced, finally, such a handful of paintings.

On mountains. That the northern bases of some Alps are not yet petrified. And this is plainly to be seen where the rivers which cut through them flow towards the north; where they cut through the strata in the living stone in the higher parts of the mountains; and, where they join the plains, these strata are all of potter's clay; as is to be seen in the valley of Lamona where the river Lamona, as it issues from the Apennines, does these things on its banks.

That the rivers have all cut and divided the mountains of the great Alps one from the other. This is visible in the order of the stratified rocks, because from the summits of the banks down to the river the correspondence of the strata in the rocks is visible on either side of the river. That the stratified stones of the mountains are all layers of clay, deposited one above the other by the various floods of the rivers. That the different size of the strata is caused by the difference in the floods—that is to say greater or lesser floods.

Of the sea which encircles the earth. I find that of old, the state of the earth was that its plains were all covered up and hidden by salt water.

Since things are much more ancient than letters, it is no marvel if, in our day, no records exist of these seas having covered so many countries; and if, moreover, some records had existed, war and conflagrations, the deluge of waters, the changes of languages and of laws, have consumed everything ancient. But sufficient for us is the testimony of things created in the salt waters, and found again in high mountains far from the seas.

GEOLOGICAL PROBLEMS

In this work you have first to prove that the shells at a thousand braccia of elevation were not carried there by the deluge, because they are seen to be all at one level, and many mountains are seen to be above that level; and to inquire whether the deluge was caused by rain or by the swelling of the sea; and then you must show how, neither by rain nor by swelling of the rivers, nor by the overflow of this sea, could the shells—being heavy objects—be floated up the mountains by the sea, nor have been carried there by the rivers against the course of their waters.

Of the deluge and of marine shells. If you were to say that the shells which are to be seen within the confines of

Italy now, in our days, far from the sea and at such heights, had been brought there by the deluge which left them there, I should answer that if you believe that this deluge rose 7 cubits above the highest mountains—as he who measured it has written—these shells, which always live near the seashore, should have been left on the mountains; and not such a little way from the foot of the mountains; nor all at one level, nor in layers upon layers. And if you were to say that these shells are desirous of remaining near to the margin of the sea, and that, as it rose in height, the shells quitted their first home, and followed the increase of the waters up to their highest level; to this I answer, that the cockle is an animal of not more rapid movement than the snail is out of water, or even somewhat slower; because it does not swim, on the contrary it makes a furrow in the sand by means of its sides, and in this furrow it will travel each day from 3 to 4 braccia; therefore this creature, with so slow a motion, could not have traveled from the Adriatic Sea as far as Monferrato in Lombardy, which is 250 miles distance, in 40 days; which he has said who took account of the time. And if you say that the waves carried them there, by their gravity they could not move, excepting at the bottom. And if you will not grant me this, confess at least that they would have to stay at the summits of the highest mountains, in the lakes which are enclosed among the mountains, like the lakes of Lario, or of Como and il Maggiore and of Fiesole, and of Perugia, and others.

And if you should say that the shells were carried by the waves, being empty and dead, I say that where the dead went they were not far removed from the living; for in these mountains living ones are found, which are recognizable by the shells being in pairs; and they are in a layer where there are no dead ones; and a little higher up they are found, where they were thrown by the waves, all the dead ones with their shells separated, near to where the rivers fell into the sea, to a great depth; like the Arno which fell from the Gonfolina near to Monte Lupo, where it left a deposit of gravel which may still be seen, and which has agglomerated; and of stones of various districts, natures, and colors and hardness, making one single conglomerate. And a little beyond the sandstone conglomerate a tufa has been formed, where it turned towards Castel Fiorentino; farther on, the mud was deposited on which the shells lived, and which rose in layers according to the levels at which the turbid Arno flowed into that sea. And from time to time the bottom of the sea was raised, depositing

these shells in layers, as may be seen in the cutting at Colle Gonzoli, laid open by the Arno which is wearing away the base of it; in which cutting the said layers of shells are very plainly to be seen in clay of a bluish color, and various marine objects are found there. And if the earth of our hemisphere is indeed raised by so much higher than it used to be, it must have become by so much lighter by the waters which it lost through the rift between Gibraltar and Ceuta; and all the more the higher it rose, because the weight of the waters which were thus lost would be added to the earth in the other hemisphere. And if the shells had been carried by the muddy deluge they would have been mixed up, and separated from one another amidst the mud, and not in regular steps and layers—as we see them now in our time.

As to those who say that shells existed for a long time and were born at a distance from the sea, from the nature of the place and of the cycles, which can influence a place to produce such creatures—to them it may be answered: such an influence could not place the animals all on one line, except those of the same sort and age; and not the old with the young, nor some with an operculum and others without their operculum, nor some broken and others whole, nor some filled with sea sand and large and small fragments of other shells inside the whole shells which remained open; nor the claws of crabs without the rest of their bodies; nor the shells of other species stuck on to them like animals which have moved about on them; since the traces of their track still remain, on the outside, after the manner of worms in the wood which they ate into. Nor would there be found among them the bones and teeth of fish which some call arrows and others serpents' tongues, nor would so many portions of various animals be found all together if they had not been thrown on the seashore. And the deluge cannot have carried them there, because things that are heavier than water do not float on the water. But these things could not be at so great a height if they had not been carried there by the water, such a thing being possible from their weight. In places where the valleys have not been filled with salt water, shells are never to be seen; as is plainly visible in the great valley of the Arno above Gonfolina, a rock formerly united to Monte Albano in the form of a very high bank which kept the river pent up, in such a way that before it could flow into the sea, which was afterwards at its foot, it formed two great lakes; of which the first was where we now see the city of Florence together

with Prato and Pistoia, and Monte Albano. It followed the
rest of its bank as far as where Serravalle now stands. From
the Val d'Arno upwards, as far as Arezzo, another lake was
formed, which discharged its waters into the former lake. It
was closed at about the spot where now we see Girone, and
occupied the whole of that valley above for a distance of
40 miles in length. This valley received on its bottom all the
soil brought down by the turbid waters. And this is still to
be seen at the foot of Prato Magno; it there lies very high
where the rivers have not worn it away. Across this land are
to be seen the deep cuts of the rivers that have passed there,
falling from the great mountain of Prato Magno; in these cuts
there are no vestiges of any shells or of marine soil. This lake
was joined with that of Perugia.

A great quantity of shells are to be seen where the rivers
flow into the sea, because on such shores the waters are not so
salt owing to the admixture of the fresh water which is poured
into it. Evidence of this is to be seen where, of old, the
Apennines poured their rivers into the Adriatic Sea; for there
in most places great quantities of shells are to be found,
among the mountains, together with bluish marine clay; and
all the rocks which are torn off in such places are full of
shells. The same may be observed to have been done by
the Arno when it fell from the rock of Gonfolina into the
sea, which was not so very far below; for at that time it was
higher than the top of San Miniato al Tedesco, since at the
highest summit of this the shores may be seen full of shells
and oysters within its flanks. The shells did not extend towards
Val di Nievole, because the fresh waters of the Arno did not
extend so far.

That the shells were not carried away from the sea by the
deluge, because the waters which came from the earth, al-
though they drew the sea towards the earth, were those which
struck its depths; because the water which goes down from
the earth has a stronger current than that of the sea, and in
consequence is more powerful, and it enters beneath the sea
water and stirs the depths and carries with it all sorts of
movable objects which are to be found in the earth, such as
the above-mentioned shells and other similar things. And in
proportion as the water which comes from the land is muddier
than sea water it is stronger and heavier than this; therefore
I see no way of getting the said shells so far inland, unless
they had been born there. If you were to tell me that the
river Loire, which traverses France, covers when the sea

rises more than eighty miles of country, because it is a district of vast plains, and the sea rises about 20 braccia, and shells are found in this plain at the distance of 80 miles from the sea; here I answer that the flow and ebb in our Mediterranean Sea do not vary so much; for at Genoa it does not rise at all, and at Venice but little and very little in Africa; and where it varies little it covers but little of the country.

The course of the water of a river always rises higher in a place where the current is impeded; it behaves as it does where it is reduced in width to pass under the arches of a bridge.

A confutation of those who say that shells may have been carried to a distance of many days' journey from the sea by the deluge, which was so high as to be above those heights. I say that the deluge could not carry objects native to the sea up to the mountains, unless the sea had already increased so as to create inundations as high up as those places; and this increase could not have occurred because it would cause a vacuum; and if you were to say that the air would rush in there, we have already concluded that what is heavy cannot remain above what is light, whence of necessity we must conclude that this deluge was caused by rain water, so that all these waters ran to the sea, and the sea did not run up the mountains; and as they ran to the sea, they thrust the shells from the shore of the sea and did not draw them towards themselves. And if you were then to say that the sea, raised by the rain water, had carried these shells to such a height, we have already said that things heavier than water cannot rise upon it, but remain at the bottom of it, and do not move unless by the impact of the waves. And if you were to say that the waves had carried them to such high spots, we have proved that the waves in a great depth move in a contrary direction at the bottom to the motion at the top, and this is shown by the turbidity of the sea from the earth washed down near its shores. Anything which is lighter than the water moves with the waves, and is left on the highest level of the highest margin of the waves. Anything which is heavier than the water moves, suspended in it, between the surface and the bottom; and from these two conclusions, which will be amply proved in their place, we infer that the waves of the surface cannot convey shells, since they are heavier than water. . . .

If the deluge had to carry shells three hundred and four hundred miles from the sea, it would have carried them mixed

with various other natural objects heaped together; and we see at such distances oysters all together, and sea snails, and cuttlefish, and all the other shells which congregate together, all to be found together and dead; and the solitary shells are found wide apart from one another, as we may see them on seashores every day. And if we find oysters of very large shells joined together and among them very many which still have the covering attached, indicating that they were left here by the sea, and still living when the Strait of Gibraltar was cut through; there are to be seen, in the mountains of Parma and Piacenza, a multitude of shells and corals, full of holes, and still sticking to the rocks there. When I was making the great horse for Milan, a large sack full was brought to me in my workshop by certain peasants; these were found in that place and among them were many preserved in their first freshness.

Underground, and under the foundations of buildings, timbers are found of wrought beams and already black. Such were found in my time in those diggings at Castel Fiorentino. And these had been in that deep place before the sand carried by the Arno into the sea, then covering the plain, had been raised to such a height; and before the plains of Casentino had been so much lowered, by the earth being constantly carried down from them.

And if you were to say that these shells were created, and were continually being created, in such places by the nature of the spot, and of the heavens which might have some influence there, such an opinion cannot exist in a brain of much reason; because here are the years of their growth, numbered on their shells, and there are large and small ones to be seen which could not have grown without food, and could not have fed without motion—and here they could not move.

And if you choose to say that it was the deluge which carried these shells away from the sea for hundreds of miles, this cannot have happened, since that deluge was caused by rain; because rain naturally forces the rivers to rush towards the sea with all the things they carry with them, and not to bear the dead things of the seashores to the mountains. And if you choose to say that the deluge afterwards rose with its waters above the mountains, the movement of the sea must have been so sluggish in its rise against the currents of the rivers that it could not have carried, floating upon it, things

heavier than itself; and even if it had supported them, in its receding it would have left them strewn about in various spots. But how are we to account for the corals which are found every day towards Monte Ferrato in Lombardy, with the holes of the worms in them, sticking to rocks left uncovered by the currents of rivers? These rocks are all covered with stocks and families of oysters, which, as we know, never move, but always remain with one of their halves stuck to a rock, and the other they open to feed themselves on the animalcules that swim in the water, which, hoping to find good feeding ground, become the food of these shells. We do not find that the sand mixed with seaweed has been petrified, because the weed which was mingled with it has shrunk away, and this the Po shows us every day in the debris of its banks.

Why do we find the bones of great fishes and oysters and corals and various other shells and sea snails on the high summits of mountains by the sea, just as we find them in low seas?

You now have to prove that the shells cannot have originated if not in salt water, almost all being of that sort; and that the shells in Lombardy are at four levels, and thus it is everywhere, having been made at various times. And they all occur in valleys that open towards the seas.

Of the force of the vacuum formed in a moment. I saw, at Milan, a thunderbolt fall on the tower della Credenza on its northern side, and it descended with a slow motion down that side, and then at once parted from that tower and carried with it and tore away from that wall a space of 3 braccia wide and two deep; and this wall was 4 braccia thick and was built of thin and small old bricks; and this was dragged out by the vacuum which the flame of the thunderbolt had caused, etc.

Lake of Como. Valley of Chiavenna. Above the Lake of Como towards Germany is the valley of Chiavenna, where the river Mera flows into this lake. Here are barren and very high mountains, with huge rocks. Among these mountains are to be found the water birds called gulls. Here grow fir trees, larches, and pines; deer, wild goats, chamois, and terrible bears. It is impossible to climb them without using hands and feet. The peasants go there at the time of the snows with great snares to make the bears fall down these rocks. These mountains, which very closely approach one another, are

parted by the river. They are to the right and left for the distance of 20 miles throughout of the same nature. From mile to mile there are good inns. Above on the said river there are waterfalls of 400 braccia in height, which are fine to see; and there is good living at 4 soldi the reckoning. This river brings down a great deal of timber.

Val Sasina. Val Sasina runs down towards Italy; this is almost the same form and character. There grow here many *mappello* and there are great ruins and falls of water.

Valley of Introzzo. This valley produces a great quantity of firs, pines, and larches; and from here Ambrogio Fereri has his timber brought down; at the head of the Valtellina are the mountains of Bormio, terrible and always covered with snow; ermine are found there.

Bellaggio. Opposite the castle Bellaggio there is the river Latte, which falls from a height of more than 100 braccia from the source whence it springs, perpendicularly, into the lake with an inconceivable roar and noise. This spring flows only in August and September.

Valtellina. Valtellina, as it is called, is a valley enclosed in high and terrible mountains; it produces much strong wine, and there is so much cattle that the natives conclude that more milk than wine grows there. This is the valley through which the Adda passes, which first runs more than 40 miles through Germany; this river breeds the fish *temolo,* which live on silver, of which much is to be found in its sands. In this country everyone can sell bread and wine, and the wine is worth at most one soldo the bottle and a pound of veal one soldo, and salt ten dinari and butter the same, and their pound is 30 ounces, and eggs are one soldo the lot.

At Bormio. At Bormio are the baths;—about eight miles above Como is the Pliniana, which increases and ebbs every six hours, and its swell supplies water for two mills; and its ebbing makes the spring dry up; two miles higher up there is Nesso, a place where a river falls with great violence into a vast rift in the mountain. These excursions are to be made in the month of May. And the largest bare rocks that are to be found in this part of the country are the mountains of Mandello near to those of Lecco, and of Gravidona towards Bellinzona, 30 miles from Lecco, and those of the valley of Chiavenna; but the greatest of all is that of Mandello, which has at its base an opening towards the lake, which goes down 200 steps, and there at all times is ice and wind.

In Val Sasina. In Val Sasina, between Vimognio and In-

trobbio, to the right hand, going in by the road to Lecco, is the river Troggia, which falls from a very high rock, and as it falls it goes underground and the river ends there. 3 miles farther we find the buildings of the mines of copper and silver near a place called Pra' Santo Pietro, and mines of iron and curious things. La Grigna is the highest mountain there is in this part, and it is quite bare.

At Santa Maria Hoé in the Valley of Rovagnate in the mountains of Brianza are rods of chestnuts of 9 braccia and one out of an average of 100 will be 14 braccia.

At Varallo di Pombia near to Sesto on the Ticino the quinces are white, large, and hard.

Stairs of the palace of the Count of Urbino—rough.

In Romagna, the realm of all stupidity, vehicles with four wheels are used, of which the two in front are small and two high ones are behind; an arrangement which is very unfavorable to the motion, because on the fore wheels more weight is laid than on those behind, as I showed in the first of the 5th on "Elements."

There might be a harmony of the different falls of water as you saw them at the fountain of Rimini on the 8th day of August, 1502.

At Alessandria della Paglia in Lombardy there are no stones for making lime of, but such as are mixed up with an infinite variety of things native to the sea, which is now more than 200 miles away.

That there are springs which suddenly break forth in earthquakes or other convulsions and suddenly fail; and this happened in a mountain in Savoy where certain forests sank in and left a very deep gap, and about four miles from here the earth opened itself like a gulf in the mountain, and threw out a sudden and immense flood of water which scoured the whole of a little valley of the tilled soil, vineyards and houses, and did the greatest mischief, wherever it overflowed.

And this may be seen, as I saw it, by anyone going up Monbroso, a peak of the Alps which divide France from Italy.

The base of this mountain gives birth to the 4 rivers which flow in four different directions through the whole of Europe. And no mountain has its base at so great a height as this, which lifts itself above almost all the clouds; and snow seldom falls there, but only hail in the summer, when the clouds are highest. And this hail lies unmelted there, so that if it were not for the absorption of the rising and falling clouds, which does not happen more than twice in an age, an enormous mass of ice would be piled up there by the layers of hail, and in the middle of July I found it very considerable; and I saw the sky above me quite dark, and the sun as it fell on the mountain was far brighter here than in the plains below, because a smaller extent of atmosphere lay between the summit of the mountain and the sun.

In the mountains of Verona the red marble is found all mixed with cockle shells turned into stone; some of them have been filled at the mouth with the cement which is the substance of the stone; and in some parts they have remained separate from the mass of the rock which enclosed them, because the outer covering of the shell had interposed and had not allowed them to unite with it; while in other places this cement had petrified those which were old and almost stripped the outer skin.

That part of the earth which was lightest remained farthest from the center of the world; and that part of the earth became the lightest over which the greatest quantity of water flowed. And therefore that part became lightest where the greatest number of rivers flow; like the Alps which divide Germany and France from Italy; whence issue the Rhone flowing southwards, and the Rhine to the north. The Danube or Tanoia towards the northeast, and the Po to the east, with innumerable rivers which join them, and which always run turbid with the soil carried by them to the sea.

The shores of the sea are constantly moving towards the middle of the sea and displace it from its original position. The lowest portion of the Mediterranean will be reserved for the bed and current of the Nile, the largest river that flows into that sea. And with it are grouped all its tributaries, which at first fell into the sea; as may be seen with the Po and its tributaries, which first fell into that sea, which between the Apennines and the German Alps was united to the Adriatic Sea.

That the Gallic Alps are the highest part of Europe.

And of these I found some in the rocks of the high Apennines and mostly at the rock of La Vernia.

The shepherds in the Romagna at the foot of the Apennines make peculiar large cavities in the mountains in the form of a horn, and on one side they fasten a horn. This little horn becomes one and the same with the said cavity and thus they produce by blowing into it a very loud noise.

A spring may be seen to rise in Sicily which at certain times of the year throws out chestnut leaves in quantities; but in Sicily chestnuts do not grow, hence it is evident that that spring must issue from some abyss in Italy and then flow beneath the sea to break forth in Sicily.

That the valleys were formerly in great part covered by lakes—the soil of which always forms the banks of rivers—and by seas, which afterwards, by the persistent wearing of the rivers, cut through the mountains, and the wandering courses of the rivers carried away the other plains enclosed by the mountains; and the cutting away of the mountains is evident from the strata in the rocks, which correspond in their sections as made by the courses of the rivers. The Haemus mountains which go along Thrace and Dardania and join the Sardonius mountains which, going on to the westward, change their name from Sardus to Rebi, as they come near Dalmatia; then turning to the west cross Illyria, now called Sclavonia, changing the name of Rebi to Albanus, and, going on still to the west, they change to Mount Ocra in the north; and to the south above Istria they are named Caruancas; and to the west above Italy they join the Adula, where the Danube rises, which stretches to the east and has a course of 1,500 miles; its shortest line is about 1,000 miles, and the same or about the same is that branch of the Adula mountains changed as to their name, as before mentioned. To the north are the Carpathians, closing in the breadth of the valley of the Danube, which, as I have said extends eastward, a length of about 1,000 miles, and is sometimes 200 and in some places 300 miles wide; and in the midst flows the Danube, the principal river of Europe as to size. The said Danube runs through the middle of Austria and Albania and northwards through Bavaria, Poland, Hungary, Wallachia, and Bosnia and then the Danube or Donau flows into the Black Sea, which formerly extended almost to Austria and occupied the plains through which the Danube

now courses; and the evidence of this is in the oysters and cockle shells and scallops and bones of great fishes which are still to be found in many places on the sides of those mountains; and this sea was formed by the filling up of the spurs of the Adula mountains which then extended to the east joining the spurs of the Taurus which extend to the west. And near Bithynia the waters of this Black Sea poured into the Propontis [Marmara], falling into the Aegean Sea, that is the Mediterranean, where, after a long course, the spurs of the Adula mountains became separated from those of the Taurus. The Black Sea sank lower and laid bare the valley of the Danube with the above-named countries, and the whole of Asia Minor beyond the Taurus range to the north, and the plains from Mount Caucasus to the Black Sea to the west, and the plains of the Don this side—that is to say, at the foot of the Ural Mountains. And thus the Black Sea must have sunk about 1,000 braccia to uncover such vast plains.

The gulf of the Mediterranean, as an inland sea, received the principal waters of Africa, Asia, and Europe that flowed towards it; and its waters came up to the foot of the mountains that surrounded it and made its shores. And the summits of the Apennines stood up out of this sea like islands, surrounded by salt water. Africa again, behind its Atlas Mountains did not expose uncovered to the sky the surface of its vast plains about 3,000 miles in length, and Memphis was on the shores of this sea, and above the plains of Italy, where now birds fly in flocks, fish were wont to wander in large shoals.

Describe the mountains of shifting deserts; that is to say the formation of waves of sand borne by the wind, and of its mountains and hills, such as occur in Libya. Examples may be seen on the wide sands of the Po and the Ticino, and other large rivers.

THE LEVANT

On the shores of the Mediterranean 300 rivers flow, and there are 40,200 ports; and this sea is 3,000 miles long. Many times has the increase of its waters, heaped up by their backward flow and the blowing of the west winds, caused the overflow of the Nile and of the rivers which flow out through the Black Sea, and have so much raised the seas that they

have spread with vast floods over many countries. And these floods take place at the time when the sun melts the snows on the high mountains of Ethiopia that rise up into the cold regions of the air; and in the same way the approach of the sun acts on the mountains of Sarmatia in Asia and on those in Europe; so that the gathering together of these three things is, and has been, the cause of tremendous floods: that is, the return flow of the sea with the west wind and the melting of the snows. So every river will overflow in Syria, in Samaria, in Judea between Sinai and the Lebanon, and in the rest of Syria between the Lebanon and the Taurus Mountains, and in Cilicia, in the Armenian mountains, and in Pamphilia and in Lycia within the hills, and in Egypt as far as the Atlas Mountains. The Gulf of Persia, which was formerly a vast lake of the Tigris and discharged into the Indian Sea, has now worn away the mountains which formed its banks and laid them even with the level of the Indian Ocean. And if the Mediterranean had continued its flow through the Gulf of Arabia, it would have done the same, that is to say, would have reduced the level of the Mediterranean to that of the Indian Sea.

For a long time the water of the Mediterranean flowed out through the Red Sea, which is 100 miles wide and 1,500 long, and full of reefs; and it has worn away the sides of Mount Sinai, a fact which testifies, not to an inundation from the Indian Sea beating on these coasts, but to a deluge of water which carried with it all the rivers which abound round the Mediterranean, and besides this there is the reflux of the sea; and then, a cutting being made to the west 3,000 miles away from this place, Gibraltar was separated from Ceuta, which had been joined to it. And this passage was cut very low down, in the plains between Gibraltar and the ocean at the foot of the mountain, in the low part, aided by the hollowing out of some valleys made by certain rivers, which might have flowed here. Hercules came to open the sea to the westward and then the sea waters began to pour into the Western Ocean; and in consequence of this great fall the Red Sea remained the higher; whence the water, abandoning its course here, ever after poured away through the Straits of Spain.

The surface of the Red Sea is on a level with the ocean. . . .

A mountain may have fallen and closed the mouth of the Red Sea and prevented the outlet of the Mediterranean, and the Mediterranean Sea, thus overfilled, had for outlet the

passage between the mountains of Gades; for in our own times a similar thing has been seen; a mountain fell seven miles across a valley and closed it up and made a lake. And thus most lakes have been made by mountains, as the Lake of Garda, the lakes of Como and Lugano, and the Lago Maggiore. The Mediterranean fell but little on the confines of Syria, in consequence of the Gaditanean passage, but a great deal in this passage, because before this cutting was made the Mediterranean Sea flowed to the southeast, and then the fall had to be made by its run through the Straits of Gades.

At *a* the water of the Mediterranean fell into the ocean.

All the plains which lie between the sea and mountains were formerly covered with salt water.

Every valley has been made by its own river; and the proportion between valleys is the same as that between river and river.

The greatest river in our world is the Mediterranean river, which moves from the sources of the Nile to the Western Ocean.

And its greatest height is in Outer Mauretania and it has a course of ten thousand miles before it reunites with its ocean, the father of the waters.

That is, 3,000 miles for the Mediterranean, 3,000 for the Nile, as far as discovered, and 3,000 for the Nile which flows to the east, etc.

In the Bosporus the Black Sea flows always into the Aegean Sea, and the Aegean Sea never flows into it. And this is because the Caspian, which is 400 miles to the east, with the rivers which pour into it, always flows through subterranean caves into this Black Sea; and the Don does the same as well as the Danube, so that the waters of the Black Sea are always higher than those of the Aegean; for the higher always fall towards the lower, and never the lower towards the higher.

The bridge of Pera at Constantinople, 40 braccia wide, 70 braccia high above the water, 600 braccia long; that is, 400 over the sea and 200 on the land, thus making its own abutments.

Mounts Caucasus, Comedorum, and Paropemisidae are joined together between Bactria and India, and give birth to the river Oxus, which takes its rise in these mountains and flows 500 miles towards the north and as many towards the

west, and discharges its waters into the Caspian Sea; and is accompanied by the Oxus, Dargados, Arthamis, Xariaspes, Dragamaim, Ocus, and Margus, all very large rivers. From the opposite side towards the south rises the great river Indus, which sends its waters for 600 miles southwards and receives as tributaries in this course the rivers Xaradrus, Hyphasis, Vadris, Vandabal, Bislaspus to the east, Suastus to the west, uniting with these rivers, and with their waters it flows 800 miles to the west; then, turning back by the Arbiti mountains, makes an elbow and turns southwards, where after a course of about 100 miles it finds the Indian Sea, in which it pours itself by seven branches. On the side of the same mountains rises the great Ganges, which river flows southwards for 500 miles and to the southwest a thousand . . . and Sarabas, Diarnuna, Soas, and Scilo, with big waves, are its tributaries. It flows into the Indian Sea by many mouths.

Book 43. Of the movement of air enclosed in water. I have seen motions of the air so furious that they 'have carried, mixed up in their course, the largest trees of the forest and whole roofs of great palaces, and I have seen the same fury bore a hole with a whirling movement digging out a gravel pit, and carrying gravel, sand, and water more than half a mile through the air.

Like a whirling wind which rushes down a sandy and hollow valley, and which, in its hasty course, drives to its center everything that opposes its furious course . . .

No otherwise does the northern blast whirl round in its tempestuous progress. . . .

Nor does the tempestuous sea bellow so loud, when the northern blast dashes it, with its foaming waves, between Scylla and Charybdis; nor Stromboli, nor Mount Etna, when their sulphurous flames, having been forcibly confined, rend and burst open the mountain, fulminating stones and earth through the air together with the flames they vomit.

Nor when the inflamed caverns of Mount Etna, rejecting the ill-restrained element, vomit it forth, back to its own region, driving furiously before it every obstacle that comes in the way of its impetuous rage. . . .

Unable to resist my eager desire and wanting to see the great multitude of the various and strange shapes made by formative nature, and having wandered some distance among

gloomy rocks, I came to the entrance of a great cavern, in front of which I stood some time, astonished and unaware of such a thing. Bending my back into an arch I rested my left hand on my knee and held my right hand over my downcast and contracted eyebrows: often bending first one way and then the other, to see whether I could discover anything inside, and this being forbidden by the deep darkness within, and after having remained there some time, two contrary emotions arose in me, fear and desire—fear of the threatening dark cavern, desire to see whether there were any marvelous thing within it. . . .

Chapter 9

THE MUSICIAN

It appears to have been more as a musician than as a painter that Leonardo, a young exquisite, elegant in person and in manner, authoritative in address, talented as a singer, was first sent to the Sforza court at Milan. Although the notes on music do not compare in bulk with those which the manuscripts include on other arts, there is sufficient material to convey Leonardo's grasp of musical theory and his inventiveness in suggesting new instruments.

In the paragoni *contained in the first book of the* Treatise on Painting *he uses this literary device of comparisons, which was extremely popular at the time, to set forth his views on music and painting. Music and Poetry had long been considered among the seven Liberal Arts, regarded as man's loftiest achievement. Painting, however, was classed as a somewhat inferior branch of the Mechanical Arts, and no matter how much Leonardo may later have been reported as impatient and disenchanted with his brush, he was at this stage of his development jealous of the standing of his art and convincing in his application of the Platonic comparison. The contrast of Painting and Music had already been excellently set forth by Leon Battista Alberti in his book on painting, a book which had had a profound influence on Leonardo's thinking. Although the enlargement on the* paragoni *contained in the* Treatise *is in intention an establishment of painting as the faculty of minds almost godlike in their powers of creation, his descriptions of the beauties of harmonious music reflect his familiarity with and understanding of it as well.*

A drum with cogs working by wheels with springs.

A square drum of which the parchment may be drawn tight or slackened by the lever *a b*.

A drum for harmony.

A clapper for harmony; that is, three clappers together.

Just as one and the same drum makes a deep or acute sound according as the parchments are more or less tightened, so these parchments variously tightehed on one and the same drum will make various sounds.

Keys narrow and holes will be far apart; these will be right for the trumpet shown above.

a must enter instead of the ordinary keys which have the . . . in the openings of a flute.

Tymbals to be played like the monochord, or the soft flute.

Here there is to be a cylinder of cane after the manner of clappers with a musical round called a canon, which is sung in four parts; each singer singing the whole round. Therefore I here make a wheel with 4 teeth so that each tooth takes by itself the part of a singer.

Chapter 10

THE INSATIABLE MIND

Always touchy as to his lack of education, Leonardo was a man obsessed with words, though not in the literary sense. The endless memoranda which flowed from his pen, which he always intended to organize into books but never found time to systematize, seem almost to have been the compulsive expression of a lonely mind, isolated because so far above that of his contemporaries, in constant conversation with itself.

In the following section we glimpse the astonishing variety of his interests, the jackdaw aspect of his notebooks, and their quality. The same man who could leap ahead centuries in scientific intuition, painstakingly copied down great sections of medieval bestiaries and delighted in the creation of "fables"; here are recorded the tales and anecdotes which were in vogue for court conversation, a fifteenth-century version of the after-dinner speaker's little notebook of funny stories. Particularly cherished were the "prophecies," in which everyday occurrences were so described as to make them sound like the most extravagantly menacing disasters.

The material of the notebooks, in short, varies from the increasingly disillusioned expression of greater and greater loneliness to bits and pieces of Leonardo's lighter side, a side which loved practical jokes and the grotesque; but a repeated theme, as in his drawings, is the sense of an impending doom to be loosed upon the world in a destroying deluge.

Of mechanics. Mechanics are the paradise of mathematical science, because here we come to the fruits of mathematics.

Every instrument requires to be made by experience.

The man who blames the supreme certainty of mathematics feeds on confusion, and can never silence the contradictions of sophistical sciences which lead to an eternal quackery.

There is no certainty in sciences where one of the mathematical sciences cannot be applied, or which are not in relation with these mathematics.

Anyone who in discussion relies upon authority uses, not his understanding, but rather his memory. Good culture is born of a good disposition; and since the cause is more to be praised than the effect, I will rather praise a good disposition without culture, than good culture without the disposition.

Science is the captain, and practice the soldiers.

Of the errors of those who depend on practice without science. Those who fall in love with practice without science are like a sailor who enters a ship without a helm or a compass, and who never can be certain whither he is going.

1 Of inequality in the concavity of a ship.

1 A book of the inequality in the curve of the sides of ships.

1 A book of the inequality in the position of the tiller.

1 A book of the inequality in the keel of ships.

2 A book of various forms of apertures by which water flows out.

3 A book of water contained in vessels with air, and of its movements.

4 A book of the motion of water through a syphon.

5 A book of the meetings and union of waters coming from different directions.

6 A book of the various forms of the banks through which rivers pass.

7 A book of the various forms of shoals formed under the sluices of rivers.

8 A book of the windings and meanderings of the currents of rivers.

9 A book of the various places whence the waters of rivers are derived.

10 A book of the configuration of the shores of rivers and of their permanency.

11 A book of the perpendicular fall of water on various objects.

12 A book of the course of water when it is impeded in various places.

12 A book of the various forms of the obstacles which impede the course of waters.

13 A book of the concavity and globosity formed round various objects at the bottom.

14 A book of conducting navigable canals above or beneath the rivers which intersect them.

15 A book of the soils which absorb water in canals and of repairing them.

16 A book of creating currents for rivers, which quit their beds, and for rivers choked with soil.

POLEMICS. SPECULATION

Oh! speculators on things, boast not of knowing the things that nature ordinarily brings about; but rejoice if you know the end of those things which you yourself devise.

There can be no voice where there is no motion or percussion of the air; there can be no percussion of the air where there is no instrument; there can be no instrument without a body; and, this being so, a spirit can have neither voice, nor form, nor strength. And if it were to assume a body it could not penetrate nor enter where the passages are closed. And if anyone should say that by air, compressed and compacted together, a spirit may take bodies of various forms and by this means speak and move with strength—to him I reply that when there are neither nerves nor bones there can be no force exercised in any kind of movement made by such imaginary spirits.

Beware of the teaching of these speculators, because their reasoning is not confirmed by experience.

Of all human opinions that is to be reputed the most foolish which deals with the belief in Necromancy, the sister of Alchemy, which gives birth to simple and natural things. But it is all the more worthy of reprehension than Alchemy, because it brings forth nothing but what is like itself, that is, lies; this does not happen in Alchemy, which deals with simple products of nature and whose function cannot be exercised by nature itself, because it has no organic instruments with which it can work, as men do by means of their hands, who have produced, for instance, glass, etc., but this Necromancy, the flag and flying banner, blown by the winds, is the guide of the stupid crowd which is constantly witness

to the dazzling and endless effects of this art; and there are books full, declaring that enchantments and spirits can work and speak without tongues and without organic instruments—without which it is impossible to speak—and can carry the heaviest weights and raise storms and rain; and that men can be turned into cats and wolves and other beasts, although indeed it is those who affirm these things who first became beasts.

And surely if this Necromancy did exist, as is believed by small wits, there is nothing on the earth that would be of so much importance alike for the detriment and service of men, if it were true that there were in such an art a power to disturb the calm serenity of the air, converting it into darkness and making coruscations or winds, with terrific thunder and lightnings rushing through the darkness, and with violent storms overthrowing high buildings and rooting up forests; and thus to oppose armies, crushing and annihilating them; and, besides these, frightful storms that would deprive the peasants of the reward of their labors. Now what kind of warfare is there to hurt the enemy so much as to deprive him of the harvest? What naval warfare could be compared with this? I say, the man who has power to command the winds and to make ruinous gales by which any fleet may be submerged—surely a man who could command such violent forces would be lord of the nations, and no human ingenuity could resist his crushing force. The hidden treasures and gems reposing in the body of the earth would all be made manifest to him. No lock or fortress, though impregnable, would be able to save anyone against the will of the necromancer. He would have himself carried through the air from east to west and through all the opposite sides of the universe. But why should I enlarge further upon this? What is there that could not be done by such a craftsman? Almost nothing, except to escape death. Hereby I have explained in part the mischief and the usefulness, contained in this art, if it is real; and if it is real, why has it not remained among men who desire it so much, having nothing to do with any deity? For I know that there are numberless people who would, to satisfy a whim, destroy God and all the universe; and if this necromancy, being, as it were, so necessary to men, has not been left among them, it can never have existed, nor will it ever exist according to the definition of the spirit, which is invisible in substance; for within the elements there are no incorporate things, because where there is no body, there is a vacuum;

and no vacuum can exist in the elements because it would be immediately filled up. Turn over.

Of spirits. We have said, on the other side of this page, that the definition of a spirit is a power conjoined to a body; because it cannot move of its own accord, nor can it have any kind of motion in space; and if you were to say that it moves itself, this cannot be within the elements. For, if the spirit is an incorporeal quantity, this quantity is called a vacuum, and a vacuum does not exist in nature; and granting that one were formed, it would be immediately filled up by the rushing in of the element in which the vacuum had been generated. Therefore, from the definition of weight, which is this—gravity is an accidental power, created by one element being drawn to or suspended in another—it follows that an element, not weighing anything compared with itself, has weight in the element above it and lighter than it; as we see that the parts of water have no gravity or levity compared with other water, but if you draw it up into the air, then it will acquire weight, and if you were to draw the air beneath the water then the water which remains above this air would acquire weight, which weight could not sustain itself, whence collapse is inevitable. And this happens in water; wherever the vacuum may be in this water it will fall in; and this would happen with a spirit amid the elements, where it would continuously generate a vacuum in whatever element it might find itself, whence it would be inevitable that it should be constantly flying towards the sky until it had quitted these elements.

Every quantity is intellectually conceivable as infinitely divisible.

Amid the vastness of the things among which we live, the existence of nothingness holds the first place; its function extends over all things that have no existence, and its essence, as regards time, lies precisely between the past and the future, and has nothing in the present. This nothingness has the part equal to the whole, and the whole to the part, the divisible to the indivisible; and the product of the sum is the same whether we divide or multiply, and in addition as in subtraction; as is proved by arithmeticians by their tenth figure which represents zero; and its power has not extension among the things of Nature.

What is called nothingness is to be found only in time and in speech. In time it stands between the past and future and

has no existence in the present; and thus in speech it is one of the things of which we say: They are not, or they are impossible.

With regard to time, nothingness lies between the past and the future, and has nothing to do with the present, and as to its nature it is to be classed among things impossible: hence, from what has been said, it has no existence; because where there is nothing there would necessarily be a vacuum.

Example of the lightning in clouds. O mighty and once living instrument of formative nature. Incapable of availing thyself of thy vast strength thou hast to abandon a life of stillness and to obey the law which God and time gave to procreative nature.

Ah! how many a time the shoals of terrified dolphins and the great tunny were seen to flee before thy cruel fury, to escape; while thy fulminations raised in the sea a sudden tempest with buffeting and submersion of ships in the great waves; and filling the uncovered shores with the terrified and desperate fishes which fled from thee, and were left high and dry when the sea abandoned them and became the abundant prey of the people in the neighborhood.

O time, swift robber of all created things, how many kings, how many nations hast thou undone, and how many changes of states and of various events have happened since the wondrous forms of this fish perished here in this cavernous and winding recess! Now destroyed by time thou liest patiently in this confined space with bones stripped and bare; serving as a support and prop for the superimposed mountain.

The watery element was left enclosed between the raised banks of the rivers, and the sea was seen between the uplifted earth and the surrounding air which has to envelop and enclose the complicated machine of the earth, and whose mass, standing between the water and the element of fire, remained much restricted and deprived of its indispensable moisture; the rivers will be deprived of their waters, the fruitful earth will put forth no more her light verdure; the fields will no more be decked with waving corn; all the animals, finding no fresh grass for pasture, will die and food will then be lacking to the lions and wolves and other beasts of prey, and to men who after many efforts will be compelled to abandon their life, and the human race will die out. In this way the fertile and fruitful earth will remain deserted, arid, and sterile from

the water being shut up in its interior, and from the activity of nature it will continue a little time to increase until, the cold and subtle air being gone, it will be forced to end with the element of fire; and then its surface will be left burnt up to cinder and this will be the end of all terrestrial nature.

Why did nature not ordain that one animal should not live by the death of another? Nature, being inconstant and taking pleasure in creating and making constantly new lives and forms, because she knows that her terrestrial materials become thereby augmented, is more ready and more swift in her creating than time in his destruction; and so she has ordained that many animals shall be food for others. Nay, this not satisfying her desire, to the same end she frequently sends forth certain poisonous and pestilential vapors upon the vast increase and congregation of animals; and most of all upon men, who increase vastly because other animals do not feed upon them; and, the causes being removed, the effects would not follow. This earth therefore seeks to lose its life, desiring only continual reproduction; and as, by the argument you bring forward and demonstrate, like effects always follow like causes, animals are the image of the world.

BESTIARY

Cheerfulness. Cheerfulness is proper to the cock, which rejoices over every little thing, and crows with varied and lively movements.

Gratitude. The virtue of gratitude is said to be more developed in the birds called hoopoes, which, knowing the benefits of life and food they have received from their father and their mother, when they see them grow old, make a nest for them and brood over them and feed them, and with their beaks pull out their old and shabby feathers; and then, with a certain herb restore their sight so that they return to a prosperous state.

Cruelty. The basilisk is so utterly cruel that when it cannot kill animals by its baleful gaze, it turns upon herbs and plants, and fixing its gaze on them withers them up.

Generosity. It is said of the eagle that it is never so hungry but that it will leave a part of its prey for the birds that are

round it, which, being unable to provide their own food, are necessarily dependent on the eagle, since it is thus that they obtain food.

Flatterers, or sirens. The siren sings so sweetly that she lulls the mariners to sleep; then she climbs upon the ships and kills the sleeping mariners.

Prudence. The ant, by her natural foresight, provides in the summer for the winter, killing the seeds she harvests that they may not germinate, and on them in due time she feeds.

Justice. We may liken the virtue of justice to the king of the bees which orders and arranges everything with judgment. For some bees are ordered to go to the flowers, others are ordered to labor, others to fight with the wasps, others to clear away all dirt, others to accompany and escort the king; and when he is old and has no wings they carry him. And if one of them fails in his duty, he is punished without reprieve.

Truth. Although partridges steal one another's eggs, nevertheless the young born of these eggs always return to their true mother.

Fidelity, or loyalty. The cranes are so faithful and loyal to their king that at night, when he is sleeping, some of them go round the field to keep watch at a distance; others remain near, each holding a stone in his foot, so that if sleep should overcome them, this stone would fall and make so much noise that they would wake up again. And there are others which sleep together round the king; and this they do every night, changing in turn so that their king may never find them wanting.

The love of virtue. The goldfinch is a bird of which it is related that, when it is carried into the presence of a sick person, if the sick man is going to die, the bird turns away its head and never looks at him; but if the sick man is to be saved the bird never loses sight of him but is the cause of curing him of all his sickness.

Like unto this is the love of virtue. It never looks at any vile or base thing, but rather clings always to pure and virtuous things and takes up its abode in a noble heart; as the birds do in green woods on flowery branches. And this love shows itself more in adversity than in prosperity; as light does, which shines most where the place is darkest.

Rage. It is said of the bear that when it goes to the haunts of bees to take their honey, the bees having begun to sting him he leaves the honey and rushes to revenge himself. And as he seeks to be revenged on all those that sting him, he is revenged on none; in such wise that his rage is turned to madness, and he flings himself on the ground, vainly exasperating, by his hands and feet, the foes against which he is defending himself.

Falsehood. The fox when it sees a flock of magpies or daws or birds of that kind, suddenly flings himself on the ground with his mouth open to look as he were dead; and these birds want to peck at his tongue, and he bites off their heads.

Magnanimity. The falcon never preys but on large birds; and it will let itself die rather than feed on little ones, or eat stinking meat.

Vainglory. As regards this vice, we read that the peacock is more guilty of it than any other animal. For it is always contemplating the beauty of its tail, which it spreads in the form of a wheel, and by its cries attracts to itself the gaze of the creatures that surround it.

And this is the last vice to be conquered.

Inconstancy. The swallow may serve for inconstancy, for it is always in movement, since it cannot endure the smallest discomfort.

Continence. The camel is the most lustful animal there is, and will follow the female for a thousand miles. But if you keep it constantly with its mother or sister it will leave them alone, so temperate is its nature.

The tiger. This beast is a native of Hyrcania, and it is something like the panther from the various spots on its skin. It is an animal of terrible swiftness; the hunter when he finds its young carries them off hastily, placing mirrors in the place whence he takes them, and at once escapes on a swift horse. The panther returning finds the mirrors fixed on the ground and looking into them believes it sees its young; then scratching with its paws it discovers the cheat. Forthwith, by means of the scent of its young, it follows the hunter, and when this hunter sees the tigress he drops one of the young ones and

she takes it, and having carried it to the den she immediately returns to the hunter and does the same until he gets into his boat.

The cerastes. This has four movable little horns; so, when it wants to feed, it hides under leaves all of its body except these little horns which, as they move, seem to the birds to be some small worms at play. Then they immediately swoop down to pick them and the cerastes suddenly twines round them and encircles and devours them.

A fable. The ant found a grain of millet. The seed feeling itself taken prisoner cried out to her: "If you will do me the kindness to allow me to accomplish my function of reproduction, I will give you a hundred such as I am." And so it was.

A spider found a bunch of grapes which for its sweetness was much resorted to by bees and divers kinds of flies. It seemed to her that she had found a most convenient spot to spread her snare, and having settled herself on it with her delicate web, and entered into her new habitation, there, every day placing herself in the openings made by the spaces between the grapes, she fell like a thief on the wretched creatures which were not aware of her. But, after a few days had passed, the vintager came, and cut away the bunch of grapes and put it with others, with which it was trodden; and thus the grapes were a snare and pitfall both for the treacherous spider and the betrayed flies.

An ass having gone to sleep on the ice over a deep lake, his heat dissolved the ice and the ass awoke under water to his great grief, and was forthwith drowned.

A falcon, unable to endure with patience the disappearance of a duck, which, flying before him, had plunged under water, wished to follow it under water, and having soaked his feathers had to remain in the water, while the duck, rising to the air, mocked at the falcon as he drowned.

The spider wishing to take flies in her treacherous net, was cruelly killed in it by the hornet.

An eagle wanting to mock at the owl was caught by the wings in birdlime and was taken and killed by a man.

The water finding itself in its element, the lordly ocean, was seized with a desire to rise above the air, and being encouraged by the element of fire and rising as a very subtle

vapor, it seemed as though it were really as thin as air. But having risen very high, it reached the air that was still more rare and cold, where the fire forsook it, and the minute particles, being brought together, united and became heavy; whence, its haughtiness deserting it, it betook itself to flight and it fell from the sky, and was drunk up by the dry earth, where, being imprisoned for a long time, it did penance for its sin.

A fable. The razor having one day come forth from the handle which serves as its sheath and having placed himself in the sun, saw the sun reflected in his body, which filled him with great pride. And turning it over in his thoughts he began to say to himself: "And shall I return again to that shop from which I have just come? Certainly not; such splendid beauty shall not, please God, be turned to such base uses. What folly it would be that could lead me to shave the lathered beards of rustic peasants and perform such menial service! Is this body destined for such work? Certainly not. I will hide myself in some retired spot and there pass my life in tranquil repose." And having thus remained hidden for some months, one day he came out into the air, and, issuing from his sheath, saw himself turned to the similitude of a rusty saw while his surface no longer reflected the resplendent sun. With useless repentance he vainly deplored the irreparable mischief, saying to himself: "Oh! how far better was it to employ at the barber's my lost edge of such exquisite keenness! Where is that lustrous surface? It has been consumed by this vexatious and unsightly rust."

The same thing happens to those minds which instead of exercise give themselves up to sloth. They are like the razor here spoken of, and lose the keenness of their edge, while the rust of ignorance spoils their form.

An artisan often going to visit a great gentleman without any definite purpose, the gentleman asked him what he did this for. The other said that he came there to have a pleasure which his lordship could not have; since to him it was a satisfaction to see men greater than himself, as is the way with the populace; while the gentleman could only see men of less consequence than himself; and so lords and great men were deprived of that pleasure.

Lies. The mole has very small eyes and it always lives underground; and it lives as long as it is in the dark but when

it comes into the light it dies immediately, because it becomes known—and so it is with lies.

Fear, or cowardice. The hare is always frightened; and the leaves that fall from the trees in autumn always keep him in terror and generally put him to flight.

Constancy. Constancy may be symbolized by the phoenix, which, knowing that by nature it must be resuscitated, has the constancy to endure the burning flames which consume it, and then it rises anew.

Incontinence. The unicorn, through its intemperance and not knowing how to control itself, for the love it bears to fair maidens forgets its ferocity and wildness; and laying aside all fear it will go up to a seated damsel and go to sleep in her lap, and thus the hunters take it.

Chastity. The turtledove is never false to its mate; and if one dies the other preserves perpetual chastity, and never again sits on a green bough, nor ever drinks of clear water.

Moderation. The ermine out of moderation never eats but once a day; it will rather let itself be taken by the hunters than take refuge in a dirty lair, in order not to stain its purity.

The swan. The swan is white without any spot, and it sings sweetly as it dies, its life ending with that song.

The stork. This bird, by drinking salt water, purges itself of distempers. If the male finds his mate unfaithful, he abandons her; and when it grows old its young ones brood over it, and feed it till it dies.

The oyster—for treachery. This creature, when the moon is full, opens itself wide, and when the crab looks in he throws in a piece of rock or seaweed and the oyster cannot close again, whereby it serves for food to that crab. This is what happens to him who opens his mouth to tell his secret. He becomes the prey of the treacherous hearer.

The asp. This carries instantaneous death in its fangs; and, that it may not hear the charmer it stops its ears with its tail.

The crocodile—hypocrisy. This animal catches a man and straightway kills him; after he is dead, it weeps for him with a lamentable voice and many tears. Then, having done lamenting, it cruelly devours him. It is thus with the hypocrite, who, for the smallest matter, has his face bathed with tears, but shows the heart of a tiger and rejoices in his heart at the woes of others, while wearing a pitiful face.

The caterpillar—for virtue in general. The caterpillar, which by means of assiduous care is able to weave round itself a new dwelling place with marvelous artifice and fine workmanship, comes out of it afterwards with painted and lovely wings, with which it rises towards Heaven.

The elephant. The huge elephant has by nature what is rarely found in man; that is Honesty, Prudence, Justice, and the Observance of Religion; inasmuch as, when the moon is new, these beasts go down to the rivers, and there, solemnly cleansing themselves, they bathe, and so, having saluted the planet, return to the woods. And when they are ill, being laid down, they fling up plants towards Heaven as though they would offer sacrifice. —They bury their tusks when they fall out from old age. —Of these two tusks they use one to dig up roots for food; but they save the point of the other for fighting with; when they are taken by hunters and when worn out by fatigue, they dig up these buried tusks and ransom themselves therewith.

They are merciful, and know the dangers, and if one finds a man alone and lost, he kindly puts him back in the road he has missed, if he finds the footprints of the man before the man himself. It dreads betrayal, so it stops and blows, pointing it out to the other elephants who form in a troop and go warily.

These beasts always go in troops, and the oldest goes in front and the second in age remains the last, and thus they enclose the troop. Out of shame they pair only at night and secretly, nor do they then rejoin the herd but first bathe in the river. The females do not fight as with other animals; and it is so merciful that it is most unwilling by nature ever to hurt those weaker than itself. And if it meets in the middle of its way a flock of sheep it puts them aside with its trunk, so as not to trample them under foot; and it never hurts anything unless when provoked. When one has fallen into a pit

the others fill up the pit with branches, earth, and stones, thus raising the bottom that he may easily get out. They greatly dread the noise of swine and fly in confusion, doing no less harm then, with their feet, to their own kind than to the enemy. They delight in rivers and are always wandering about near them, though on account of their great weight they cannot swim. They devour stones, and the trunks of trees are their favorite food. They have a horror of rats. Flies delight in their smell and settle on their back, and the beast scrapes its skin making its folds even and kills them.

When they cross rivers they send their young ones up against the stream of the water; thus, being themselves set towards the fall, they break the united current of the water so that the current does not carry them away. The dragon flings itself under the elephant's body, and with its tail it ties its legs; with its wings and with its arms it also clings round its ribs and cuts its throat with its teeth, and the elephant falls upon it and the dragon is burst. Thus, in its death it is revenged on its foe.

The panther in Africa. This has the form of the lioness but it is taller on its legs and slimmer and long bodied; and it is all white and marked with black spots after the manner of rosettes; and all animals delight to look upon these rosettes, and they would always be standing round it if it were not for the terror of its face; therefore, knowing this, it hides its face, and the surrounding animals grow bold and come close, the better to enjoy the sight of so much beauty; when suddenly it seizes the nearest and at once devours it.

Camels. The Bactrian have two humps; the Arabian one only. They are swift in battle and most useful to carry burdens. This animal is extremely observant of rule and measure, for it will not move if it has a greater weight than it is used to, and if it is taken too far it does the same, and suddenly stops and so the merchants are obliged to lodge there.

The hippopotamus. This beast when it feels itself overfull goes about seeking thorns, or where there may be the remains of canes that have been split, and it rubs against them till a vein is opened; then when the blood has flowed as much as he needs, he plasters himself with mud and heals the wound. In form he is something like a horse with hooves cloven, a twisted tail, and the teeth of a wild boar; his neck has a

mane; the skin cannot be pierced, unless when he is bathing; he feeds on plants in the fields and goes into them backwards so that it may seem as though he had come out.

A fable. A dog lying asleep on the fur of a sheep, one of his fleas, perceiving the odor of the greasy wool, judged that this must be a land of better living, and also more secure from the teeth and nails of the dog than where he fed on the dog; and without farther reflection he left the dog and went into the thick wool. There he began with great labor to try to pass among the roots of the hairs; but after much sweating had to give up the task as vain, because these hairs were so close that they almost touched one another, and there was no space where fleas could taste the skin. Hence, after much labor and fatigue, he began to wish to return to his dog, who, however, had already departed; so he was constrained, after long repentance and bitter tears, to die of hunger.

A fable. The monkey, finding a nest of small birds, went up to it greatly delighted. But they being already fledged, he could only succeed in taking the smallest: greatly delighted he took it in his hand and went to his abode; and having begun to look at the little bird he took to kissing it, and from excess of love he kissed it so much and turned it about and squeezed it till he killed it. This is said for those who by not punishing their children let them come to mischief.

A fable. A stone of some size recently uncovered by the water lay on a certain spot somewhat raised, and just where a delightful grove ended by a stony road; here it was surrounded by plants decorated by various flowers of divers colors. And as it saw the great quantity of stones collected together in the roadway below, it began to wish it could let itself fall down there, saying to itself: "What have I to do here with these plants? I want to live in the company of those, my sisters." And letting itself fall, its rapid course ended among these longed-for companions. When it had been there some time it began to find itself constantly toiling under the wheels of the carts, the iron-shod feet of horses, and of travelers. This one rolled it over, that one trod upon it; sometimes it lifted itself a little and then it was covered with mud or the dung of some animal, and it was in vain that it

looked at the spot whence it had come as a place of solitude and tranquil peace.

Thus it happens to those who choose to leave a life of solitary contemplation, and come to live in cities among people full of infinite evil.

The citron, being desirous of producing a fine and noble fruit at its summit, set to work to form it with all the strength of its sap. But this fruit, when grown, was the cause of the tall and upright treetop being bent over.

The peach, being envious of the vast quantity of fruit which she saw borne on the nut tree, her neighbor, determined to do the same, and loaded herself with her own in such a way that the weight of the fruit pulled her up by the roots and broke her down to the ground.

A fable. A nut, having been carried by a crow to the top of a tall campanile and released by falling into a chink from the mortal grip of its beak, it prayed the wall by the grace bestowed on it by God in allowing it to be so high and thick, and to own such fine bells and of so noble a tone, that it would succor it, and that, as it had not been able to fall under the verdurous boughs of its venerable father and lie in the fat earth covered up by his fallen leaves, it would not abandon it; because, finding itself in the beak of the cruel crow, it had there made a vow that if it escaped from her it would end its life in a little hole. At these words the wall, moved to compassion, was content to shelter it in the spot where it had fallen; and after a short time the nut began to split open and put forth roots between the rifts of the stones and push them apart, and to throw out shoots from its hollow shell; and, to be brief, these rose above the building and the twisted roots, growing thicker, began to thrust the walls apart, and tear out the ancient stones from their old places. Then the wall too late and in vain bewailed the cause of its destruction, and in a short time it wrought the ruin of a great part of it.

A jest. A priest, making the rounds of his parish on Easter Eve, and sprinkling holy water in the houses as is customary, came to a painter's room, where he sprinkled the water on some of his pictures. The painter turned round, somewhat angered, and asked him why this sprinkling had been bestowed on his pictures; then said the priest that it was the custom

and his duty to do so, and that he was doing good; and that he who did good might look for good in return, and, indeed, for better, since God had promised that every good deed that was done on earth should be rewarded a hundredfold from above. Then the painter, waiting till he went out, went to an upper window and flung a large pail of water on the priest's back, saying: "Here is the reward a hundredfold from above, which you said would come from the good you had done me with your holy water, by which you have damaged my pictures."

Franciscan begging friars are wont, at certain times, to keep fasts when they do not eat meat in their convents. But on journeys, as they live on charity, they have license to eat whatever is set before them. Now a couple of these friars on their travels stopped at an inn, in company with a certain merchant, and sat down with him at the same table, where, from the poverty of the inn, nothing was served to them but a small roast chicken. The merchant, seeing this to be but little even for himself, turned to the friars and said: "If my memory serves me, you do not eat any kind of flesh in your convents at this season." At these words the friars were compelled by their rule to admit, without cavil, that this was the truth; so the merchant had his wish, and ate the chicken and the friars did the best they could. After dinner the messmates departed, all three together, and after traveling some distance they came to a river of some width and depth. All three being on foot—the friars by reason of their poverty, and the other from avarice—it was necessary by the custom of company that one of the friars, being barefoot, should carry the merchant on his shoulders: so, having given his wooden shoes into his keeping, he took up his man. But it so happened that when the friar had got to the middle of the river, he again remembered a rule of his order, and, stopping short, he looked up, like Saint Christopher, to the burden on his back and said: "Tell me, have you any money about you?" "You know I have," answered the other. "How do you suppose that a merchant like me should go about otherwise?" "Alack!" cried the friar, "our rules forbid us to carry any money on our persons," and forthwith he dropped him into the water, which the merchant perceived was a facetious way of being revenged on the indignity he had done them; so, with a smiling face, and blushing somewhat with shame, he peaceably endured the revenge.

A jest. It was asked of a painter why, since he made such beautiful figures, which were but dead things, his children were so ugly; to which the painter replied that he made his pictures by day, and his children by night.

A jest. A sick man finding himself *in articulo mortis* heard a knock at the door, and asking one of his servants who was knocking, the servant went out, and answered that it was a woman calling herself Madonna Bona. Then the sick man lifting his arms to Heaven thanked God with a loud voice, and told the servants that they were to let her come in at once, so that he might see one good woman before he died, since in all his life he had never yet seen one.

A jest. A man was desired to rise from his bed, because the sun was already risen. To which he replied: "If I had as far to go and as much to do as he has, I should be risen by now; but having but a little way to go, I shall not rise yet."

PROPHECIES

Many who hold the faith of the Son only build temples in the name of the Mother. —*Of Christians.*

A great portion of bodies that have been alive will pass into the bodies of other animals; which is as much as to say, that the deserted tenements will pass piecemeal into the inhabited ones, furnishing them with good things, and carrying with them their evils. That is to say the life of man is formed from things eaten, and these carry with them that part of man which dies. . . . —*Of food which has been alive.*

That shall be brought forth out of dark and obscure caves, which will put the whole human race in great anxiety, peril, and death. To many that seek them, after many sorrows they will give delight, and to those who are not in their company, death with want and misfortune. This will lead to the commission of endless crimes; this will increase and persuade bad men to assassinations, robberies, and enslavement, and by reason of it each will be suspicious of his partner. This will deprive free cities of their happy condition; this will take away the lives of many; this will make men torment one another with many artifices, deceptions, and treasons. O monstrous creature! How much better would it be for men

that everything should return to Hell! For this the vast forests will be devastated of their trees; for this endless animals will lose their lives. —*Of metals.*

Huge bodies will be seen, devoid of life, carrying, in fierce haste, a multitude of men to the destruction of their lives. —*Of ships which sink.*

The high walls of great cities will be seen upside down in their ditches. —*Of the reflection of walls of cities in the water of their ditches.*

All men will suddenly be transferred into opposite hemispheres. —*The world may be divided into two hemispheres at any point.*

All living creatures will be moved from the east to the west; and in the same way from the north to the south, and vice versa. —*The division of the East from the West may be made at any point.*

Oh! how many will they be that never come to birth! —*Of eggs which being eaten cannot form chickens.*

Throughout Europe there will be a lamentation of great nations over the death of one man who died in the East. —*Of the lamentation on Good Friday.*

Men will walk and not stir, they will talk to those who are not present, and hear those who do not speak. —*Of dreaming.*

Shapes and figures of men and animals will be seen following these animals and men wherever they flee. And exactly as the one moves the other moves; but what seems so wonderful is the variety of height they assume. —*Of a man's shadow which moves with him.*

Many persons puffing out a breath with too much haste, will thereby lose their sight, and soon after all consciousness. —*Of putting out the light when going to bed.*

The severest labor will be repaid with hunger and thirst, and discomfort, and blows, and goadings, and curses, and great abuse. —*Of asses.*

Many men will be seen carried by large animals, swift of pace, to the loss of their lives and immediate death.

In the air and on earth animals will be seen of divers colors furiously carrying men to the destruction of their lives. —*Of soldiers on horseback.*

The motions of a dead thing will make many living ones flee with pain and lamentation and cries. —*Of a stick, which is dead.*

With a stone and with iron, things will be made visible which before were not seen. —*Of tinder.*

Invisible money will procure the triumph of many who will spend it. —*Of friars, who, spending nothing but words, receive great gifts and bestow Paradise.*

Men will speak with each other from the most remote countries, and reply. —*Of writing letters from one country to another.*

There will be many men who, when they go to their labor, will put on the richest clothes, and these will be made after the fashion of aprons [petticoats]. —*Of priests who say Mass.*

And unhappy women will, of their own free will, reveal to men all their sins and shameful and most secret deeds. —*Of friars who are confessors.*

Many will there be who will give up work and labor and poverty of life and goods, and will go to live among wealth in splendid buildings, declaring that this is the way to make themselves acceptable to God. —*Of churches and habitations of friars.*

Those who give light for divine service will be destroyed. —*The bees which make the wax for candles.*

The water dropped from the clouds still in motion on the flanks of mountains will lie still for a long period of time without any motion whatever; and this will happen in many and divers lands. —*Snow, which falls in flakes, and is water.*

Blood will be seen issuing from the torn flesh of men, and trickling down the surface.

Men will have such cruel maladies that they will tear their flesh with their own nails. —*The itch.*

Plants will be seen left without leaves, and the rivers standing still in their channels.

The waters of the sea will rise above the high peaks of the mountains towards heaven and fall again on to the dwellings of men. —*That is, in clouds.*

The largest trees of the forest will be seen carried by the fury of the winds from east to west. —*That is, across the sea.*

Men will cast away their own victuals. —*That is, in sowing.*

Feathers will raise men, as they do birds, towards heaven. —*That is, by the letters which are written with their quills.*

The works of men's hands will occasion their death. —*Swords and spears.*

Men out of fear will cling to the thing they most fear. —*That is, they will be miserable lest they should fall into misery.*

Things that are separate shall be united and acquire such virtue that they will restore to man his lost memory. —*That is, papyrus sheets which are made of separate strips and have preserved the memory of the things and acts of men.*

The bones of the dead will be seen by their rapid movement to govern the fortunes of him who moves them. —*By dice.*

Cattle with their horns protect the flame from its death. —*In a lantern.*

The forests will bring forth young which will be the cause of their death. —*The handle of the hatchet.*

Men will take pleasure in seeing their own work destroyed and injured. —*Shoemakers.*

If Petrarch was so fond of bay, it was because it is of good taste with sausages and thrush; I cannot put any value on their foolery.

We are two brothers, each of us has a brother. —*Here the way of saying it makes it appear that the two brothers have become four.*

Tricks of dividing. Take in each hand an equal number; put 4 from the right hand into the left; cast away the remainder; cast away an equal number from the left hand; add 5, and now you will find 13 in this left hand; that is—I made you put 4 from the right hand into the left, and cast away the

remainder; now your right hand has 4 more; then I make you throw away as many from the right as you threw away from the left; so throwing from each hand a quantity of which the remainder may be equal, you now have 4 and 4, which make 8, and that the trick may not be detected I made you put 5 more, which made 13.

Take any number less than 12 that you please; then take of mine enough to make up the number 12, and that which remains to me is the number which you at first had; because when I said, take any number less than 12 as you please, I took 12 into my hand, and of that 12 you took such a number as made up your number of 12; and what you added to your number, you took from mine; that is, if you had 8 to go as far as to 12, you took of my 12, 4; hence this 4 transferred from me to you reduced my 12 to a remainder of 8, and your 8 became 12; so that my 8 is equal to your 8, before it was made 12.

ON WATER

The beginning of the treatise on water. By the ancients man has been called the world in miniature; and certainly this name is well bestowed, because, inasmuch as man is composed of earth, water, air, and fire, his body resembles that of the earth; and as man has in him bones, the supports and framework of his flesh, the world has its rocks, the supports of the earth; as man has in him a pool of blood in which the lungs rise and fall in breathing, so the body of the earth has its ocean tide which likewise rises and falls every six hours, as if the world breathed; as in that pool of blood veins have their origin, which ramify all over the human body, so likewise the ocean sea fills the body of the earth with infinite springs of water. The body of the earth lacks sinews, and this is because the sinews are made expressly for movements, and, the world being perpetually stable, no movement takes place, and no movement taking place, muscles are not necessary. But in all other points they are much alike.

The order of the first book on water. Define first what is meant by height and depth; also how the elements are situated one inside another. Then what is meant by solid weight and by liquid weight; but first what weight and lightness are in themselves. Then describe why water moves, and why its motion ceases; then why it becomes slower or more rapid;

besides this, how it always falls, being in contact with the air but lower than the air. And how water rises in the air by means of the heat of the sun, and then falls again in rain; again, why water springs forth from the tops of mountains; and if the water of any spring higher than the ocean can pour forth water higher than the surface of that ocean. And how all the water that returns to the ocean is higher than the sphere of water. And how the waters of the equatorial seas are higher than the waters of the north, and higher beneath the body of the sun than in any part of the equatorial circle; for experiment shows that under the heat of a burning brand the water near the brand boils, and the water surrounding this boiling center always sinks with a circular eddy. And how the waters of the north are lower than the other seas, and more so as they become colder until they are converted into ice.

The centers of the sphere of water are two, one universal and common to all water, the other particular. The universal one is that which is common to all waters not in motion, which exist in great quantities. As canals, ditches, ponds, fountains, wells, dead rivers, lakes, stagnant pools, and seas, which, although they are at various levels, have each in itself the limits of their surfaces equally distant from the center of the earth, such as lakes placed at the tops of high mountains; as the lake near Pietra Pana and the lake of the Sybil near Norcia; and all the lakes that give rise to great rivers, as the Ticino from Lago Maggiore, the Adda from the lake of Como, the Mincio from the lake of Garda, the Rhine from the lakes of Constance and of Chur, and from the lake of Lucerne, like the Trigon which passes through Minor Africa, carrying with it the waters of three marshes, one above the other at different heights, of which the highest is Munace, the middle one Pallas, and the lowest Triton; the Nile again flows from three very high marshes in Ethiopia.

Of the sea which changes the weight of the earth. The shells, oysters, and other similar animals, which originate in sea mud, bear witness to the changes of the earth round the center of our elements. This is proved thus: Great rivers always run turbid, being colored by the earth, which is stirred by the friction of their waters at the bottom and on their shores; and this wearing disturbs the face of the strata made by the layers of shells, which lie on the surface of the marine

mud, and which were produced there when the salt waters covered them; and these strata were covered over again from time to time with mud of various thickness, or carried down to the sea by the rivers and floods of more or less extent; and thus these shells remained walled in and dead underneath layers of mud raised to such a height that they came up from the bottom to the air. At the present time these bottoms are so high that they form hills or high mountains, and the rivers, which wear away the sides of these mountains, uncover the strata of these shells, and thus the softened side of the earth continually rises and the antipodes sink closer to the center of the earth, and the ancient bottoms of the seas have become mountain ridges.

Of the heat that is in the world. Where there is life there is heat, and where vital heat is, there is movement of vapor. This is proved, inasmuch as we see that the element of fire by its heat always draws to itself damp vapors and thick mists as opaque clouds, which it raises from seas as well as lakes and rivers and damp valleys; and these being drawn by degrees as far as the cold region, the first portion stops, because heat and moisture cannot exist with cold and dryness; and where the first portion stops, the rest settle; and thus one portion after another being added, thick and dark clouds are formed. They are often wafted about and borne by the winds from one region to another, where by their density they become so heavy that they fall in thick rain; and if the heat of the sun is added to the power of the element of fire, the clouds are drawn up higher still and find a greater degree of cold, in which they form ice and fall in storms of hail. Now the same heat which holds up so great a weight of water as is seen to rain from the clouds, draws them from below upwards, from the foot of the mountains, and leads and holds them within the summits of the mountains, and these, finding some fissure, issue continuously and cause rivers.

The opinion of some persons who say that the water of some seas is higher than the highest summits of mountains; and nevertheless the water was forced up to these summits. Water would not move from place to place if it were not that it seeks the lowest level, and by a natural consequence it never can return to a height like that of the place where it first, on issuing from the mountain, came to light. And that portion of the sea which, in your vain imagining, you say was so high that it flowed over the summits of the high moun-

tains, for so many centuries would be swallowed up and poured out again through the issue from these mountains. You can well imagine that all the time that Tigris and Euphrates have flowed from the summits of the mountains of Armenia, it must be believed that all the water of the ocean has passed very many times through these mouths. And do you not believe that the Nile must have sent more water into the sea than at present exists of all the element of·water? Undoubtedly, yes. And if all this water had fallen away from this body of the earth, this terrestrial machine would long since have been without water. Whence we may conclude that the water goes from the rivers to the sea, and from the sea to the rivers, thus constantly circulating and returning, and that all the sea and the rivers have passed through the mouth of the Nile an infinite number of times.

That the ocean does not penetrate under the earth. The ocean does not penetrate under the earth, and this we learn from the many and various springs of fresh water which, in many parts of the ocean, make their way up from the bottom to the surface. The same thing is further proved by wells dug beyond the distance of a mile from the said ocean, which fill with fresh water; and this happens because the fresh water is lighter than salt water and consequently more penetrating.

Which weighs most, water when frozen or when not frozen?

Fresh water penetrates more against salt water than salt water against fresh water. That fresh water penetrates more against salt water than salt water against fresh is proved by a thin cloth, dry and old, hanging with the two opposite ends equally low in the two different waters, the surfaces of which are at an equal level; and it will then be seen how much higher the fresh water will rise in this piece of linen than the salt: by so much is the fresh lighter than the salt.

Of waves. A wave of the sea always breaks in front of its base, and that portion of the crest will then be lowest which before was highest.

Of the flow and ebb. All seas have their flow and ebb in the same period, but they seem to vary because the days do not begin at the same time throughout the universe; in such wise as that when it is midday in our hemisphere, it is midnight in the opposite hemisphere; and at the eastern boundary of the two hemispheres the night begins which follows on the

day, and at the western boundary of these hemispheres begins the day which follows the night from the opposite side. Hence it is to be inferred that the above-mentioned swelling and diminution in the height of the seas, although they take place in one and the same space of time, are seen to vary from the above-mentioned causes. The waters are then withdrawn into the fissures which start from the depths of the sea and which ramify inside the body of the earth, corresponding to the sources of rivers, which are constantly taking from the bottom of the sea the water which has flowed into it. A sea of water is incessantly being drawn off from the surface of the sea. And if you should think that the moon, rising at the eastern end of the Mediterranean Sea, must there begin to attract to herself the waters of the sea, it would follow that we must at once see the effect of it at the eastern end of that sea. Again, as the Mediterranean Sea is about the eighth part of the circumference of the aqueous sphere, being 3,000 miles long, while the flow and ebb only occur 4 times in 24 hours, these results would not agree with the time of 24 hours, unless this Mediterranean Sea were six thousand miles in length; because if such a superabundance of water had to pass through the Strait of Gibraltar in running behind the moon, the rush of the water through that strait would be so great, and would rise to such a height, that beyond the strait it would for many miles rush so violently into the ocean as to cause floods and tremendous seething, so that it would be impossible to pass through. This agitated ocean would afterwards return the waters it had received with equal fury to the place they had come from, so that no one ever could pass through that strait. Now experience shows that at every hour they are passed in safety, but when the wind sets in the same direction as the current, the strong ebb increases. The sea does not raise the water that has issued from the strait, but it checks them and this retards the tide; then it makes up with furious haste for the time it has lost until the end of the ebb movement.

It is the property of water that it constitutes the vital humor of this arid earth; and the cause which moves it through its ramified veins, against the natural course of heavy matters, is the same property which moves the humors in every species of animate body. But that which crowns our wonder in contemplating it is that it rises from the utmost depths of the sea to the highest tops of the mountains, and flowing from the

opened veins returns to the low seas; then once more, and with extreme swiftness, it mounts again and returns by the same descent, thus rising from the inside to the outside, and going round from the lowest to the highest, from whence it rushes down in a natural course. Thus by these two movements combined in a constant circulation, it travels through the veins of the earth.

Of springs of water on the tops of mountains. It is quite evident that the whole surface of the ocean—when there is no storm—is at an equal distance from the center of the earth, and that the tops of the mountains are farther from this center in proportion as they rise above the surface of that sea; therefore, if the body of the earth were not like that of man, it would be impossible that the waters of the sea—being so much lower than the mountains—could by their nature rise up to the summits of these mountains. Hence it is to be believed that the same cause which keeps the blood at the top of the head in man keeps the water at the summits of the mountains.

Of the vibration of the earth. The subterranean channels of waters, like those which exist between the air and the earth, are those which unceasingly wear away and deepen the beds of their currents.

A river that flows from mountains deposits a great quantity of large stones in its bed which still have some of their angles and sides, and in the course of its flow it carries down smaller stones with the angles more worn; that is to say, the large stones become smaller. And farther on it deposits coarse gravel and then smaller, and as it proceeds this becomes coarse sand and then finer, and going on thus the water, turbid with sand and gravel, joins the sea; and the sand settles on the seashores, being cast up by the salt waves; and there results the sand of so fine a nature as to seem almost like water, and it will not stop on the shores of the sea but returns by reason of its lightness, because it was originally formed of rotten leaves and other very light things. Still, being almost— as was said—of the nature of water itself, it afterwards, when the weather is calm, settles and becomes solid at the bottom of the sea, where by its fineness it becomes compact and by its smoothness resists the waves which glide over it; and in this shells are found; and this is white earth, fit for pottery.

All the torrents of water flowing from the mountains to

the sea carry with them the stones from the hills to the sea, and by the influx of the sea water towards the mountains these stones were thrown back towards the mountains, and as the waters rose and retired, the stones were tossed about by it, and, in rolling, their angles hit together; then as the parts which least resisted the blows were worn off, the stones ceased to be angular and became round in form, as may be seen on the shores of Elba. And those remained larger which were less removed from their native spot: and they became smaller the farther they were carried from that place, so that in the process they were converted into small pebbles and then into sand and at last into mud. After the sea had receded from the mountains the brine left by the sea with other humors of the earth made a concretion of these pebbles and this sand, so that the pebbles were converted into rock and the sand into tufa. And of this we see an example in the Adda where it issues from the mountains of Como, and in the Ticino, the Adige, the Oglio and Adria from the German Alps, and in the Arno at Monte Albano, near Monte Lupo and Capraia, where the rocks, which are very large, are all of conglomerated pebbles of various kinds and colors.

Men born in hot countries love the night because it refreshes them and have a horror of light because it burns them; and therefore they are of the color of night, that is black. And in cold countries it is just the contrary.

Chapter 11

THE WHOLE MAN— THE MAN HIMSELF— THE ENIGMA

In this final section are found all sorts of jottings and memoranda, reminders, expense accounts, the sort of lists, slightly crumpled, which are drawn from the pocket of an old coat, as well as letters or drafts of letters to patrons and friends, grumbled complaints about the beautiful young scoundrels who seemed constantly to be troublesome members of his household, but from whom he could not part. These tell us all we can know—and it is not much—of Leonardo's personal life. They are fascinating in their homeliness, and serve to underline, for the most part, the loneliness of the great man. Here as we search we find indications of the never-flinching, never-tiring eye, which could dispassionately append to a sketch of a hanged man the colors and fabrics of the rather elegant clothes in which he had gone to his ignominious traitor's death. Here are complaints, notations of money due, suspicions of other men, reminders of the faces, beautiful or grotesque, seen in the streets, followed perhaps, noted as possibilities for some painting just taking shape in the artist's mind. And here too are the avid scholar's reminders of books to read and who owns them. It is little enough considering the stature of the man it represents.

Obstacles cannot crush me
Every obstacle yields to stern resolve
He who is fixed to a star does not change his mind.

Movement will cease before we are weary
of being useful
Movement will fail sooner than usefulness.
Death sooner than weariness. I am never weary of being
useful,
In serving others I cannot do is a motto for carnival.
enough. Without fatigue
No labor is sufficient to tire
me.
Hands into which ducats and
precious stones fall like
snow; they never become
tired of serving, but this
service is only for its
utility and not for our I am never weary
own benefit. of being useful.
Naturally
nature has so disposed
me.
Truth here makes Falsehood torment lying tongues.
Such as harm is when it hurts me not, is good which avails
me not.

[Costume notes on a drawing of the hanged Pazzi conspirator]
A tan-colored small cap,
A doublet of black serge,
A black jerkin lined,
A blue coat lined
with fur of foxes' breasts,
and the collar of the jerkin
covered with black
and red stippled velvet.
Bernardo di Bandino
Baroncelli;
black hose.

[An inventory of drawings]
A head, full face, of a young man
with fine flowing hair,
Many flowers drawn from nature,
A head, full face, with curly hair,
Certain figures of Saint Jerome,
The measurements of a figure,
Drawings of furnaces.

A head of the Duke,
many designs for knots,
4 studies for the panel of Saint Angelo,
A small composition of Girolamo da Fegline,
A head of Christ done with the pen,
8 Saint Sebastians,
Several compositions of Angels,
A chalcedony,
A head in profile with fine hair,
Some pitchers seen in perspective,
Some machines for ships,
Some machines for waterworks,
A head, a portrait of Atalanta raising her face;
The head of Geronimo da Fegline,
The head of Gian Francesco Boso,
Several throats of old women,
Several heads of old men,
Several nude figures, complete,
Several arms, legs, feet, and poses,
A Madonna, finished,
Another almost, which is in profile,
Head of Our Lady ascending into Heaven,
A head of an old man with very long neck,
A head of a gypsy girl,
A head with a hat on,
A representation of the Passion, a cast,
A head of a girl with her hair gathered in a knot,
A head, with the brown hair dressed.

Il Moro as representing Good Fortune, with hair, and robes, and his hands in front, and Messer Gualtieri taking him by the robes with a respectful air from below, having come in from the front.

Again, Poverty in a hideous form running behind a youth. Il Moro covers him with the skirt of his robe, and with his gilt scepter he threatens the monster.

A plant with its roots in the air to represent one who is at his last; a robe and Favor.

Of tricks [or of magpies] and of burlesque poems [or of starlings].

Those who trust themselves to live near him, and who will be a large crowd, these shall all die cruel deaths; and fathers and mothers together with their families will be devoured and killed by cruel creatures.

Fame should be depicted as covered all over with tongues instead of feathers, and in the figure of a bird.

Pleasure and Pain represent as twins, since there never is one without the other; and as if they were united back to back, since they are contrary to each other.

Clay, gold.

If you take Pleasure know that he has behind him one who will deal you Tribulation and Repentance.

This is Pleasure together with Pain, and show them as twins because one is never apart from the other. They are back to back because they are opposed to each other; and they exist as contraries in the same body, because they have the same basis, inasmuch as the origin of pleasure is labor and pain, and the various forms of evil pleasure are the origin of pain. Therefore he is here represented with a reed in his right hand which is useless and without strength, and the wounds it inflicts are poisoned. In Tuscany they are put to support beds, to signify that it is here that vain dreams come, and here a great part of life is consumed. It is here that much precious time is wasted, that is, in the morning, when the mind is composed and rested, and the body is made fit to begin new labors; there again many vain pleasures are enjoyed; both by the mind in imagining impossible things, and by the body in taking those pleasures that are often the cause of the failing of life. And for these reasons the reed is held as their support.

Evil-thinking is either Envy or Ingratitude.

A dress for the carnival. To make a beautiful dress cut it in thin cloth and give it an odoriferous varnish, made of oil of turpentine and of varnish; ingrain, with a pierced stencil, which must be wetted, that it may not stick to the cloth; and this stencil may be made in a pattern of knots which afterwards may be filled up with black and the ground with white millet.

Snow taken from the high peaks of mountains might be carried to hot places and let to fall at festivals in open places at summer time.

A remedy for scratches taught me by the Herald to the King of France. 4 ounces of virgin wax, 4 ounces of colophony, 2 ounces of incense. Keep each thing separate; and melt the wax, and then put in the incense and then the colophony, make a mixture of it and put it on the sore place.

I teach you to preserve your health; and in this you will succeed better in proportion as you shun physicians, because their medicines are the work of alchemists.

To keep in health, this rule is wise: Eat only when you want and relish food. Chew thoroughly that it may do you good. Have it well cooked, unspiced, and undisguised. He who takes medicine is ill advised.

At Candia in Lombardy, near Alessandria della Paglia, in making a well for Messer Gualtieri of Candia, the skeleton of a very large boat was found about 10 braccia underground; and as the timber was black and fine, it seemed good to the said Messer Gualtieri to have the mouth of the well lengthened in such a way as that the ends of the boat should be uncovered.

At Monbracco, above Saluzzo—a mile above the Certosa, at the foot of Monte Viso, there is a quarry of flaky stone, which is as white as Carrara marble, without a spot, and as hard as porphyry or even harder; of which my worthy gossip, Master Benedetto the sculptor, has promised to give me a small slab, for the colors, the second day of January 1511.

The Egyptians, the Ethiopians, and the Arabs, in crossing the Nile with camels, are accustomed to attach two bags on the sides of the camels' bodies, that is, skins in the form shown underneath.

In these four meshes of the net the camels for baggage place their feet.

The Assyrians and the people of Euboea accustom their horses to carry sacks which they can at pleasure fill with air, and which in case of need they carry instead of the girth of the saddle above and at the side, and they are well covered with plates of *cuir bouilli,* in order that they may not be perforated by flights of arrows. Thus they have not on their minds their security in flight, when the victory is uncertain; a horse thus equipped enables four or five men to cross over at need.

The Spaniards, the Scythians and the Arabs, when they want to make a bridge in haste, fix hurdle-work made of willows on bags of oxhide, and so cross in safety.

Write to Bartolomeo the Turk as to the flow and ebb of the Black Sea, and whether he is aware if there be such a flow and ebb in the Hyrcanean or Caspian Sea.

How the five senses are the ministers of the soul. The soul seems to reside in the judgment, and the judgment would seem to be seated in that part where all the senses meet; and this is called the Common Sense and is not all-pervading throughout the body, as many have thought. Rather is it entirely in one part. Because, if it were all-pervading and the same in every part, there would have been no need to make the instruments of the senses meet in one center and in one single spot; on the contrary it would have sufficed that the eye should fulfill the function of its sensation on its surface only, and not transmit the image of the things seen to the sense, by means of the optic nerves, so that the soul— for the reason given above—may perceive it in the surface of the eye. In the same way as to the sense of hearing, it would have sufficed if the voice had merely sounded in the porous cavity of the indurated portion of the temporal bone which lies within the ear, without making any farther transit from this bone to the Common Sense, where the voice confers with and discourses to the common judgment. The sense of smell, again, is compelled by necessity to refer itself to that same judgment. Feeling passes through the perforated cords and is conveyed to this common sense. These cords diverge with infinite ramifications into the skin which encloses the members of the body and the viscera. The perforated cords convey volition and sensation to the subordinate limbs. These cords and the nerves direct the motions of the muscles and sinews, between which they are placed; these obey, and this obedience takes effect by reducing their thickness; for in swelling their length is reduced, and the nerves shrink which are interwoven among the particles of the limbs; being extended to the tips of the fingers, they transmit to the sense the object which they touch.

The nerves with their muscles obey the tendons as soldiers obey the officers, and the tendons obey the Common [central] Sense as the officers obey the general. Thus the joint of the bones obeys the nerve, and the nerve the muscle, and the muscle the tendon, and the tendon the Common Sense. And the Common Sense is the seat of the soul, and memory is its ammunition, and the impressibility is its referendary, since the sense waits on the soul and not the soul on the sense. And where the sense that ministers to the soul is not at the service

of the soul, all the functions of that sense are also wanting in that man's life, as is seen in those born mute and blind.

There are four Powers: memory and intellect, desire and covetousness. The two first are mental and the others sensual. The three senses: sight, hearing, and smell, cannot well be prevented; touch and taste not at all. Smell is connected with taste in dogs and other gluttonous animals.

I reveal to men the origin of the first, or perhaps second, cause of their existence.

Our life is made by the death of others.

In dead matter insensible life remains, which, reunited to the stomachs of living beings, resumes life, both sensual and intellectual.

That the blood which returns when the heart opens again is not the same as that which closes the valves of the heart.

Nothing originates in a spot where there is no sentient, vegetable, and rational life; feathers grow upon birds and are changed every year; hairs grow upon animals and are changed every year, excepting some parts, like the hairs of the beard in lions, cats, and their like. The grass grows in the fields, and the leaves on the trees, and every year they are, in great part, renewed. So that we might say that the earth has a spirit of growth; that its flesh is the soil, its bones the arrangement and connection of the rocks of which the mountains are composed, its cartilage the tufa, and its blood the springs of water. The pool of blood which lies round the heart is the ocean, and its breathing, and the increase and decrease of the blood in the pulses, is represented in the earth by the flow and ebb of the sea; and the heat of the spirit of the world is the fire which pervades the earth, and the seat of the vegetative soul is in the fires, which in many parts of the earth find vent in baths and mines of sulphur, and in volcanoes, as at Mount Etna in Sicily, and in many other places.

Of walking under water.
Method of walking on water.

The soul can never be corrupted with the corruption of the body, but is in the body as it were the air which causes the

sound of the organ, where when a pipe bursts, the wind
would cease to have any good effect.

I obey Thee Lord, first for the love I ought, in all reason,
to bear Thee; secondly for that Thou canst shorten or pro-
long the lives of men.

A prayer. Thou, O God, dost sell us all good things at the
price of labor.

Necessity is the mistress and guide of nature.

Necessity is the theme and the inventress, the eternal curb
and law of nature.

In many cases one and the same thing is attracted by two
strong forces, namely Necessity and Potency. Water falls in
rain; the earth absorbs it from the necessity for moisture; and
the sun raises it, not from necessity, but by its power.

Weight, force, and casual impulse, together with resistance,
are the four external powers in which all the visible actions
of mortals have their being and their end.

Our body is dependent on heaven and heaven on the Spirit.

The motive power is the cause of all life.

And you, O Man, who will discern in this work of mine
the wonderful works of Nature, if you think it would be a
criminal thing to destroy it, reflect how much more criminal
it is to take the life of a man; and if this, his external form,
appears to thee marvelously constructed, remember that it is
nothing as compared with the soul that dwells in that structure;
for that indeed, be it what it may, is a thing divine. Leave
it then to dwell in His work at His good will and pleasure,
and let not your rage or malice destroy a life—for, indeed,
he who does not value it, does not himself deserve it.

If anyone wishes to see how the soul dwells in its body,
let him observe how this body uses its daily habitation; that
is to say, if this is devoid of order and confused, the body
will be kept in disorder and confusion by its soul.

Why does the eye see a thing more clearly in dreams than
with the imagination, being awake?

The senses are of the earth; Reason stands apart in con-
templation.

Every action needs to be prompted by a motive.

To know and to will are two operations of the human mind.

Discerning, judging, deliberating, are acts of the human mind.

All our knowledge has its origin in our perceptions.

Science is the observation of things possible, whether present or past; prescience is the knowledge of things which may come to pass, though but slowly.

Experience, the interpreter between formative nature and the human race, teaches how that nature acts among mortals; and being constrained by necessity cannot act otherwise than as reason, which is its helm, requires her to act.

Nature is full of infinite causes that have never occurred in experience.

Truth was the only daughter of Time.

Experience never errs; it is only your judgments that err by promising themselves effects such as are not caused by your experiments.

Experience does not err; only your judgments err by expecting from her what is not in her power.

The part always has a tendency to reunite with its whole in order to escape from its imperfection.

The spirit desires to remain with its body, because, without the organic instruments of that body, it can neither act nor feel anything.

Avoid studies of which the result dies with the worker.

Men wrongly complain of Experience; with great abuse they accuse her of leading them astray, but they set Experience aside, turning from it with complaints as to our ignorance causing us to be carried away by vain and foolish desires to promise ourselves, in her name, things that are not in her power; saying that she is fallacious. Men are unjust in complaining of innocent Experience, constantly accusing her of error and of false evidence.

Instrumental or mechanical science is of all the noblest and the most useful, seeing that by means of this all animated bodies that have movement perform all their actions; and these

movements are based on the center of gravity which is placed in the middle dividing unequal weights, and it has dearth and wealth of muscles and also lever and counterlever.

MORALS

Now you see that the hope and the desire of returning home and to one's former state is like the moth to the light, and that the man who with constant longing awaits with joy each new springtime, each new summer, each new month and new year—deeming that the things he longs for are ever too late in coming—does not perceive that he is longing for his own destruction. But this desire is the very quintessence, the spirit, of the elements, which, finding itself imprisoned with the soul, is ever longing to return from the human body to its giver. And you must know that this same longing is that quintessence, inseparable from nature, and that man is the image of the world.

Every evil leaves behind a grief in our memory, except the supreme evil, that is death, which destroys this memory together with life.

The knowledge of past times and of the places on the earth is both an ornament and nutriment to the human mind.

To lie is so vile, that even if it were in speaking well of godly things it would take off. something from God's grace; and truth is so excellent that if it praises but small things they become noble.

Beyond a doubt, truth bears the same relation to falsehood as light to darkness; and this truth is in itself so excellent that, even when it dwells on humble and lowly matters, it is still infinitely above uncertainty and lies, disguised in high and lofty discourses; because in our minds, even if lying should be their fifth element, this does not prevent that the truth of things is the chief nutriment of superior intellects, though not of wandering wits.

But you who live in dreams are better pleased by the sophistical reasons and frauds of wits in great and uncertain things than by those reasons which are certain and natural and not so far above us.

Learning acquired in youth arrests the evil of old age; and if you understand that old age has wisdom for its food, you

will so conduct yourself in youth that your old age will not lack for nourishment.

The acquisition of any knowledge is always of use to the intellect, because it may thus drive out useless things and retain the good.

For nothing can be loved or hated unless it is first known.

As a day well spent procures a happy sleep, so a life well employed procures a happy death.

The water you touch in a river is the last of that which has passed, and the first of that which is coming. Thus it is with time present.

Life, if well spent, is long.

Just as eating against one's will is injurious to health, so study without a liking for it spoils the memory, and it retains nothing it takes in.

When Fortune comes, seize her in front with a sure hand, because behind she is bald.

Just as food eaten without caring for it is turned into loathsome nourishment, so study without a taste for it spoils memory, by retaining nothing which it has taken in.

Some there are who are nothing else than a passage for food and augmenters of excrement and fillers of privies, because through them no other things in the world, nor any good effects, are produced, since nothing but full privies results from them.

It seems to me that men of coarse and clumsy habits and of small knowledge do not deserve such fine instruments nor so great a variety of natural mechanism as men of speculation and of great knowledge; but merely a sack in which their food may be stowed and whence it may issue, since they cannot be judged to be anything else than vehicles for food; for it seems to me they have nothing about them of the human species but the voice and the figure, and for all the rest are much below beasts.

The greatest deception men suffer is from their own opinions.

That is not riches, which may be lost; virtue is our true good and the true reward of its possessor. That cannot be lost;

that never deserts us, but when life leaves us. As to property and external riches, hold them with trembling; they often leave their possessor in contempt, and mocked at for having lost them.

Every man wishes to make money to give it to the doctors, destroyers of life; they then ought to be rich.

Man has much power of discourse, which for the most part is vain and false; animals have but little, but it is useful and true, and a small truth is better than a great lie.

He who possesses most must be most afraid of loss.

He who wishes to be rich in a day will be hanged in a year.

That man is of supreme folly who always wants for fear of wanting; and his life flies away while he is still hoping to enjoy the good things which he has with extreme labor acquired.

We ought not to desire the impossible.

Ask counsel of him who rules himself well.

Justice requires power, insight, and will; and it resembles the queen bee.

He who does not punish evil commands it to be done.

He who takes the snake by the tail will presently be bitten by it.

The grave will fall in upon him who digs it.

The man who does not restrain wantonness, allies himself with beasts.

You can have no dominion greater or less than that over yourself.

He who thinks little, errs much.

It is easier to contend with evil at the first than at the last.

No counsel is more loyal than that given on ships which are in peril: He may expect loss who acts on the advice of an inexperienced youth.

The memory of benefits is a frail defense against ingratitude.

Reprove your friend in secret and praise him openly.

Be not false about the past.

A simile for patience. Patience serves us against insults precisely as clothes do against the cold. For if you multiply your garments as the cold increases, that cold cannot hurt you; in the same way increase your patience under great offenses, and they cannot hurt your feelings.

Just as courage imperils life, fear protects it.

Threats alone are the weapons of the threatened man.

Wherever good fortune enters, envy lays siege to the place and attacks it; and when it departs, sorrow and repentance remain behind.

He who walks straight rarely falls.

Envy wounds with false accusations, that is, with detraction, a thing which scares virtue.

We are deceived by promises and time disappoints us. . . .

Fear arises sooner than anything else.

It is bad if you praise, and worse if you reprove, a thing, I mean, if you do not understand the matter well.

It is ill to praise, and worse to reprimand in matters that you do not understand.

The subject with its form. The lover is moved by the beloved object as the senses are by sensible objects; and they unite and become one and the same thing. The work is the first thing born of this union; if the thing loved is base, the lover becomes base.

When the thing taken into union is perfectly adapted to that which receives it, the result is delight and pleasure and satisfaction.

When that which loves is united to the thing beloved it can rest there; when the burden is laid down it finds rest there.

Words which do not satisfy the ear of the hearer weary him or vex him, and the symptoms of this you will often see in such hearers in their frequent yawns; you, therefore, who speak before men whose good will you desire, when you see such an excess of fatigue, abridge your speech, or change your discourse; and if you do otherwise, then instead of the favor you desire, you will get dislike and hostility.

And if you would see in what a man takes pleasure, without hearing him speak, change the subject of your discourse in talking to him, and when you presently see him intent, without yawning or wrinkling his brow or other actions of various kinds, you may be certain that the matter of which you are speaking is such as is agreeable to him, etc.

Oh! speculators on perpetual motion how many vain projects of the like character you have created! Go and be the companions of the searchers for gold.

The false interpreters of nature declare that quicksilver is the common seed of every metal, not remembering that nature varies the seed according to the variety of the things she desires to produce in the world.

[Drafts of letters and reports on Armenia]

To the Devatdar of Syria, Lieutenant of the Sacred Sultan of Babylon

The recent disaster in our northern parts which I am certain will terrify not you alone but the whole world, which shall be related to you in due order, showing first the effect and then the cause. . . .

Finding myself in this part of Armenia to carry into effect with due love and care the task for which you sent me; and to make a beginning in a place which seemed to me to be most to our purpose, I entered into the city of Calindra, near to our frontiers. This city is situated at the base of that part of the Taurus Mountains which is divided from the Euphrates and looks towards the peaks of the great Mount Taurus to the west. These peaks are of such a height that they seem to touch the sky, and in all the world there is no part of the earth higher than its summit, and the rays of the sun always fall upon it on its east side, four hours before daytime; and being of the whitest stone it shines resplendently and fulfills the function to these Armenians which a bright moonlight would in the midst of the darkness; and by its great height it outreaches the utmost level of the clouds by a space of four miles in a straight line. This peak is seen in many places towards the west, illuminated by the sun after its setting the third part of the night. This it is which, with you, we formerly in calm weather had supposed to be a comet, and appears to us in the darkness of night to change its form, being sometimes divided in two or three parts, and sometimes long and sometimes short. And this is caused by the clouds on the horizon of the sky which interpose between part of this mountain and the sun, and by cutting off some of the solar rays, the light on the mountain is intercepted by various intervals of clouds, and therefore varies in the form of its brightness.

The divisions of the book.

The praise and confession of the faith.

The sudden inundation, to its end.

The destruction of the city.

The death of the people and their despair.

The search for the preacher, his release and benevolence.

Description of the cause of this fall of the mountain.

The mischief it did.

Fall of snow.

The finding of the prophet.

His prophecy.

The inundation of the lower portion of Eastern Armenia, the draining of which was effected by the cutting through the Taurus Mountains.

How the new prophet showed that this destruction had happened as he had foretold.

Description of the Taurus Mountains and the river Euphrates.

Why the mountain shines at the top, from half to a third of the night, and looks like a comet to the inhabitants of the West after the sunset, and before day to those of the East.

Why this comet appears of variable forms, so that it is now round and now long, and now again divided into two or three parts, and now in one piece, and when it is to be seen again.

Of the shape of the Taurus Mountains. I am not to be accused, O Devatdar, of idleness, as your chidings seem to hint; but your excessive love for me, which gave rise to the benefits you have conferred on me is that which has also compelled me to the utmost painstaking in seeking out and diligently investigating the cause of so great and stupendous an effect. And this could not be done without time; now, in order to satisfy you fully as to the cause of so great an effect, it is requisite that I should explain to you the form of the place, and then I will proceed to the effect, by which I believe you will be amply satisfied.

Do not be aggrieved, O Devatdar, by my delay in responding to your pressing request, for those things which you require of me are of such a nature that they cannot be well expressed without some lapse of time; particularly because, in order to explain the cause of so great an effect, it is necessary to describe with accuracy the nature of the place; and by this means I can afterwards easily satisfy your above-mentioned request.

I will pass over any description of the form of Asia Minor, or as to what seas or lands form the limits of its outline and extent, because I know that by your own diligence and carefulness in your studies you have not remained in ignorance

of these matters; and I will go on to describe the true form
of the Taurus Mountain which is the cause of this stupendous
and harmful marvel, and which will serve to advance us in our
purpose. This Taurus is that mountain which by many others
is said to be the ridge of Mount Caucasus; but, wishing to be
very clear about it, I desired to speak to some of the in-
habitants of the shores of the Caspian Sea, who give evidence
that this must be the true Caucasus, and that though their
mountains bear the same name, yet these are higher; and to
confirm this in the Scythian tongue Caucasus means a very
high peak, and in fact we have no information of there
being, in the east or in the west, any mountain so high. And
the proof of this is that the inhabitants of the countries to the
west see the rays of the sun illuminating a great part of its
summit for as much as a quarter of the longest night. And in
the same way, in those countries which lie to the east.

Of the structure and size of Mount Taurus. The shadow
of this ridge of the Taurus is of such a height that when, in
the middle of June, the sun is at its meridian, its shadow ex-
tends as far as the borders of Sarmatia, twelve days off; and
in the middle of December it extends as far as the Hyperborean
Mountains, which are at a month's journey to the north. And
the side which faces the wind is always full of clouds and
mists, because the wind which is parted in beating on the rock,
closes again on the farther side of that rock, and in its motion
carries with it the clouds from all quarters and leaves them
where it strikes. And it is always full of thunderbolts from
the great quantity of clouds which accumulate there, whence
the rock is all riven and full of huge debris. This mountain,
at its base, is inhabited by a very rich population and is full
of most beautiful springs and rivers, and is fertile and abound-
ing in all good produce, particularly in those parts which face
to the south. But after mounting about three miles we begin to
find forests of great fir trees, and beech and other similar
trees; after this, for a space of three more miles, there are
meadows and vast pastures; and all the rest, as far as the
beginning of the Taurus, is eternal snows which never disap-
pear at any time, and extend to a height of about fourteen
miles in all. From this beginning of the Taurus up to the
height of a mile the clouds never pass away; thus we have
fifteen miles, that is, a height of about five miles in a straight
line; and the summit of the peaks of the Taurus are as much,
or about that. There, halfway up, we begin to find a scorching
air and never feel a breath of wind; but nothing can live long

there; there nothing is brought forth save a few birds of prey which breed in the high fissures of Taurus and descend below the clouds to seek their prey. Above the wooded hills all is bare rock, that is, from the clouds upwards; and the rock is the purest white. And it is impossible to walk to the high summit on account of the rough and perilous ascent.

Having often made you, by my letters, acquainted with the things which have happened, I think I ought not to be silent as to the events of the last few days, which— . . .

Having several times—

Having many times rejoiced with you by letters over your prosperous fortunes, I know now that, as a friend, you will be sad with me over the miserable state in which I find myself; and this is that, during the last few days, I have been in so much trouble, fear, peril, and loss, besides the miseries of the people here, that we have been envious of the dead; and certainly I do not believe that since the elements by their separation reduced the vast chaos to order, they have ever combined their force and fury to do so much mischief to man. As far as regards us here, what we have seen and gone through is such that I could not imagine that things could ever rise to such an amount of mischief, as we experienced in the space of ten hours. In the first place we were assailed and attacked by the violence and fury of the winds; to this was added the falling of great mountains of snow which filled up all this valley, thus destroying a great part of our city. And not content with this the tempest sent a sudden flood of water to submerge all the low part of this city; added to which there came a sudden rain, or rather a ruinous torrent and flood of water, sand, mud, and stones, entangled with roots and stems and fragments of various trees; and every kind of thing flying through the air fell upon us; finally a great fire broke out, not brought by the wind, but carried, as it would seem, by ten thousand devils, which completely burned up all this neighborhood and it has not yet ceased. And those few who remain unhurt are in such dejection and such terror that they hardly have courage to speak to one another, as if they were stunned. Having abandoned all our business, we stay here together in the ruins of some churches, men and women mingled together, small and great, just like herds of goats. The neighbors out of pity succored us with victuals, and they had previously been our enemies. And if it had not been for certain people who succored us with victuals, all would have died of hunger. Now you see the state we are in. And all these

evils are as nothing compared with those which are promised to us shortly.

I know that as a friend you will grieve for my misfortunes, as I, in former letters, have shown my joy at your prosperity. . . .

[Drafts of letters to Lodovico il Moro (1340–1345)]

Most Illustrious Lord, having now sufficiently considered the specimens of all those who proclaim themselves skilled contrivers of instruments of war, and that the invention and operation of the said instruments are nothing different from those in common use: I shall endeavor, without prejudice to anyone else, to explain myself to Your Excellency showing Your Lordship my secrets, and then offering them to your best pleasure and approbation to work with effect at opportune moments on all those things which, in part, shall be briefly noted below.

(1) I have bridges of a sort extremely light and strong, adapted to be most easily carried, and with them you may pursue, and at any time flee from, the enemy; and others, secure and indestructible by fire and battle, easy and convenient to lift and place. Also methods of burning and destroying those of the enemy.

(2) I know how, when a place is besieged, to take the water out of the trenches, and make endless variety of bridges, and covered ways and ladders, and other machines pertaining to such expeditions.

(3) Item. If, by reason of the height of the banks, or the strength of the place and its position, it is impossible, when besieging a place, to avail oneself of the plan of bombardment, I have methods for destroying every rock or other fortress, even if it were founded on a rock, etc.

(4) Again I have kinds of mortars; most convenient and easy to carry; and with these can fling small stones almost resembling a storm; and with the smoke of these cause great terror to the enemy, to his great detriment and confusion.

(9) And when the fight should be at sea I have kinds of many machines most efficient for offense and defense; and vessels which will resist the attack of the largest guns and powder and fumes.

(5) Item. I have means by secret and tortuous mines and ways, made without noise, to reach a designated spot, even if it were needed to pass under a trench or a river.

(6) Item. I will make covered chariots, safe and unattackable, which, entering among the enemy with their artillery, there is no body of men so great but they would break them. And behind these, infantry could follow quite unhurt and without any hindrance.

(7) Item. In case of need I will make big guns, mortars, and light ordnance of fine and useful forms, out of the common type.

(8) Where the operation of bombardment should fail, I would contrive catapults, mangonels, *trabocchi* and other machines of marvelous efficacy and not in common use. And, in short, according to the variety of cases, I can contrive various and endless means of offense and defense.

(10) In time of peace I believe I can give perfect satisfaction and to the equal of any other in architecture and the composition of buildings public and private; and in guiding water from one place to another.

Item. I can carry out sculpture in marble, bronze, or clay, and also in painting whatever may be done, and as well as any other, be he whom he may be.

Again, the bronze horse may be taken in hand, which is to be to the immortal glory and eternal honor of the prince your father of happy memory, and of the illustrious house of Sforza.

And if any of the above-named things seem to anyone to be impossible or not feasible, I am most ready to make the experiment in your park, or in whatever place may please Your Excellency—to whom I commend myself with the utmost humility, etc.

I am greatly vexed to be in necessity, but I still more regret that this should be the cause of the hindrance of my wish which is always disposed to obey Your Excellency.

Perhaps Your Excellency did not give further orders to Messer Gualtieri, believing that I had money enough. . . .

I am greatly annoyed that you should have found me in necessity, and that my having to earn my living should have hindered me. . . .

It vexes me greatly that having to earn my living has forced me to interrupt the work and to attend to small matters, instead of following up the work which Your Lordship entrusted to me. But I hope in a short time to have earned so much that I may carry it out quietly to the satisfaction of

Your Excellency, to whom I commend myself; and if Your Lordship thought that I had money, Your Lordship was deceived. I had to feed 6 men for 36 months, and have had 50 ducats.

And if any other commission is given me by any . . .* of the reward of my service. Because I am not able to be . . . things assigned because meanwhile they have . . . to them . . . which they well may settle rather than I . . . not my art which I wish to change and . . . given some clothing if I dare a sum. . . .

My Lord, I knowing Your Excellency's mind to be occupied . . . to remind Your Lordship of my small matters and the arts put to silence . . . that my silence might be the cause of making Your Lordship scorn . . . my life in your service. I hold myself ever in readiness to obey. . . . Of the horse I will say nothing because I know the times are bad . . . to Your Lordship how I had still to receive two years' salary of the . . . with the two skilled workmen who are constantly in my pay and at my cost . . . that at last I found myself advanced the said sum about 15 lire . . . works of fame by which I could show to those who shall see it that I have been . . . everywhere, but I do not know where I could bestow my work more . . . I, having been working to gain my living . . . I not having been informed what it is, I find myself . . . remember the commission to paint the rooms . . . I conveyed to Your Lordship only requesting you. . . .

[Draft of letter to be sent to Piacenza (1346–1347)]

Magnificent Commissioners of Buildings, I, understanding that your Magnificencies have made up your minds to make certain great works in bronze, will remind you of certain things: first, that you should not be so hasty or so quick to give the commission, lest by this haste it should become impossible to select a good model and a good master; and some man of small merit may be chosen who by his insufficiency may cause you to be abused by your descendants, judging that this age was but ill supplied with men of good counsel and with good masters; seeing that other cities, and chiefly the city of the Florentines, has been, as it were, in these very days endowed with beautiful and grand works in bronze; among which are the doors of their Baptistery. And this town

* This page is torn down the middle, leaving about half of each line.

of Florence, like Piacenza, is a place of intercourse, through which many foreigners pass; who, seeing that the works are fine and of good quality, carry away a good impression, and will say that that city is well filled with worthy inhabitants, seeing the works which bear witness to their opinion; and, on the other hand, I say, seeing so much metal expended and so badly wrought, it were less shame to the city if the doors had been of plain wood; because, the material, costing so little, would not seem to merit any great outlay of skill. . . .

Now the principal parts which are sought for in cities are their cathedrals, and of these the first things which strike the eye are the doors, by which one passes into these churches.

Beware, gentlemen of the Commission, lest too great speed in your determination, and so much haste to expedite the entrusting of so great a work as that which I hear you have ordered, be the cause that that which was intended for the honor of God and of men should be turned to great dishonor of your judgments, and of your city, which, being a place of mark, is the resort and gathering place of innumerable foreigners. And this dishonor would result if by your lack of diligence you were to put your trust in some vaunter, who by his tricks or by favor shown to him here should obtain such work from you, by which lasting and very great shame would result to him and to you. Thus I cannot help being angry when I consider what men those are who have conferred with you as wishing to undertake this great work without thinking of their sufficiency for it, not to say more. This one is a potter, that one a maker of cuirasses, this one is a bell founder, another a bell ringer, and one is even a bombardier; and among them one in His Lordship's service, who boasted that he was the gossip of Messer Ambrosio Ferrere, who has some power and who has made him some promises; and if this were not enough he would mount on horseback, and go to his Lord and obtain such letters that you could never refuse to give him the work. But consider where masters of real talent and fit for such work are brought when they have to compete with such men as these. Open your eyes and look carefully lest your money should be spent in buying your own disgrace. I can declare to you that from that place you will procure none but average works of inferior and coarse masters. There is no capable man—and you may believe me—except Leonardo the Florentine, who is making the equestrian statue in bronze of the Duke Francesco and who has no need to bring himself into notice, because he has work for all his lifetime;

and I doubt whether, being so great a work, he will ever finish it.

The miserable painstakers . . . with what hope may they expect a reward of their merit?

There is one whom his Lordship invited from Florence to do this work and who is a worthy master, but with so very much business he will never finish it; and you may imagine what a difference there is to be seen between a beautiful object and an ugly one. Quote Pliny.

Most Illustrious and most Reverend Lord.
 The Lord Ippolito, Cardinal of Este
 at Ferrara.

Most Illustrious and most Reverend Lord.

I arrived from Milan but a few days since, and, finding that my elder brother refuses to carry into effect a will, made three years ago when my father died—as also, and no less, because I would not fail in a matter I esteem most important—I cannot forbear to crave of your most Reverend Highness a letter of recommendation and favor to Ser Raphaello Hieronymo, at present one of the illustrious members of the Signoria before whom my cause is being argued; and more particularly it has been laid by His Excellency the Gonfaloniere into the hands of the said Ser Raphaello, that his Worship may have to decide and end it before the festival of All Saints. And therefore, my Lord, I entreat you, as urgently as I know how and am able, that Your Highness will write a letter to the said Ser Raphaello in that admirable and pressing manner which Your Highness can use, recommending to him Leonardo Vincio, your most humble servant, as I am, and shall always be; requesting him and pressing him not only to do me justice but to do so with dispatch; and I have not the least doubt, from many things that I hear, that Ser Raphaello, being most affectionately devoted to Your Highness, the matter will issue *ad votum*. And this I shall attribute to your most Reverend Highness's letter, to whom I once more humbly commend myself. *Et bene valeat.*

Florence XVIIIᵃ₇bris 1507.
E. V. R. D.
your humble servant
Leonardus Vincius, *pictor.*

[Draft of letter to Charles d'Amboise, Maréchal de Chaumont, Governor of Milan under Louis XII]

I am afraid lest the small return I have made for the great benefits I have received from Your Excellency, has not made you somewhat angry with me, and that this is why to so many letters which I have written to Your Lordship I have never had an answer. I now send Salai to explain to Your Lordship that I am almost at an end of the litigation I had with my brothers; that I hope to find myself with you this Easter, and to carry with me two pictures of two Madonnas of different sizes. These were done for our most Christian King, or for whomsoever Your Lordship may please. I should be very glad to know on my return thence where I may have to reside, for I would not give any more trouble to Your Lordship. Also, as I have worked for the most Christian King, whether my salary is to continue or not. I wrote to the President as to that water which the king granted me, and which I was not put in possession of because at that time there was a dearth in the canal by reason of the great droughts and because its outlets were not regulated; but he certainly promised me that when this was done I should be put in possession. Thus I pray Your Lordship that you will take so much trouble, now that these outlets are regulated, as to remind the President of my matter; that is, to give me possession of this water, because on my return I hope to make there instruments and other things which will greatly please our most Christian King. Nothing else occurs to me. I am always yours to command.

[Drafts of letters to the Superintendent of Canals and to Francesco Melzi]

Magnificent President, I am sending thither Salai, my pupil, who is the bearer of this, and from him you will hear by word of mouth the cause of my . . .

Magnificent President, I . . .

Magnificent President: —Having ofttimes remembered the proposals made many times to me by Your Excellency, I take the liberty of writing to remind Your Lordship of the promise made to me at my last departure, that is, the possession of the twelve inches of water granted to me by the most Christian King. Your Lordship knows that I did not enter into posses-

sion because at that time when it was given to me there was a dearth of water in the canal, as well by reason of the great drought as also because the outlets were not regulated; but Your Excellency promised me that as soon as this was done I should have my rights. Afterwards hearing that the canal was complete I wrote several times to Your Lordship and to Messer Girolamo da Cusano, who has in his keeping the deed of this gift; and so also I wrote to Corigero and never had a reply. I now send thither Salai, my pupil, the bearer of this, to whom Your Lordship may tell by word of mouth all that happened in the matter about which I petition Your Excellency. I expect to go thither this Easter since I am nearly at the end of my lawsuit, and I will take with me two pictures of Our Lady which I have begun, and at the present time have brought them on to a very good end; nothing else occurs to me.

My Lord, the love which Your Excellency has always shown me and the benefits that I have constantly received from you I have hitherto . . .

I am fearful lest the small return I have made for the great benefits I have received from Your Excellency may not have made you somewhat annoyed with me. And this is why, to many letters which I have written to Your Excellency, I have never had an answer. I now send to you Salai to explain to Your Excellency that I am almost at the end of my litigation with my brothers, and that I hope to be with you this Easter and carry with me two pictures on which are two Madonnas of different sizes which I began for the most Christian King, or for whomsoever you please. I should be very glad to know where, on my return from this place, I shall have to reside, because I do not wish to give more trouble to Your Lordship; and then, having worked for the most Christian King, whether my salary is to be continued or not. I write to the President as to the water that the king granted me of which I had not been put in possession by reason of the dearth in the canal, caused by the great drought and because its outlets were not regulated; but he promised me certainly that as soon as the regulation was made, I should be put in possession of it; I therefore pray you that, if you should meet the said President, you would be good enough, now that the outlets are regulated, to remind the said President to cause me to be put in possession of that water, since I understand it is in great measure in his power. Nothing else occurs to me; always yours to command.

Good day to you, Messer Francesco. Why, in God's name, of all the letters I have written to you, have you never answered one? Now wait till I come, by God, and I shall make you write so much that perhaps you will become sick of it.

Dear Messer Francesco. I am sending thither Salai to learn from His Magnificence the President to what end the regulation of the water has come, since, at my departure, this regulation of the outlets of the canal had been ordered, because His Magnificence the President promised me that as soon as this was done I should be satisfied. It is now some time since I heard that the canal was in order, as also its outlets, and I immediately wrote to the President and to you, and then I repeated it, and never had an answer. So you will have the goodness to answer me as to that which happened, and as I am not to hurry the matter, would you take the trouble, for the love of me, to urge the President a little, and also Messer Girolamo Cusano, to whom you will commend me and offer my duty to His Magnificence.

[Drafts of a letter to Giuliano de' Medici]

[Most illustrious Lord. I greatly rejoice most illustrious Lord, at your . . .]

I was so greatly rejoiced, Most Illustrious Lord, by the desired restoration of your health, that it almost had the effect that [my own health recovered]—[I have got through my illness]—my own illness left me—of Your Excellency's almost restored health. But I am extremely vexed that I have not been able completely to satisfy the wishes of Your Excellency, by reason of the wickedness of that deceiver, for whom I left nothing undone which could be done for him by me and by which I might be of use to him; and in the first place his allowances were paid to him before the time, which I believe he would willingly deny, if I had not the writing signed by myself and the interpreter. And I, seeing that he did not work for me unless he had no work to do for others, which he was very careful in soliciting, invited him to dine with me, and to work afterwards near me, because, besides the saving of expense, he would acquire the Italian language. [He always promised, but would never do so.] And this I did also, because that Giovanni, the German who makes the mirrors, was there always in the workshop, and wanted to see and to know all that was being done there and made it

known outside . . . strongly criticizing it; and because he dined with those of the Pope's guard, and then they went out with guns killing birds among the ruins; and this went on from after dinner till the evening; and when I sent Lorenzo to urge him to work he said that he would not have so many masters over him, and that his work was for Your Excellency's Wardrobe; and thus two months passed and so it went on; and one day finding Gian Niccolò of the Wardrobe and asking whether the German had finished the work for Your Magnificence, he told me this was not true, but only that he had given him two guns to clean. Afterwards, when I had urged him further, he left the workshop and began to work in his room, and lost much time in making another pair of pincers and files and other tools with screws; and there he worked at reels for twisting silk which he hid when any one of my people went in, and with a thousand oaths and mutterings, so that none of them would go there any more.

I was so greatly rejoiced, Most Illustrious Lord, by the desired restoration of your health, that my own illness almost left me. But I am greatly vexed at not having been able completely to satisfy Your Excellency's wishes by reason of the wickedness of that German deceiver, for whom I left nothing undone by which I could have hope to please him; and first I invited him to lodge and board with me, by which means I should constantly see the work he was doing and with greater ease correct his errors, while, besides this, he would learn the Italian tongue, by means of which he could with more ease talk without an interpreter; his moneys were always given him in advance of the time when due. Afterwards he wanted to have the models finished in wood, just as they were to be in iron, and wished to carry them away to his own country. But this I refused him, telling him that I would give him, in drawing, the breadth, length, height, and form of what he had to do; and so we remained in ill-will.

The next thing was that he made himself another workshop and pincers and tools in his room where he slept, and there he worked for others; afterwards he went to dine with the Swiss of the guard, where there are idle fellows, in which he beat them all; and most times they went two or three together with guns, to shoot birds among the ruins, and this went on till evening.

At last I found how this master Giovanni the mirror-maker was he who had done it all, for two reasons: the first because he had said that my coming here had deprived him of the

countenance and favor of Your Lordship which always . . .
The other is that he said that his ironworkers' rooms suited
him for working at his mirrors, and of this he gave proof; for
besides making him my enemy, he made him sell all he had
and leave his workshop to him, where he works with a num-
ber of workmen making numerous mirrors to send to the fairs.

I was so greatly rejoiced, Most Illustrious Lord, by the
wished-for recovery of your health, that my own ills have
almost left me; and I say God be praised for it. But it vexes
me greatly that I have not been able completely to satisfy
Your Excellency's wishes by reason of the wickedness of that
German deceiver, for whom I left nothing undone by which I
could hope to please him; and secondly I invited him to lodge
and board with me, by which means I should see constantly
the work he was doing, for which purpose I would have a
table fixed at the foot of one of these windows, where he could
work with the file and finish the things made below; and so I
should constantly see the work he might do, and it could be
corrected with greater ease.

[A draft of a letter, Rome]

This other hindered me in anatomy, blaming it before the
Pope, and likewise at the hospital; and he has filled this whole
Belvedere with workshops for mirrors; and he did the same
thing in Maestro Giorgio's room. He said that he had been
promised eight ducats every month, beginning with the first
day, when he set out, or at latest when he spoke with you;
and that you agreed.

Seeing that he seldom stayed in the workshop, and that he
ate a great deal, I sent him word that if he liked I could deal
with him separately for each thing that he might make, and
would give him what we might agree to be a fair valuation.
He took counsel with his neighbor and gave up his room,
selling everything, and went to find . . .

Dear Benedetto de' Pertarti. . . . When the proud giant
fell because of the bloody and miry state of the ground it was
as though a mountain had fallen, so that the country shook
as with an earthquake, and terror fell on Pluto in hell. From
the violence of the shock he lay as stunned on the level
ground. Suddenly the people, seeing him as one killed by a
thunderbolt, turned back; like ants running wildly over the

body of the fallen oak, so these rushing over his ample limbs
. . . them with frequent wounds; by which, the giant being
roused and feeling himself almost covered by the multitude,
he suddenly perceived the smarting of the stabs; and sent forth
a roar which sounded like a terrific clap of thunder; and
placing his hands on the ground he raised his terrible face:
and having lifted one hand to his head he found it full of men
and rabble sticking to it like the minute creatures which not
unfrequently are found there; wherefore with a shake of his
head he sends the men flying through the air just as hail does
when driven by the fury of the winds. Many of these men
were found to be dead.

I know one who, having promised me much less than my
due, being disappointed of his presumptuous desires, has tried
to deprive me of all my friends; and as he has found them
wise and not pliable to his will, he has menaced me that,
having found means of denouncing me, he would deprive me
of my benefactors. Hence I have informed Your Lordship of
this, to the end [that this man who wishes to sow the usual
scandals may find no soil fit for sowing the thoughts and deeds
of his evil nature] so that he, trying to make Your Lordship
the instrument of his iniquitous and malicious nature may be
disappointed of his desire.

And in this case I know that I shall make not a few enemies,
seeing that no one will believe what I can say of him; for
they are but few whom his vices have disgusted, and he only
dislikes those men whose natures are contrary to those vices.
And many hate their fathers, and break off friendship with
those who reprove their vices; and he will not permit any
examples against them, nor any advice.

If you meet with anyone who is virtuous, do not drive him
from you; do him honor, so that he may not have to flee
from you and be reduced to hiding in hermitages, or caves,
or other solitary places, to escape from your treachery; if
there is such a one among you do him honor, for these are
our saints upon earth; these are they who deserve statues
from us, and images; but remember that their images are not
to be eaten by you, as is still done in some parts of India,
where, when the images have, according to them, performed
some miracle, the priests cut them in pieces, being of wood,
and give them to all the people of the country, not without
payment; and each one grates his portion very fine, and puts
it upon the first food he eats; and thus believes that by faith
he has eaten his saint who then preserves him from all perils.

What do you think here, man, of your own species? Are you so wise as you believe yourself to be? Are these things to be done by men?

This writing distinctly about the kites seems to be my destiny, because among the first recollections of my infancy it seemed to me that, as I was in my cradle, a kite came to me and opened my mouth with its tail, and struck me several times with its tail inside my lips.

When I did well as a boy you used to put me in prison. Now if I do it being grown up, you will do worse to me.

Do not reveal, if liberty is precious to you; my face is the prison of love.

Maestro Leonardo of Florence.

On the 9th of July 1504, Wednesday, at seven o'clock, died Ser Piero da Vinci, notary at the Palazzo del Podesta, my father—at seven o'clock, being eighty years old, leaving behind ten sons and two daughters.

The Magnifico Giuliano de' Medici left Rome on the 9th of January, 1515, just at daybreak, to take a wife in Savoy; and on the same day fell the death of the king of France.

. . . at Pistoja, Fioravante di Domenico at Florence is my most beloved friend, as though he were my [brother].

A nun lives at La Colomba at Cremona; she works good straw plait; and a friar of Saint Francis.

Find Ligny and tell him that you wait for him at Rome and will go with him to Naples; make you pay the donation and take the book by Vitolone, and the measurements of the public buildings. Have two covered boxes made to be carried on mules, but bedcovers will be best; this makes three, of which you will leave one at Vinci. Obtain the . . . from Giovanni Lombardo the linen draper of Verona. Buy hand-

kerchiefs and towels . . . and shoes, 4 pairs of hose, a jerkin of . . . and skins, to make new ones; the lake of Alessandro. Sell what you cannot take with you. Get from Jean de Paris the method of painting in tempera and the way of making white salt, and how to make tinted paper; sheets of paper folded up; and his box of colors; learn to work flesh colors in tempera, learn to dissolve gum lac, linseed . . . white, of the garlic of Piacenza; take *de Ponderibus;* take the works of Leonardo of Cremona. Remove the small furnace . . . seed of lilies and of . . . Sell the boards of the support. Make him who stole it give you the . . . learn leveling and how much soil a man can dig out in a day.

On the 16th day of July.
Caterina came on 16th day of July, 1493.
Messer Mariolo's Morel the Florentine is a big horse with a fine neck and a beautiful head.
The white stallion belonging to the falconer has fine hindquarters; it is behind the Comasina Gate.
The big horse of Cermonino, of Signor Giulio.

Maestro Giuliano da Marliano has a fine herbal. He lives opposite to the Strami the Carpenters.
Christofano da Castiglione who lives at the Pietà has a fine head.

Giovannina has a fantastic face, is at Santa Caterina, at the hospital.

Giuliano da Marian, physician, has a steward without hands.
Paul of Vannochio at Siena . . .
The upper chamber for the apostles.
Buildings by Bramante.
The governor of the castle made a prisoner.
Visconti carried away and his son killed.
Giovanni della Rosa deprived of his money.
Borgonzio began . . . and moreover his fortunes fled.
The Duke has lost the state, property, and liberty, and none of his enterprises was carried out by him.

Piece of tapestry—pair of compasses—Tommaso's book— the book of Giovanni Benci—the box in the custom house— to cut the cloth—the sword belt—to sole the boots—a light hat—the cane from the ruined houses—the debt for the table

linen—swimming belt—a book of white paper for drawing—
charcoal.—How much is a florin . . . a leather bodice.

Borges shall get for you the Archimedes from the bishop
of Padua, and Vitellozzo the one from Borgo a San Sepolcro.

Where is Valentino?—boots—boxes in the custom house
. . . —the monk at the Carmine—squares—Piero Martelli—
Salvi Borgherini—send back the bags—a support for the
spectacles—the nude study of the San Gallo—the cloak.
Porphyry—groups—square—Pandolfino.

Concave mirrors; philosophy of Aristotle;

the books of Avicenna; — Messer Ottaviano
Italian and Latin vocabulary; — Palavicino for his
Vitruvius.

Bohemian knives; — Go every Saturday to the
Vitruvius; — hot bath where you will
see naked men;

"Meteora."
Archimedes, on the center of — Inflate the lungs
gravity;

of a pig and observe
anatomy Alessandro — whether they
Benedetto;

increase in width
The Dante of Niccolò della — and in length, or
Croce;

in width dimin-
ishing in length.

Marliano, on Calculation, to Bertuccio.
Albertus, on heaven and earth, [from the monk Bernardino].
Horace has written on the movements of the heavens.

Have Avicenna's work on useful inventions translated;
spectacles with the case, steel and fork and . . . charcoal,
boards, and paper, and chalk and white, and wax; . . . for
glass, a saw for bones with fine teeth, a chisel, inkstand . . .
three herbs, and Agnolo Benedetto. Get a skull, nut, mustard.

Boots—gloves, socks, combs, papers, towels, shirts, . . .
shoelaces— . . . shoes, penknife, pens. A skin for the chest.

The book of Piero Crescenzo—studies from the nude by
Giovanni Ambrosio—compasses—the book of Giovanni Gia-
como . . .

Memorandum. To make some provision for my garden—
Giordano, *De Ponderibus*—the peacemaker, the flow and ebb

of the sea—have two baggage trunks made, look to Beltraffio's
lathe and have the stone taken—but leave the books belong-
ing to Messer Andrea the German—make scales of a long
reed and weigh the substance when hot and again when cold.
The mirror of Master Luigi; *a b* the flow and ebb of the water
is shown at the mill of Vaprio—a cap.

Pandolfino's book—knives—a pen for ruling—to have the
vest dyed—The library at St. Mark's—The library at Santo
Spirito—Lactantius of the Daldi—Antonio Covoni—A book
by Maestro Paolo Infermieri—Boots, shoes, and hose—
(Shell) lac—An apprentice to do the models for me. Gram-
mar, by Lorenzo de' Medici—Giovanni del Sodo—Sansovino
—a ruler—a very sharp knife—Spectacles—fractions . . . —
repair . . . —Tommaso's book—Michelagnolo's chain; learn
the multiplication of roots from Maestro Luca—my map
of the world which Giovanni Benci has—socks—clothes from
the custom-house officer—red Cordova leather—the map of
the world, of Giovanni Benci—a print, the districts about
Milan—market book.

An algebra, which the Marliani have, written by their
father—
On the bone, by the Marliani—
On the bone which penetrates, Gian Giacomo of Bellinzona,
to draw out the nail with facility—
The measurement of Boccalino—
The measurement of Milan and the suburbs—
A book, treating of Milan and its churches, which is to be
had at the last stationer's on the way to Corduso—
The measurement of the Corte Vecchia—
The measurement of the Castle—
Get the master of arithmetic to show you how to
square . . . —
Get Messer Fazio to show you the [book] on proportion—
Get the Friar di Brera to show you the book *de Ponderi-
bus*—
Of the measurement of San Lorenzo—
I lent certain groups to Fra Filippo di Brera—
Memorandum: to ask Maestro Giovannino as to the mode
in which the tower of Ferrara is walled without loopholes—
Ask Maestro Antonio how mortars are placed on bastions
by day or by night—
Ask Benedetto Portinari how the people go on the ice in
Flanders—

On proportions, by Alchino, with notes by Marliano, from Messer Fazio—

The measurement of the sun, promised me by Maestro Giovanni, the Frenchman—

The crossbow of Maestro Gianetto—

The book by Giovanni Taverna that Messer Fazio—

You will draw Milan—

The measurement of the canal, locks and supports, and large boats; and the expense—

Plan of Milan—

Groups by Bramante—

The book on celestial phenomena by Aristotle, in Italian—

Try to get Vitolone, which is in the library at Pavia and which treats of Mathematics—Find a master learned in water-works and get him to explain the repairs and the costs, and a lock and a canal and a mill in the Lombard fashion.

A grandson of Gian Angelo's, the painter, has a book on water which was his father's.

Paolino Scarpellino, called Assiolo, has great knowledge of waterworks.

A box
A square,
Pandolfino's book,
Small knives,
Pen for ruling,
To have the vest dyed,
The Libraries,

Lactantius of the
Daldi—
Book from Maestro
Paolo Infermieri—
 Boots, shoes and
hose,
 Lac,
 An apprentice for
models,
 Grammar of Lorenzo
 de' Medici,
 Giovanni del Sodo for
 . . . —the broken
 Sansovino,
 Piero di Cosimo,
 Filippo and Lorenzo—

a cage—
to make the bird—
mortar[?]—
Renieri for the
stone—star—
Alfieri's tazza—
the book on celestial
 phenomena—
go to the house of
the Pazzi,
small box—

small gimlet—

. . . —

. . . —

the amount of the . . .

the amount of material for
the wings—
A ruler—

spectacles—to do the . . . again—Tommaso's book—
Michelagnolo's chain—the multiplication of roots—of the bow
and string—the map of the world from Benci—socks—the
clothes from the custom-house officer—Cordova leather—
market books—waters of Cronaca—waters of Tanaglino . . .
—the caps—Rosso's mirror; to see him make it—⅛ of which
I have ⅝—on the celestial phenomena, by Aristotle—boxes
of Lorenzo di Pier Francesco—Maestro Piero of the Borgo—
to have my book bound—show the book to Serigatto—and
get the rule of the clock—ring—nutmeg—gum—the square—
Giovan' Batista at the piazza de' Mozzi—Giovanni Benci has
my book and jaspers—brass for the spectacles.

Giacomo came to live with me on St. Mary Magdalen's
day, 1490, aged 10 years. The second day I had two shirts
cut out for him, a pair of hose, and a jerkin, and when I put
aside some money to pay for these things he stole 4 lire
the money out of the purse; and I could never make him con-
fess, though I was quite certain of the fact.—Thief, liar, ob-
stinate, glutton.

The day after, I went to sup with Giacomo Andrea, and the
said Giacomo supped for two and did mischief for four; for
he broke 3 cruets, spilled the wine, and after this came to sup
where I . . .

Item: on the 7th day of September he stole a silver point
of the value of 22 soldi from Marco, who was living with me,
4 lire this being of silver; and he took it from his studio, and
when the said Marco had searched for it a long while he found
it hidden in the said Giacomo's box 4 lire

Item: on the 26th January following, I being in the house
of Messer Galeazzo da San Severino, was arranging the festi-
val for his jousting, and certain footmen having undressed to
try on some costumes of wild men for the said festival, Gia-
como went to the purse of one of them which lay on the bed
with other clothes, 2 lire 4 S, and took out such money as
was in it.

Item: when I was in the same house, Maestro Agostino da
Pavia gave to me a Turkish hide to have a pair of short
boots made of it; this Giacomo stole it of me within a month
and sold it to a cobbler for 20 soldi, with which money, by
his own confession, he bought anise comfits. 2 lire

Item: again, on the 2nd April, Giovan Antonio having left

a silver point on a drawing of his, Giacomo stole it, and this
was of the value of 24 soldi 1 lira 4 S.

The first year—
A cloak, 2 lire,
6 shirts, 4 lire,
3 jerkins, 6 lire,
4 pairs of hose, 7 lire 8 soldi,
1 lined doublet, 5 lire,
24 pairs of shoes, 6 lire 5 soldi,
A cap, 1 lira,
laces, 1 lira.

I left Milan for Rome on the 24th day of September, 1513,
with Giovanni, Francesco di Melzi, Salai, Lorenzo, and il
Fanfoia.

On the last day but one of February;
Thursday the 27th day of September Maestro Tommaso
came back and worked for himself until the last day but one
of February. On the 18th day of March, 1493, Giulio, a Ger-
man, came to live with me—Antonio, Bartolomeo, Lucia,
Piero, Leonardo.

On the 6th day of October.

1493.

On the 1st day of November we settled accounts. Giulio had
to pay 4 months; and Maestro Tommaso 9 months; Maestro
Tommaso afterwards made 6 candlesticks, 10 days' work;
Giulio some fire tongs 15 days' work. Then he worked for him-
self till the 27th May, and worked for me at a lever till the
18th July; then for himself till the 7th of August, and for
one day, on the fifteenth, for a lady. Then again for me at
2 locks until the 20th of August. ·

On the 23rd day of August, 12 lire from Pulisona. On the
14th of March, 1494, Galeazzo came to live with me, agreeing
to pay 5 lire a month for his cost, paying on the 14th of
each month.

His father gave me 2 Rhenish florins.

On the 14th of July I had from Galeazzo 2 Rhenish florins.

On the 15th day of September Giulio began the lock of my
studio; 1494.

Saturday morning the 3rd of August, 1504, Jacopo the
German came to live with me in the house, and agreed with
me that I should charge him a carlino a day.

On the 26th of September Antonio broke his leg; he must rest 40 days.

On the 3rd day of January.

Benedetto came on the 17th of October; he stayed with me two months and 13 days of last year, in which time he earned 38 lire, 18 soldi and 8 dinari; he had of this 26 lire and 8 soldi, and there remains to be paid for the past year 12 lire 10 soldi.

Giodatti (?) came on the 8th of September, at 4 soldi a month, and stayed with me 3 months and 24 days, and earned 59 lire 14 soldi and 8 dinari; he has had 43 lire, 4 soldi, there remains to pay 16 lire, 10 soldi and 8 dinari. Benedetto, 24 grossoni.

Book on Arithmetic,
Pliny,
The Bible,
"On warfare,"
The first decade,

The third decade,
The fourth decade,
Guido,
Piero Crescentio,
"Quadriregio,"
Donato,
Justinus,

Guido,
"Doctrinale,"
Morgante,
John de Mandeville,
"On honest recreation,"
Manganello,
The Chronicle of Isidoro,
The Epistles of Ovid,
Epistles of Filelfo,
Sphere,
The Jests of Poggio,
Chiromancy,
Formulary of letters.

"Flowers of Virtue,"
"Lives of the Philosophers,"
"Lapidary,"
"Epistles of Filelfo,"
"On the preservation of health,"
Ciecho d'Ascoli,
Albertus Magnus,
New treatise on rhetorics,
Cibaldone,
Aesop,
Psalms,
"On the immortality of the soul,"
Burchiello,
Driadeo,
Petrarch.

Map of Elephanta in India which Antonello Merciaio has from Maestro Maffeo; there for seven years the earth rises

and for seven years it sinks. Inquire at the stationers' about Vitruvius.

See Messer Battista *On Ships,* and Frontinus *On Aqueducts.*

Anaxagoras: Everything proceeds from everything, and everything becomes everything, and everything can be turned into everything else, because that which exists in the elements is composed of those elements.

The Archimedes belonging to the Bishop of Padua.

Archimedes gave the quadrature of a polygonal figure, but not of the circle. Hence Archimedes never squared any figure with curved sides. He squared the circle minus the smallest portion that the intellect can conceive, that is, the smallest point visible.

If any man could have discovered the utmost powers of the cannon, in all its various forms, and have given such a secret to the Romans, with what rapidity would they have conquered every country and have vanquished every army, and what reward could have been great enough for such a service! Archimedes, indeed, although he had greatly damaged the Romans in the siege of Syracuse, nevertheless did not fail of being offered great rewards from these very Romans; and when Syracuse was taken diligent search was made for Archimedes; and he being found dead, greater lamentation was made for him by the Senate and people of Rome than if they had lost all their army; and they did not fail to honor him with burial and with a statue. At their head was Marcus Marcellus. And after the second destruction of Syracuse, the sepulcher of Archimedes was found again by Cato, in the ruins of a temple. So Cato had the temple restored and the sepulcher he so highly honored. . . . Whence it is written that Cato said that he was not so proud of anything he had done as of having paid such honor to Archimedes.

Aristotle, Book 3 of the Physics, and Albertus Magnus, and Thomas Aquinas and the others on the rebound of bodies, in the 7th on Physics, on heaven and earth.

Aristotle says that if a force can move a body a given distance in a given time, the same force will move half the same body twice as far in the same time.

Aristotle in Book 3 of the Ethics: Man merits praise or blame solely in such matters as lie within his option to do or not to do.

Aristotle says that every body tends to maintain its nature.

On the increase of the Nile, a small book by Aristotle.

Avicenna will have it that soul gives birth to soul as body to body, and each member to itself.

Roger Bacon, done in print.

Cleomedes the philosopher.

Maestro Stefano Caponi, a physician, lives at the Piscina, and has Euclid *De Ponderibus*.

Lucretius in his third [book] *De Rerum Natura*. The hands, nails, and teeth were the weapons of ancient man.

They also use for a standard a bunch of grass tied to a pole.

Ammianus Marcellinus asserts that seven hundred thousand volumes of books were burnt in the siege of Alexandria in the time of Julius Caesar.

Of the error of those who practice without knowledge; see first the *Ars poetica* of Horace.

The heirs of Maestro Giovanni Ghiringello have the works of Pelacano.

I have found in a history of the Spaniards that in their wars with the English there was Archimedes of Syracuse, who at that time was living at the court of Ecliderides, King of the Cirodastri. And in maritime warfare he ordered that the ships should have tall masts, and that on their tops there should be a spar fixed of 40 feet long and one third of a foot thick. At one end of this was a small grappling iron and at the other a counterpoise; and there was also attached 12 feet of chain; and, at the end of this chain, as much rope as would reach from the chain to the base of the top, where it was fixed with a small rope; from this base it ran down to the bottom of the mast where a very strong spar was attached and to this was fastened the end of the rope. But to go on to the use of this machine; I say that below this grappling iron was a fire which, with tremendous noise, threw down its rays and a shower of burning pitch; which, pouring down on the enemy's top, compelled the men who were in it to abandon the top to which the grappling iron had clung. This was hooked on to the edges of the top and then suddenly the cord attached at the base of the top to support the cord which went from the grappling iron was cut, giving way and drawing in the enemy's ship; and if the anchor was . . .

Theophrastus on the ebb and flow of the tide, and of eddies, and on water.

Messer Vincenzio Aliprando, who lives near the Inn of the Bear, has Giacomo Andrea's Vitruvius.

Item for each small vault	7 lire
outlay for blue and gold	3½
time, 4 days	
for the windows	1½
the cornice below the windows 6 soldi per braccio	
item for 24 pictures of Roman history	14 lire each
the philosophers	10 lire
the pilasters, one ounce of blue	10 soldi
for gold	15 soldi
Total	2 and ½ lire
The cornice above	lire 30
The cornice below	lire 7
The compositions, one with another	lire 13
How many braccia high is the level of the walls?	
123 braccia	
How large is the hall?	
How large is the garland?	
30 ducats.	
On the 29th day of January, 1494	
cloth for hose	lire 4 S 3
lining	S 16
making	S 8
to Salai	S 3
a jasper ring	S 13
a sparkling stone	S 11
to Caterina	S 10
to Caterina	S 10
The wheel	lire 7
the tire	lire 10
the shield	lire 4
the cushion	lire 8
the ends of the axletree	lire 2
bed and frame	lire 30
conduit	lire 10
Parsley	10 parts

mint	1 part
thyme	1 part

Vinegar . . . and a little salt; two pieces of
 canvas for Salai.

On Tuesday I bought wine for morning drinking; on Friday
the 4th day of September the same.

The cistern . . . at the hospital—2 ducats—beans—white
maize—red maize—millet—buckwheat—kidney beans—beans
—peas.

Expenses of the interment of Caterina

For the 3 lb. of tapers	27 S
For the bier	8 S
A pall over the bier	12 S
For bearing and placing the cross	4 S
For bearing the body	8 S
For 4 priests and 4 clerks	20 S
Bell, book, and sponge	2 S
For the gravediggers	16 S
To the senior	8 S
For a license from the authorities	1 S
	106 S
The doctor	2 S
Sugar and candles	12 S
	120 S

Salai's cloak, the 4th of April, 1497

4 braccia of silver cloth	1. 15 S 4
green velvet to trim it	1. 9 S —
binding	1. — S 9
loops	1. — S 12
the making	1. 1 S 5
binding for the front	1. — S 5
stitching	
here are 13 grossoni of his	1. 26 S 5

Salai stole the soldi.

On Monday I bought 4 braccia of cloth, lire 13 S 14½ on
the 17th of October, 1497.

Memorandum. That on the 8th day of April, 1503, I,
Leonardo da Vinci, lent to Vante, miniature painter, 4 gold
ducats, in gold. Salai carried them to him and gave them into

his own hand, and he said he would repay within the space of 40 days.

Memorandum. That on the same day I paid to Salai 3 gold ducats which he said he wanted for a pair of rose-colored hose with their trimming; and there remain 9 ducats due to him— excepting that he owes me 20 ducats, that is, 17 I lent him at Milan, and 3 at Venice.

Memorandum. That I gave Salai 21 braccia of cloth to make shirts, at 10 soldi the braccio, which I gave him on the 20th day of April, 1503.

On the morning of St. Peter's day, June 29, 1504, I took 10 ducats, of which I gave one to Tommaso my servant to spend.

On Monday morning 1 florin to Salai to spend on the house.

On Thursday I took 1 florin for my own spending.

Wednesday evening 1 florin to Tommaso, before supper.

Saturday morning 1 florin to Tommaso.

Monday morning 1 florin less 10 soldi.

Thursday to Salai 1 florin less 10 soldi.

For a jerkin, 1 florin.

For a jerkin⎰
And a cap ⎱ 2 florins.

To the hosier, 1 florin.

To Salai, 1 florin.

Friday morning, the 19th of July, 1 florin, less 6 soldi. I have 7 fl. left, and 22 in the box.

Tuesday, the 23rd day of July, 1 florin to Tommaso.

Monday morning, to Tommaso 1 florin.

[Wednesday morning, 1 fl. to Tommaso.]

Thursday morning the 1st day of August, 1 fl. to Tommaso.

Sunday, the 4th of August, 1 florin.

Friday, the 9th day of August, 1504, I took 10 ducats out of the box.

On the 9th day of August, 1504, I took 10 florins in gold . . . on Friday the 9th day of August fifteen grossoni, that is, fl. 5 S 5 . . . given to me 1 florin in gold on the 12th day of August . . . on the 14th of August, 3 grossoni to Tommaso. On the 18th of the same, 5 grossoni to Salai. On the 8th of September, 6 grossoni to the workman to spend; that is on the day of Our Lady's birth. On the 16th day of September I gave 4 grossoni to Tommaso: on a Sunday.

On the day of October, 1508, I had 30 scudi; 13 I lent to Salai to make up his sister's dowry, and 17 I have left.

Memorandum of the money I have had from the King as

my sa ary from July, 1508, till April next, 1509. First 100 scudi, then 100, then 70, then 50, then 20, and then 200 florins at 48 soldi the florin.

Saturday the 2nd day of March I had from Santa Maria Nuova 50 gold ducats, leaving 450. Of these I gave 5 the same day to Salai, who had lent them to me.

Thursday, the eighth day of June, I took 17 grossoni 18 soldi; on the same Thursday in the morning I gave to Salai 22 soldi for the expenses.

To Salai 4 grossoni, and for one braccio of velvet, 5 lire, and ½; viz., 10 soldi for loops of silver; Salai 14 soldi for binding, the making of the cloak 25 soldi.

I gave to Salai 93 lire 6 soldi, of which I have had 67 lire and there remain 26 lire 6 soldi.

On Friday morning, one florin to Salai to spend, 3 soldi received		
	bread	S..d
	wine	S..d
	grapes	S..d
	mushrooms	S..d
	fruit	S..d
	bran	S..d
	at the barber's	S..d
	for shoes	S..d

On Thursday morning one florin.

On Saint Ambrose's-day from the morning to Thursday 36 soldi.

The moneys I have had from Ser Matteo; first 20 grossoni, then on 13 occasions 3 f. and then 61 grossoni, then 3, and then 3.3; 46 soldi 12 grossoni.

For paper	S 18
for canvas	S 30
for paper	S 10 d 19
Total	S 73

Two large hatchets and one very small one, 8 brass spoons, 4 tablecloths, 2 towels, 15 small napkins, 2 coarse napkins, 2 coarse cloths, 2 wrappers, 3 pairs of sheets, 2 pairs new and 1 old.

20 pounds of German blue, at one ducat the pound	lire 80 S d

60 pounds of white, S 60 the pound	lire 15 S		d	
1½ pound at 4 S the pound	lire 6 S		d	
2 pounds of cinnabar at S 18 the pound	lire 1 S 16		d	
6 pounds of green at S 12 the pound	lire 3 S 12		d	
4 pounds of yellow at S 12 the pound	lire 2 S 8		d	
1 pound of minium at S 8 the pound	lire 0 S 8		d	
4 pounds of . . . at S 2 the pound	lire 0 S 8		d	
6 pounds of ocher at S 1 the pound	lire 0 S 6		d	
black . . . at S 2 the pound for 20	lire 2 S 0		d	
wax to make the stars 29 pounds at S—the pound	lire 0 S 0		d	
40 pounds of oil for painting at 5 soldi the pound	lire 10 S 0		d	

Altogether lire 120 S 18
without the gold. 18

tin for putting on the gold 120 18
 58

Bed	70 S
ring	70
crockery	25
gardener	12
.	28
porters	21
glasses	10
fuel	36
a lock	10

New tinware
6 small bowls,
6 bowls,
2 large dishes,
2 dishes medium size,
2 small ones

3 pairs of sheets
 each of 4 breadths,
2 small sheets,
2 tablecloths and ½,
16 coarse cloths,
8 shirts,
9 napkins,
2 hand towels,

Old tinware
3 small bowls,
4 bowls,
3 square stones,
2 small bowls,
1 large bowl,
1 platter,
4 candlesticks,
1 small candlestick.

Hose	S 40	
straw	S 60	
wheat	S 42	
wine	S 54	
bread	S 18	
meat	S 54	
eggs	S 5	
salad	S 3	
the barber	S 2 d	6
horses	S 1	

Sunday

meat	S 10 d	
wine	S 12 d	
bran	S 5 d	4
herbs	S 10 d	
buttermilk	S 4 d	4
melon	S 3 d	
bread	S 3 d	1
Monday	**S 39**	**8**
candles	S 6 d	
wine	S 12 d	
bran	S 9 d	4
buttermilk	S 4 d	4
herbs	S 8 d	
Tuesday	**S 38 d 12**	
meat	S 10 d	8
wine	S 12 d	
bread	S 3 d	

| bran | S | 5 d | 4 |
| herbs | S | 8 d | |

Wednesday

wine	S	5 d	
melon	S	2 d	
bran	S	5 d	4
herbs	S	8	

| | | 20 | 4 |

On the morning of Santo Zanobio, the 29th of May, 1504, I had from Lionardo Vinci 15 gold ducats and began to spend them.

to Mona Margarita	S	62 d	4
to remake the ring	S	19 d	8
clothes	S	13	
barber	S	4	
eggs	S	6	
debt at the bank	S	7	
velvet	S	12	
wine	S	9 d	4
meat	S	4	
mulberries	S	2 d	4
mushrooms	S	3 d	4
salad	S	1	
fruit	S	1 d	4
candles	S	3	
. . . .	S	1	
flour	S	2	

Sunday 198 8

bread	S	6	
wine	S	9 d	4
meat	S	7	
soup	S	2	
fruit	S	3 d	4
candles	S	3 d	

Monday 31

bread	S	6 d	4
meat	S	10 d	8
wine	S	9 d	4

fruit	S	4		
soup	S	1	d	8
Tuesday		**32**		
bread	S	6		
meat	S	11		
wine	S	7		
fruit	S	9		
soup	S	2		
salad	S	1		

[Will of Leonardo da Vinci]

Be it known to all persons, present and to come, that at the court of our Lord the King at Amboise before ourselves in person, Messer Leonardo da Vinci, painter to the King, at present staying at the place known as Cloux near Amboise, duly considering the certainty of death and the uncertainty of its time, has acknowledged and declared in the said court and before us that he has made, according to the tenor of these presents, his testament and the declaration of his last will, as follows. And first he commends his soul to our Lord, Almighty God, and to the Glorious Virgin Mary, and to our lord Saint Michael, to all the blessed Angels and Saints male and female in Paradise.

Item. The said Testator desires to be buried within the church of Saint Florentin at Amboise, and that his body shall be borne thither by the chaplains of the church.

Item. That his body may be followed from the said place to the said church of Saint Florentin by the *collegium* of the said church, that is to say by the rector and the prior, or by their vicars and chaplains of the church of Saint Denis of Amboise, also the lesser friars of the place, and before his body shall be carried to the said church this Testator desires that in the said church of Saint Florentin three grand Masses shall be celebrated by the deacon and subdeacon and that on the day when these three high Masses are celebrated, thirty low Masses shall also be performed at Saint Grégoire.

Item. That in the said church of Saint Denis similar services shall be performed, as above.

Item. That the same shall be done in the church of the said friars and lesser brethren.

Item. The aforesaid Testator gives and bequeaths to Messer Francesco da Melzo, nobleman, of Milan, in remuneration

for services and favors done to him in the past, each and all of the books the Testator is at present possessed of, and the instruments and portraits appertaining to his art and calling as a painter.

Item. The same Testator gives and bequeaths henceforth forever to Battista de Vilanis his servant one half, that is, the moiety, of his garden which is outside the walls of Milan, and the other half of the same garden to Salai his servant; in which garden aforesaid Salai has built and constructed a house which shall be and remain henceforth in all perpetuity the property of the said Salai, his heirs and successors; and this is in remuneration for the good and kind services which the said de Vilanis and Salai, his servants, have done him in past times until now.

Item. The said Testator gives to Maturina his waiting woman a cloak of good black cloth lined with fur, a . . . of cloth and two ducats paid once only; and this likewise is in remuneration for good service rendered to him in past times by the said Maturina.

Item. He desires that at his funeral sixty tapers shall be carried which shall be borne by sixty poor men, to whom shall be given money for carrying them, at the discretion of the said Melzo, and these tapers shall be distributed among the four above-mentioned churches.

Item. The said Testator gives to each of the said churches ten lb. of wax in thick tapers, which shall be placed in the said churches to be used on the day when those said services are celebrated.

Item. That alms shall be given to the poor of the Hôtel-Dieu, to the poor of Saint Lazare d'Amboise and, to that end, there shall be given and paid to the treasurers of that same fraternity the sum and amount of seventy soldi of Tours.

Item. The said Testator gives and bequeaths to the said Messer Franceso da Melzo, being present and agreeing, the remainder of his pension and the sums of money which are owing to him from the past time till the day of his death by the receiver or treasurer-general M. Johan Sapin, and each and every sum of money that he has already received from the aforesaid Sapin of his said pension, and in case he should die before the said Melzo and not otherwise; which moneys are at present in the possession of the said Testator in the said place called Cloux, as he says. And he likewise gives and bequeaths to the said Melzo all and each of his clothes which he at present possesses at the said place of Cloux, and all in

remuneration for the good and kind services done by him in past times till now, as well as in payment for the trouble and annoyance he may incur with regard to the execution of this present testament, which, however, shall all be at the expense of the said Testator.

And he orders and desires that the sum of four hundred *scudi del sole*, which he has deposited in the hands of the treasurer of Santa Maria Nuova in the city of Florence, may be given to his brothers now living in Florence with all the interest and usufruct that may have accrued up to the present time, and be due from the aforesaid treasurer to the aforesaid Testator on account of the said four hundred crowns, since they were given and consigned by the Testator to the said treasurers.

Item. He desires and orders that the said Messer Francesco da Melzo shall be and remain the sole and only executor of the said will of the said Testator; and that the said testament shall be executed in its full and complete meaning and according to that which is here narrated and said, to have, hold, keep, and observe, the said Messer Leonardo da Vinci, constituted Testator, has obliged and obliges by these presents the said his heirs and successors with all his goods movable and immovable present and to come, and has renounced and expressly renounces by these presents all and each of the things which to that are contrary. Given at the said place of Cloux in the presence of Magister Spirito Fleri, vicar, of the church of Saint Denis at Amboise, of M. Guglielmo Croysant, priest and chaplain, of Magister Cipriane Fulchin, Brother Francesco de Corton, and of Francesco da Milano, a brother of the Convent of the Minorites at Amboise, witnesses summoned and required to that end by the indictment of the said court in the presence of the aforesaid M. Francesco da Melzo, who accepting and agreeing to the same has promised by his faith and his oath which he has administered to us personally and has sworn to us never to do or say or act in any way to the contrary. And it is sealed by his request with the royal seal apposed to legal contracts at Amboise, and in token of good faith.

Given on the XXIIIrd day of April MDXVIII, before Easter.

And on the XXIIIrd day of this month of April MDXVIII, in the presence of M. Guglielmo Borian, Royal notary in the court of the bailiwick of Amboise, the aforesaid M. Leonardo da Vinci gave and bequeathed, by his last will and testament,

as aforesaid, to the said M. Baptista de Vilanis, being present and agreeing, the right of water which the King Louis XII of pious memory, lately deceased, gave to this same da Vinci, the stream of the canal of Santo Cristoforo in the duchy of Milan, to belong to the said Vilanis forever in such wise and manner 'that the said gentleman made him this gift in the presence of M. Francesco da Melzo, gentleman, of Milan, and in mine.

And on the aforesaid day in the said month of April in the said year MDXVIII the same M. Leonardo da Vinci by his last will and testament gave to the aforesaid M. Baptista de Vilanis, being present and agreeing, each and all of the articles of furniture and utensils of his house at present at the said place of Cloux, in the event of the said de Vilanis surviving the aforesaid M. Leonardo da Vinci, in the presence of the said M. Francesco da Melzo and of me, Notary, etc., Borean.

SUGGESTED BOOKS FOR

FURTHER READING

Berenson, Bernhard. *The Drawings of the Florentine Painters.* 3 vols. Chicago: University of Chicago Press, 1938.

Clark, Sir Kenneth. *Leonardo da Vinci: An Account of His Development as an Artist.* New York: The Macmillan Company; London: Cambridge University Press, 1939.

Dibner, Bern. *Leonardo da Vinci, Military Engineer.* New York: The Burndy Library, 1946.

Horne, Herbert (ed. and trans.). *The Life of Leonardo da Vinci by Giorgio Vasari.* London, 1903.

MacCurdy, Edward. *The Mind of Leonardo da Vinci.* London: Jonathan Cape, 1928; New York: Tudor Publishing Company, 1948.

McMurrich, J. P. *Leonardo da Vinci—the Anatomist.* Published for the Carnegie Institution, Washington, D. C. by the Williams & Wilkins Co., Baltimore, 1930.

Richter, Irma A. (ed.). *Selections from the Notebooks of Leonardo da Vinci.* New York and London: Oxford University Press (World's Classics No. 530), 1952.

Richter, Jean Paul (ed.). *The Literary Works of Leonardo da Vinci.* London: Sampson Low, Marston, Searle & Rivington, 1883.

Richter, Jean Paul and Irma A. (eds.). *The Literary Works of Leonardo da Vinci.* 2 vols. rev. and enl. ed. New York and London: Oxford University Press, 1939.

Sarton, George. *Six Wings: Men of Science in the Renaissance.* Bloomington, Indiana: Indiana University Press, 1957.

Singer, Charles. *From Magic to Science.* New York: Dover Publications, Inc., 1957.

Singer, Charles, and others (eds.). *A History of Technology.* 5 vols. New York: Oxford University Press; Oxford: The Clarendon Press, 1954–58.

Vinci, Leonardo da. *Treatise on Painting,* translated and annotated by A. Philip McMahon, introduction by Ludwig H. Heydenreich. Princeton: Princeton University Press; London: Oxford University Press, 1956.

LEONARDO MATERIAL IN
THE UNITED STATES

Three outstanding collections of books and manuscripts relating to Leonardo da Vinci exist in the United States.

The John W. Lieb Memorial collection at Stevens Institute of Technology, Hoboken, New Jersey, containing "every worthwhile book or pamphlet on Leonardo in English, French, Italian, German, Russian, Polish or the Scandinavian languages," as well as every published facsimile of his manuscripts.

The Burndy Library in Norwalk, Connecticut, intended to provide background material for the study of the industrial and scientific revolution, includes a large collection of material relating to Leonardo.

The Elmer Belt Library of Los Angeles, California, contains not only, as mentioned elsewhere, all known editions of the *Treatise on Painting,* but also copies of every book which Leonardo mentions in his notebooks, as well as a unique collection of material on Leonardo.

Reconstructions of Leonardo's Inventions;

Commemoration of Leonardo's Birth, 1952

The first set of models of the inventions of Leonardo da Vinci was constructed for the Italian government's exposition in Milan in 1938, by Dr. Roberto Guatelli, a specialist in the field of Vinciana. Exhibited in large part in the Museum of Science and Industry in New York the following year, the collection was later shipped to Japan and was destroyed in the bombing of Tokyo. In 1951 the Fine Arts Department of the International Business Machines Company exhibited a new series of models, again reconstructed from Leonardo's sketches by Dr. Guatelli.

The Congress organized in 1952 to celebrate the fifth centenary of Leonardo's birth closed on Sunday, July 14, at Amboise on the Loire, where he had ended his days in the service of Francis I. The Comte de Paris offered a dinner, and a solemn Mass was celebrated in the very church at Amboise where Leonardo is buried, the main officiant being the parish priest from Leonardo's birthplace of Vinci.

In further celebration of the anniversary, books were issued and a documentary motion picture made.

INDEX

(*See* Vinci, Leonardo da, for subject entries.)

PLUME BOOKS are part of New American Library's high quality paperback publishing program. The list includes important new books and carefully selected reprints ranging from art and the humanities to science. The high level of scholarship and writing that characterize Signet Classic and Mentor books will be continued and expanded in these large format editions.

___Z5012 THE LIVING CITY, Wright$2.95

___Z5013 NATURAL HOUSE, Wright$2.95

___Z5014 FUTURE OF ARCHITECTURE, Wright$2.95

___Z5019 THE SCOTCH, Galbraith$2.95

___Z5020 EPIGRAMS OF MARTIAL, Bovie$3.95

___Z5021 MARTHA QUEST, Lessing$2.95

___Z5022 PRICKSONGS & DESCANTS, Coover$2.45

___Z5023 RIPPLE FROM THE STORM, Lessing$3.50

___Z5024 ROOTS OF APPEASEMENT, Gilbert$3.50

___Z5025 HERO ON A DONKEY, Bulatovic$2.75

___Z5026 LANDLOCKED, Lessing$2.95

___Z5027 EUROPEAN POWERS 1900-1945, Gilbert $3.50

___Z5028 A PROPER MARRIAGE, Lessing$3.50

___Z5029 CLIMAX OF ROME, Grant$3.95

___Z5030 HARD TRAVELLIN', Allsop$3.75

___Z5031 GARIBALDI & HIS ENEMIES, Hibbert$3.95

THE NEW AMERICAN LIBRARY, INC., P.O. Box 999, Bergenfield, New Jersey 07621

Please send me the PLUME BOOKS I have checked above. I am enclosing $_____(check or money order—no currency or C.O.D.'s). Please include the list price plus 25¢ a copy to cover mailing costs.

Name_____

Address_____

City_____State_____Zip Code_____

Allow at least 3 weeks for delivery